A Walk Through
THE NATIONAL RANCHING
HERITAGE CENTER

By Marsha Pfluger

Published by the National Ranching Heritage Center
at Texas Tech University, Lubbock, Texas
in cooperation with the
Ranching Heritage Association

Third Edition Funded by Helen Jones Foundation

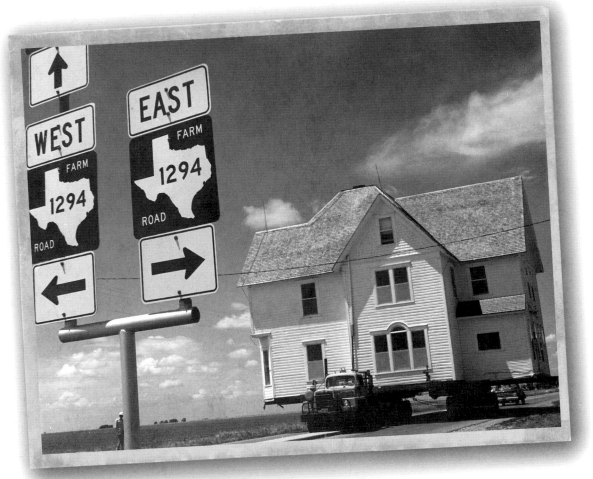

Each historic structure was disassembled or moved
intact from its original location and then restored.

John F. Lott Sr. beside Los Corralitos
(1914-2012)

DEDICATION

Structures at the National Ranching Heritage Center were saved from demolition or destruction from natural elements to be restored and preserved for the enjoyment and educational benefits of people today and generations to follow. Many people have helped with the effort to identify homes and ranch-related facilities for restoration at the NRHC. Among those dedicated individuals was John F. Lott Sr. of Lubbock. Through his efforts as a founder and as a member of the Ranch Headquarters Planning Committee in the 1960s, many of the historical buildings were identified and brought to the National Ranching Heritage Center for preservation and interpretation. With gratitude and respect we dedicate this book to the memory of John F. Lott Sr., a beloved man who was as much a part of the Heritage Center as the buildings he helped preserve. His long years of interest in the "Ranch Headquarters" can never be repaid, but they will be forever remembered. Thank you.

A Walk Through
THE NATIONAL RANCHING
HERITAGE CENTER

Marsha Pfluger

Editorial Assistants Jim Pfluger, Emily Wilkinson, Henry B. Crawford, Robin Gilliam, Stephanie K. Brinkman and Dr. Scott White

Editorial revisions for the third edition by
Jim Bret Campbell, Dr. Scott White and Sue H. Jones

A Walk Through the National Ranching Heritage Center

Copyright © 2004, 2010, 2019 National Ranching Heritage Center and Ranching Heritage Association
Photos Copyright © 2004, 2010, 2019 by Duward Campbell, Mark Hartsfield and the Ranching Heritage Association

Designed by Brandi Goodson and Mark Hartsfield
 Hartsfield Design, Lubbock, Texas
Photography by Duward Campbell, Mark Hartsfield, Sue H. Jones, John Weast
Printed by Craftsman Printers, Lubbock, Texas
Binding by Roswell Bookbinding, Phoenix, Arizona

ISBN 0-9759360-0-X

Third Edition

FOREWORD

"I was brought up in a ranch environment and have always cherished the memory of that experience. My father grew up as a cowboy for the Scharbauer Cattle Co. and other outfits and spent 36 years on the McElroy Ranch in Crane and Upton counties, first as a cowboy, then as foreman and eventually as general manager.

"Though I never had the knack to become much of a cowboy myself, I treasure the things I learned from the cowboys and ranchmen I knew. But many of the physical signs of the old-time ranch industry, as I knew it when I was a boy, are disappearing under ribbons of asphalt and oilfield roads or shaded out by tall buildings. The frugal old ranch houses of yesteryear have more often than not given way to modern split-levels or else the ranchers have moved to town. The old horse barns have been torn down to make room for a tractor shed.

"My grandchildren are missing nearly all of it. So are the children and grandchildren of thousands of other ranch-raised people who have had to go to town to make a living and cannot pass along all the rich heritage of their own youth. Often the places where they lived and worked and played as youngsters are gone with little or no trace; they can't share their experiences with anything more tangible than memories, old pictures and the stories they tell.

"The National Ranching Heritage Center, to me, is a living memorial that we can pass on to future generations to give them at least some inkling of their roots in a time and a way of life that is gone, or rapidly passing, a way of life that invisibly shapes their own attitudes wherever they live, and whatever careers they undertake."

— Elmer Kelton, award-winning author
San Angelo, Texas
(1926-2009)

CONTENTS

Masterson JY Bunkhouse,
King County, Texas

INTRODUCTION

PRESERVING A LEGACY

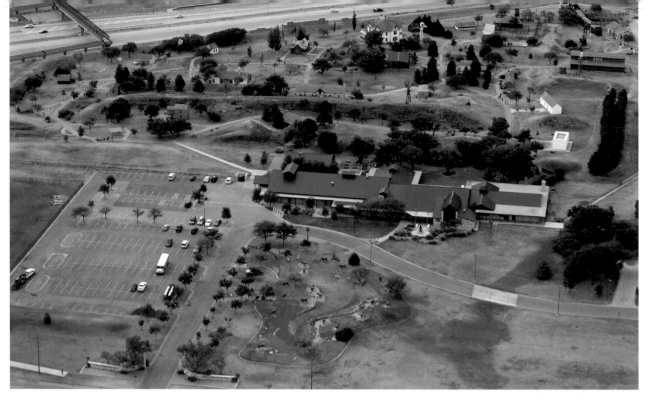

Aerial view, 2015

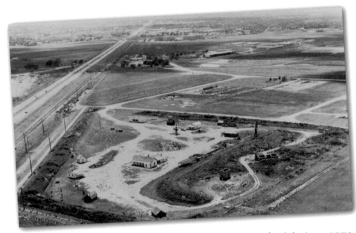

Aerial view, 1973

In the developing years of the American West, the cowman required only the essentials—water, food and protection against possible dangers. The stars were his roof, so a place of shelter was not a top priority. When conditions required him to settle in for a while, he often had to become inventive, making the best of what he had available to him. In doing so, he created one of ranching's great legacies.

How the early rancher and eventually his family adapted to a harsh frontier environment is a story of self-reliance told through the structures he built. The legacy is preserved at the National Ranching Heritage Center, a division of Texas Tech University in Lubbock. The historical park is more than buildings; it is the people who made lives in the structures and created stories, legends and history in the process.

The museum and historical park grew from an idea conveyed by Dr. Grover Murray, then president of Texas Tech University, to a committee of eminent historians, prominent ranchers and select businessmen. Meeting at the old Pioneer Hotel in Lubbock in fall 1966, the Ranch Headquarters Planning Committee enthusiastically expanded the concept from a single ranch headquarters building to dozens of structures spanning the decades since ranching's genesis in this country. The complex

> The historical park is more than buildings; it is the people who made lives in the structures and created stories and legends and history in the process.

would preserve the history of ranching through the restoration and preservation of its architecture. Members acknowledged that time was not a resource. After decades in the punishing Texas sun and withstanding floods, hail and brutal winds, historic ranch buildings were falling into ruin each year. The world was losing important visual elements of ranching history.

Murray and members of his committee developed a proposal that met with approval from the Texas Tech Board of Regents, who saw the Ranch Headquarters as a way of providing "significant evidence of the history of ranching and development of the West." The Ranch Headquarters Planning Committee was charged with locating, arranging for and overseeing placement of historic buildings onto acreage set aside by Texas Tech.

Members began the process, often at their own expense, of identifying representations of the cattle industry. They traveled across Texas seeking noteworthy ranch headquarters buildings, modest dwellings and rustic outbuildings in a wide range of architectural styles and from a variety of geographic locations. The project captured the interest of ranchers throughout the state who helped with the identification of candidate structures for the historical park. Once found and documented, meticulous field notes, measurements and photographs were taken to assure accuracy when the structure was restored to original condition at the National Ranching Heritage Center.

By October 1970, two windmills were in place plus a blacksmith's shop, a two-story dugout and a carriage house. Less than a decade after its conception, the new facility opened during formal ceremonies July 2, 1976, with 18 buildings, four windmills and corrals. Sixteen structures had been restored and most were furnished. In attendance were dignitaries from throughout the world. The ceremonies were highlighted by the arrival of the Bicentennial Longhorn Trail Drive. The Ranching Heritage Association support organization had 1,500 memberships including individuals, families and organizations representing 29 states, Canada and Mexico.

Throughout the identification process, many ranchers were willing to repair the buildings and pay for the move themselves because they believed so passionately in the concept of a ranching heritage center. To them, it represented the first time anything had been done to preserve their chosen way of life and honor the ancestors who cleared the way for them to follow.

Ranching and Texas history often appear in the same chapter and verse. The epic story tells of small-time farmers who fought to create the Republic of Texas and later became powerful ranchers, their names synonymous with Texas history. White and black men alike traveled West after the Civil War to gather wild cattle and make a living for themselves and their families. They became an integral part of the unreasonable nostalgia that glorifies the arduous trail drives, desecration of the great buffalo herds, forced captivity of the Native Americans and the eventual closing of the free range through the advent of barbed wire and the railroad. Over the decades, significant wealth has been realized for many ranchers through land and cattle operations. But the heritage of ranching has suffered important losses. It is difficult in this century to find clear recollections of ranch life on the frontier, much less actual structural remains. But the staff at the National Ranching Heritage Center is always looking. Thanks to the founders and their work that began in the late 1960s, much of the early era of ranching is reflected and preserved in the structures at the NRHC.

To better reflect its mission of preserving America's ranching heritage, the word "National" was added to the Ranching Heritage Center's name in 1999. The majority of structures in the historical park are from Texas, but in the future, more examples of ranch architecture will be added as the search continues for significant ranch buildings and artifacts that help to tell the story of the ranching industry—and ranch life—in North America.

The NRHC now has 50 authentic, furnished or outfitted ranch structures showing ranch life from the early Spanish influence to the advent of the railroad, which ended the trail drives. Each structure reflects the geography of its original location and materials available for construction. For the person with an interest in architecture, landscaping, interior design, pioneer family life, German, Spanish, history, art, photography, theater, fashion design, and more, the National Ranching Heritage Center is a unique research laboratory and a living depiction of the evolution of ranching in the American West.

The late Willard B. Robinson, architectural historian and preservationist who supervised the moving of many structures from their original sites to the park, pointed out the significance of the National Ranching Heritage Center and its mission. "Without the Center, many of those buildings would have been lost, because when they became obsolete functionally, the ranchers either neglected them or tore them down. The early houses show the manner in which the builders responded to their environment." He added that the growing affluence proved to be the ranch home's double-edged sword. "As ranchers gained means, they generally moved to town. The architectural cycle froze in time, with the Texas ranch house endangered by disrepair and disregard. Now, that vivid portrait of life on the wide open spaces lives again in Texas Tech's version of a Texas Sturbridge Village, where the houses and their range-land appendages—from windmills to one-room schoolhouse, from blacksmith shop to barns to bunkhouse—are thriving on admiration their owners never dreamed they would deserve."

The *real* West was built by uncommon people facing immense hardships and dangers. At the National Ranching Heritage Center, pathways lead back through time to those authentic ranch homes and structures, preserved to help visitors know this significant era of Texas and American history. With each turn on the path, another chapter in the story unfolds in the form of a house or cabin or barn. Go ahead; touch it. Whose hands built it? Who lived and worked inside it? With a little imagination and a squint of the eyes, one might be able to find the answers in a quiet cowboy sitting outside the lonely line camp, whittling on a wooden horse in the dim evening light. Or maybe it's the young woman, watching a distant herd of cattle growing smaller in the thick dust that eventually envelops them as they head up the trail to market with her husband at their lead.

The National Ranching Heritage Center preserves the architectural legacy of those early ranchers and, even more important, their stories, some of which unfold in the pages of this book.

> Many ranchers were willing to repair the buildings and pay for the move themselves because they believed so passionately in the concept of a ranching heritage center.

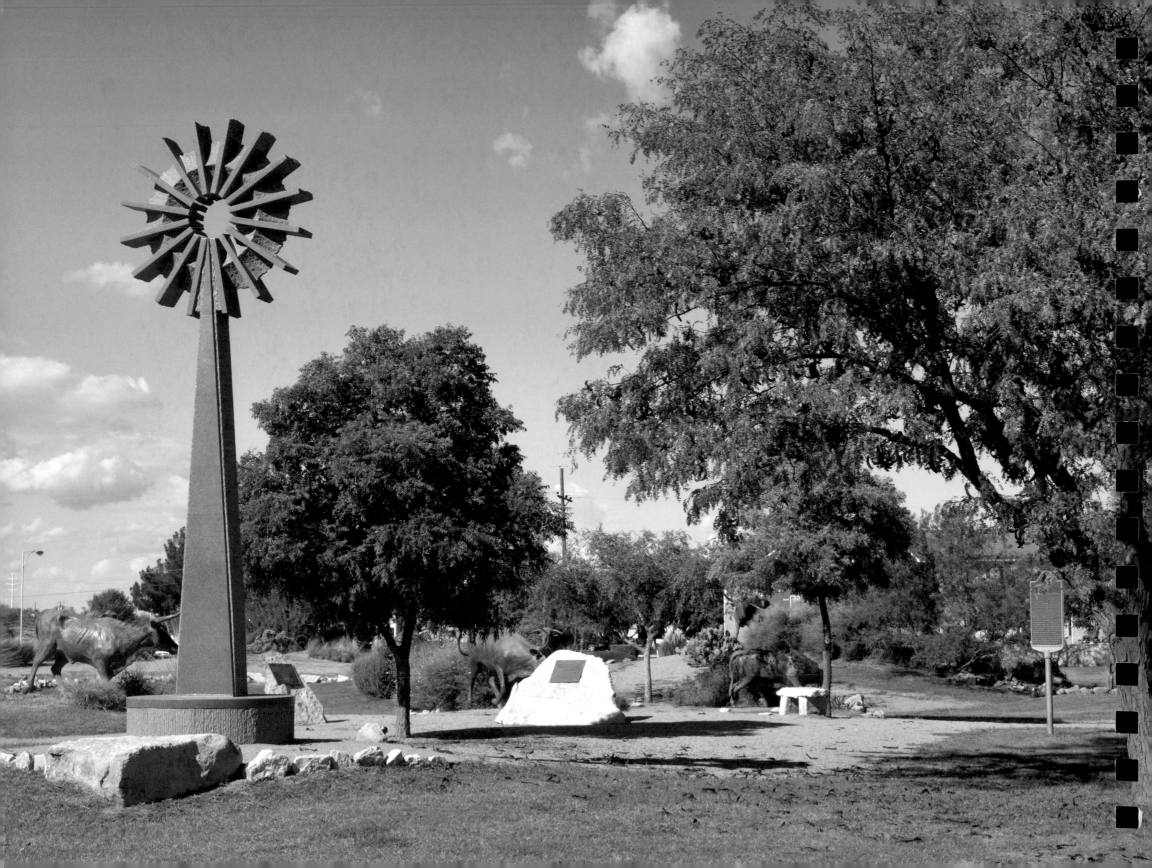

1

CHAPTER ONE

J.J. GIBSON MEMORIAL PARK

c. 2003

The Trail Drive Era of the 1860s to 1880s saw a new lifestyle, industry and folk hero emerge in the American West. The lifestyle was that of the man who left his family for long periods of time to gather and claim the wild cattle that roamed Texas after the Civil War. The industry was ranching, where men often made fortunes driving wild cattle to northern railheads for shipment to eastern markets. The folk hero was the cowboy—freedom-loving, young, restless and almost as wild as the cattle he trailed.

These men made their living from Longhorns, a breed as tough as the land that supported them. After the Civil War, men returned to Texas, where estimates were that nearly 5 million wild Longhorns were free for the taking by people willing to make the effort. With no railroad yet in Texas, it meant they had to gather, brand and drive the animals hundreds of miles to sell. One of the trails that developed between Texas and Abilene, Kansas, was the Chisholm, where in 1867 some 35,000 Longhorns moved across that now-famous trail from South Texas.

According to Tim Miller in the Bryan Woolley book, *Mythic Texas*, an estimated 10 million cattle moved over the trails out of Texas between 1866 and 1890, adding 200 million 19th century dollars to the state's economy and lifting it out of the poverty war had created. A story is told that in 1876 a barbed wire salesman named John W. "Bet a Million" Gates built a corral in San Antonio and put a small herd of Longhorns in it to demonstrate that his new barbed wire would hold them. It did. Gates said cattlemen ordered 100 train car loads of wire that day.

> After the Civil War, men returned to Texas, where estimates were that nearly 5 million wild Longhorns were free for the taking by people willing to make the effort.

LOCATION
In front of the DeVitt-Mallet Ranch Museum Building on Fourth Street in Lubbock, Texas

SIGNIFICANCE
To commemorate the trail drives of the 1860s to 1880s in Texas

DONOR
Anne W. Marion/The Burnett Foundation

DEDICATED
Sept. 19, 2003

Engraved stone bench in Gibson Park

THE FREE RANGE ERA OF RANCHING
NORTHWEST TEXAS, 1878-1885

AFTER INDIANS AND BUFFALO WERE REMOVED IN 1870s, SEVERAL HUNDRED CATTLEMEN WITH SMALL HERDS CAME TO ROLLING PLAINS NEAR SITE OF LATER LUBBOCK, TO GRAZE FREE RANGE. VITAL NATURAL WATER SOURCES WERE FOUND EAST OF THE CAPROCK, WHERE SPRINGS AND STREAMS WERE FED FROM THE OGALLALA FORMATION OF THE HIGH PLAINS.

HERE, WITH GOOD YEARS AND RISING PRICES, THE FREE RANGERS PROSPERED UNTIL 1884, WHEN SYNDICATES BEGAN PURCHASING LAND AND ENCLOSING LARGE BLOCKS WITH BARBED WIRE. FREE RANGE MEN HAD TO SELL THEIR HERDS TO THE SYNDICATES OR MOVE FARTHER WEST.

THE SPUR RANCH ALONE ACQUIRED OVER 500,000 ACRES OF LAND AND BOUGHT CATTLE AND BRANDS FROM 37 OF THE FREE RANGERS. SIMILAR RANCHES WERE DEVELOPED BY THE CURRY COMB, IOA, JUMBO, LONG S, MAGNOLIA, MATADOR, PITCHFORK, SQUARE AND COMPASS, T BAR AND TWO BUCKLE INTERESTS. BY 1885 ALL FREE RANGE OPERATIONS WERE TRANSFORMED INTO LARGE, ENCLOSED RANCHES.

SOME FREE RANGERS EXCHANGED CATTLE FOR STOCK IN SYNDICATES, OTHERS WERE EMPLOYED BY SYNDICATES, AND A FEW MOVED TO ARIZONA, NEW MEXICO OR WYOMING. A FEW INCLUDING THE EDWARDS, LONG AND SLAUGHTER FAMILIES ACQUIRED LAND AND BECAME SIZABLE OPERATORS.

(1970)

True or not, barbed wire hastened the end of the long trail drives that required a tough animal to make the dangerous trek. Ranchers traded the wild Longhorn for docile cattle that grazed quietly in fenced pastures.

Designed to permanently commemorate the open-range era in the West, 19 life-size bronzes of rangy Longhorns were sculpted and placed in a natural setting in front of the DeVitt-Mallet Museum Building at the National Ranching Heritage Center. The park-like area was named to honor the memory of longtime Four Sixes Ranch Manager J.J. Gibson of Guthrie, Texas.

The NRHC teamed with Charles Hodges Development Services in Dallas and artist Terrell O'Brien and Eagle Bronze of Lander, Wyo., to develop the bronze herd. Each animal carries the brand of its donor, including some of the most historic ranches in Texas. The steers were cast in a variety of poses and were strung out to resemble a herd walking. The Longhorns are the focal point of J.J. Gibson Memorial Park, dedicated during ceremonies Sept. 19, 2003. Funding for the park was provided by Anne W. Marion, head of the Four Sixes Ranches and the Burnett Foundation based in Fort Worth.

The National Ranching Heritage Center is pleased to commemorate the Longhorns and the role they played in the development of the ranching industry and our Western heritage.

THE NRHC'S SCULPTED LONGHORNS BEAR THE BRANDS OF:

Rich and Barbara Anderson

Don and Gayle Brothers Family

J. Fred Bucy Jr.

Don and Kay Cash

Jay and Terry Crofoot

Robert F. Fee Jr.

Joe Flores

Jack and Zoe Kirkpatrick

K.W. and Patty Kirkpatrick

John F. Lott Sr.

Anne W. Marion

C.T. McLaughlin Family

Robert and Susan Pfluger

Pitchfork Land and Cattle Co.

A life-size bronze sculpture of a cowboy on horseback surrounded by 19 life-size Texas Longhorns greets visitors at the NRHC entrance. Sculpted by Western artist Bruce Greene of Clifton, Texas, the cowboy and horse are precise in every detail.

Each bronze steer weighs 750 pounds and carries the brand of its donor.

FOR THE RECORD

Walter Schreiner's family has raised Longhorns for several generations on the YO Ranch near Mountain Home, Texas. "Longhorns live a long time," he said. "They produce a calf every year. They have strong mothering instincts and will gang up to protect their calves from coyotes and panthers. They can walk a long way to water. They can survive on marginal land during a drought. They'll eat out of the trees like a deer. When it gets real, real dry, they'll even eat cactus."

— from *Mythic Texas*

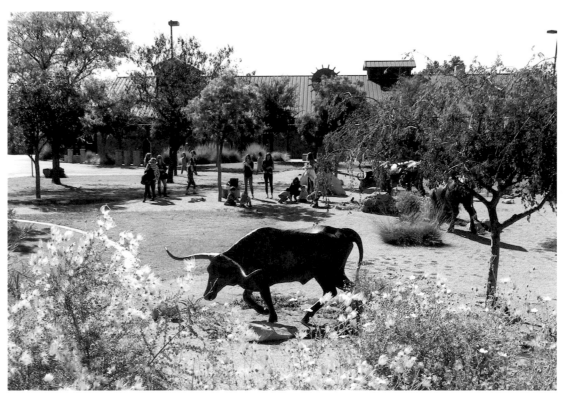

The 19 Steers are visible from Fourth Street and serve as an icon of ranching history.

The sculptures were delivered to the NRHC on a flatbed truck from Wyoming.

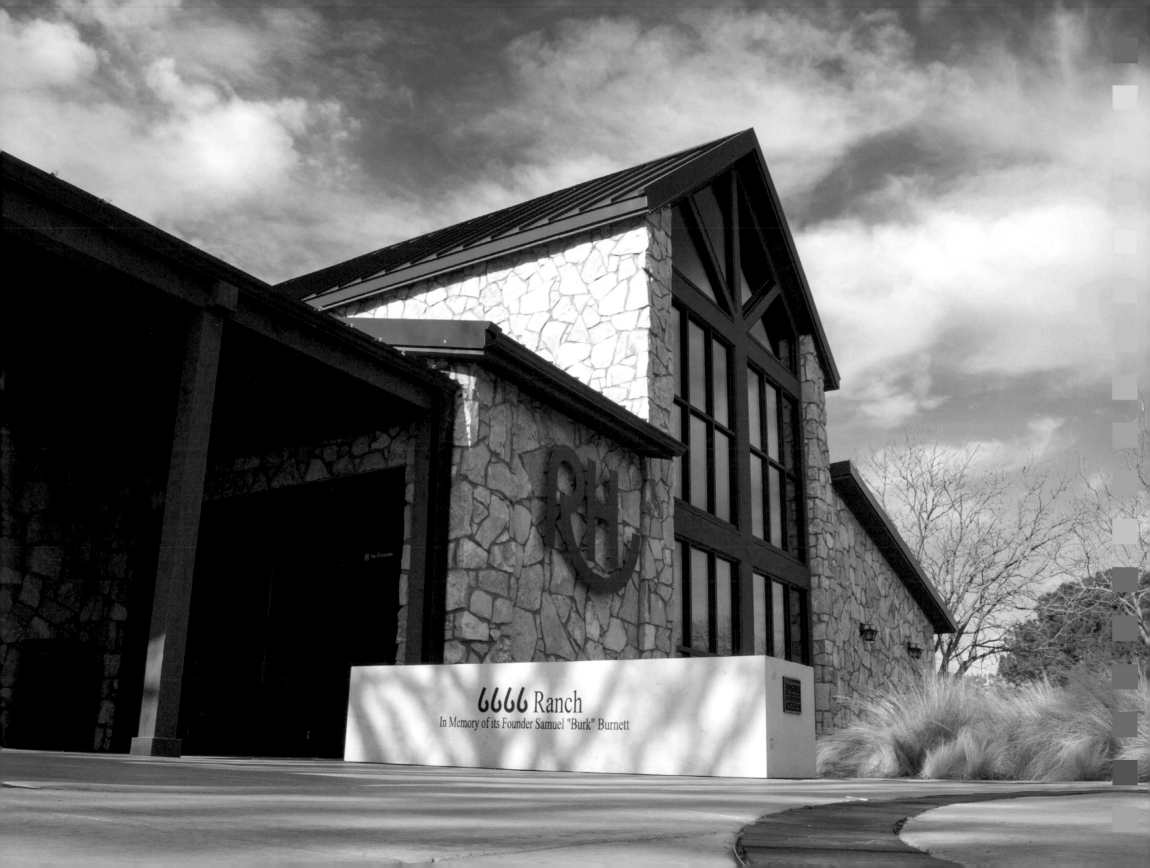

CHAPTER TWO

DAVID M. DEVITT

AND

MALLET RANCH MUSEUM BUILDING

1976, 1983

Modern-day stress fades at the main entrance of the DeVitt-Mallet Ranch Museum Building. Inside, the pace slows; the tension eases. The museum was designed by Bill Cantrell Planners, Inc., to reflect the character of Texas and Southwestern ranch architecture. The feeling of being in a sprawling ranch building is real.

The building was originally constructed for visitor orientation and meeting space. Now, professionally designed exhibits fill each of the seven galleries with images and information about ranching and allied industries, Western art, photography and ranch life.

The Heritage Center museum opened in 1976 during the U.S. bicentennial celebration. An addition was made in 1983 for RHA offices and exhibit space. The Christine DeVitt Wing was added in 2006 to provide staff offices, museum storage, curatorial workspace, an education room and a board room. Today the complex covers 44,000-square-feet and provides seven exhibit galleries.

The main building was named to honor the late David M. DeVitt, founder, owner and manager of the Mallett Ranch in the Texas counties of Cochran, Hockley, Yoakum and Terry. His story sets the stage for other amazing tales told throughout the 19-acre Foy Proctor Historical Park behind the main building.

As unlikely as it may seem, this museum's story has a New York City beginning. Young David DeVitt was a newspaper reporter for the Brooklyn (New York) Eagle in 1882 when he was sent to write a story on the development of the ranching industry on the West Texas free range. The experience caused him to move to Fort Worth in the spring of 1883 to try his hand at making a fortune. After his sheep herd was destroyed in a prairie fire, one challenge followed another. Then the cattle industry boom ended just as DeVitt launched his cattle business.

> As unlikely as it might seem, this museum's story has a New York City beginning.

LOCATION
National Ranching Heritage Center, 3121 Fourth Street, Lubbock, Texas

SIGNIFICANCE
Originally planned to be a visitor's orientation center

DONORS
Christine DeVitt, the DeVitt family foundations and private contributors

DEDICATED
July 2, 1976

Barbed wire closed off the free range and droughts followed one after the other, causing cattle prices to plummet. DeVitt's marriage, however, produced four children: Christine, Harold, Helen and David Jr. His financial circumstances changed in 1903 when he established the Mallett Land and Cattle Co. DeVitt managed 52,000 acres, discovered oil on those acres and remained company president until his death in 1934. His wife lived another 11 years, and his daughters became well-known as philanthropists. They established foundations from the Mallet Ranch revenue and used the money to support educational institutions and social and cultural programs, including the National Ranching Heritage Center museum and historical park.

Cogdell's General Store, the museum gift shop, is located in the main building and named in recognition of a donor family who has been an important part of West Texas ranching heritage. Exhibit galleries, a meeting room and the Burk Burnett Library and Reading Room complete the building.

Campbell Patio and the Foy Proctor Historical Park

Funds for the wide patio behind the main building were donated in 1976 by Ann and Trent Campbell in memory of his parents, Richard Thomas Campbell and Elizabeth Keen Campbell. The Campbell Patio was constructed from the same brick pavers that cover Broadway Avenue in Lubbock. Landscaped for shade and beauty, the patio was dedicated on July 2, 1976, and offers visitors an attractive place to rest. It also serves as a transition to the past as visitors move along the walkway into the historical park, which was named for well-known West Texas rancher Foy Proctor.

The park has 50 historic ranching structures arranged in chronological order to tell the story of ranching as it developed from the

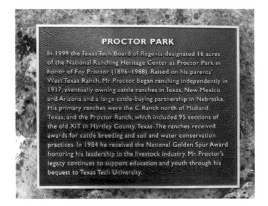

PROCTOR PARK

In 1999 the Texas Tech Board of Regents designated 16 acres of the National Ranching Heritage Center as Proctor Park in honor of Foy Proctor (1896–1988). Raised on his parents' West Texas Ranch, Mr. Proctor began ranching independently in 1917, eventually owning cattle ranches in Texas, New Mexico and Arizona and a large cattle-buying partnership in Nebraska. His primary ranches were the C Ranch north of Midland, Texas, and the Proctor Ranch, which included 95 sections of the old XIT in Hartley County, Texas. The ranches received awards for cattle breeding and soil and water conservation practices. In 1984 he received the National Golden Spur Award honoring his leadership in the livestock industry. Mr. Proctor's legacy continues to support education and youth through his bequest to Texas Tech University.

late 1700s to the 1950s. More than 30 of those structures are between 100 and 200 years old.

The atmosphere created by the outdoor park may be the greatest attraction of the center. The park makes visitors feel they're in a rural area in another time and place even though the massive Texas Tech campus is just over the hill. Those hills on the flat plains are actually berms created by moving and covering the debris left from the 1970 tornado that damaged downtown Lubbock. The berms have been planted with native grasses and wildflowers. In addition, trees provide shade along the 1.5-mile pathway, which is wheelchair and stroller accessible to visitors.

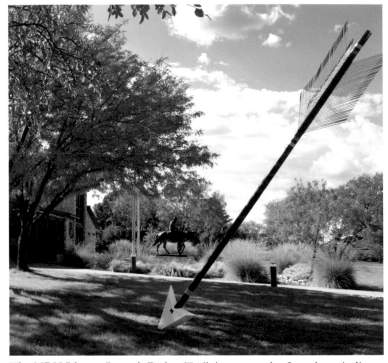

The NRHC has a Quanah Parker Trail Arrow on the front lawn indicating a connection with Quanah and the Comanche tribe. The center has the second largest collection of Comanche artifacts in the nation, all owned at one time by Quanah.

Christine DeVitt Wing

Cogdell's General Store

Burk Burnett Library and Reading Room features a fireplace made from Old Fort Bascom bricks.

FOR THE RECORD

Bricks for the wall and fireplace in the beautiful far southwest room of the DeVitt-Mallet Ranch Museum Building were donated by Val Hampton in memory of her husband, Howard. The material came from the Hampton Ranch, where the remains of Fort Bascom are located. Hampton had sold some of the ranch land surrounding the Civil War-era fort but kept the bricks. Handmade by soldiers who provided protection for wagons headed West on the Texas and New Mexico frontiers, the bricks were baked in a kiln at the fort. Hampton was one of the original NRHC founders who worked to make the historical park a reality.

The Campbell Patio provides a transition from the DeVitt-Mallet Ranch Museum Building to Proctor Park, and it also provides an entertainment area for special events.

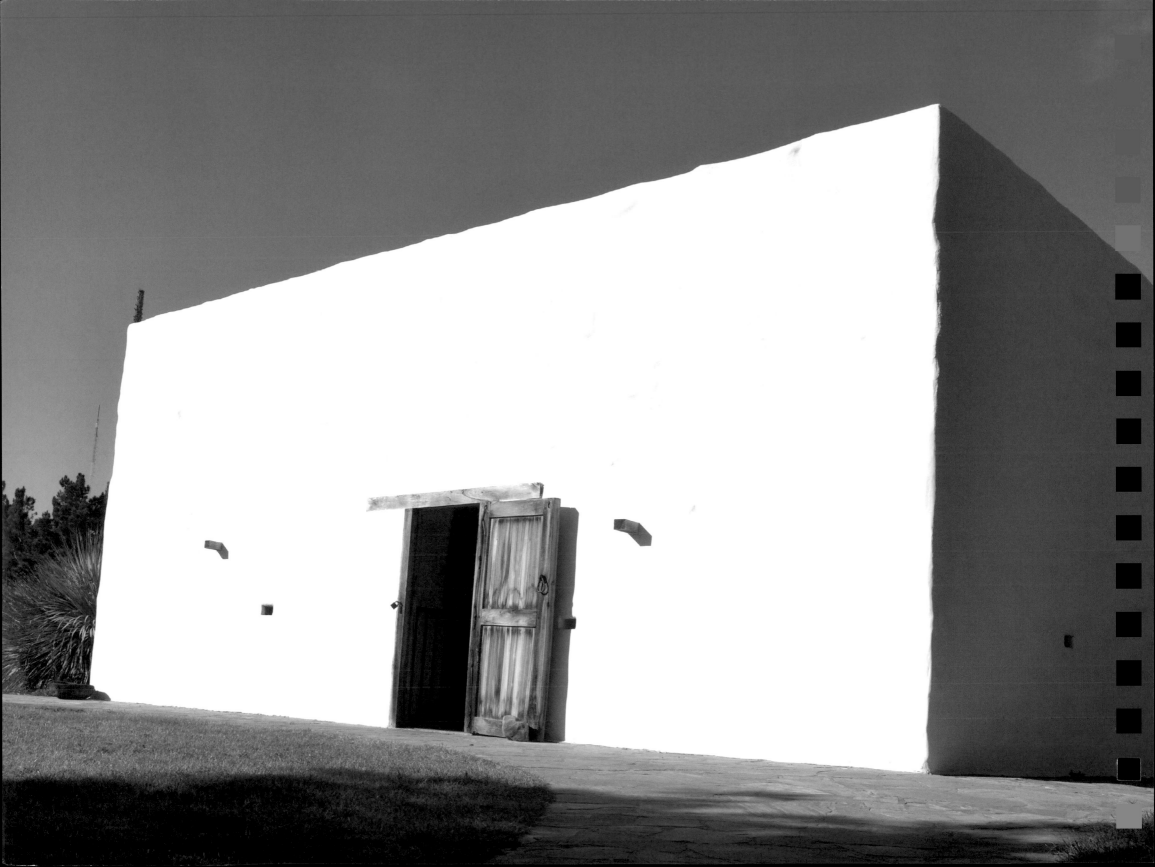

CHAPTER THREE

LOS CORRALITOS
c. 1780

In the late 1960s and early 1970s, great care was taken in selecting a building to recognize the early days of ranching endeavors in Texas and the Southwest. San José de Los Corralitos from Zapata County was chosen because evidence suggests it may be the earliest standing ranch structure in Texas.

The first building erected on this particular land grant, Los Corralitos, was fashioned as a fortified ranch building, or *fortaleza*, to protect the family from Indians and also marauders from across the Rio Grande. Comanches, Apaches and other tribes attacked the settlements, burned homes, killed villagers and claimed the livestock as their own. A constant threat to the new settlers, Indians and *banditos* saw the cattle and horses as prizes to be taken. The Indians sought the animals for themselves, but they also stole to keep the valuable livestock away from rival factions to barter as trade items and grow rich. In *Borderlands* by José Cisneros, the author-illustrator states, "Villages and ranches alike were hit; men, women and children fell to arrow, lance and war-club. Cries and curses of the attacked mingled with the war whoops of the attackers, the roar of musket fire and the pounding of hooves, as the livestock were driven away. When a raid ended, the Indians withdrew to mountain strongholds in the West, or to the wilderness north of the Rio Grande. So it went, year after year."

Don José Fernando Vidaurri, grandson of the original Borrego grant owner, built the single-room dwelling of sandstone, mud mortar, mesquite and Montezuma cypress. It had 33-inch thick walls (one Spanish *vara*, a standard unit of measurement); one door on the east elevation; no windows; six gun ports; and a flat, 11-foot tall ceiling. The gun ports allowed the muzzle of a black-powder firearm to extend through the opening when defense was necessary.

The interior features included a *nicho* on the west wall, a single shelf and wooden blocks. Nearly everything the family owned was kept in the house for protection. Furnishings were limited to the

> Villages and ranches alike were hit; men, women and children fell to arrow, lance and war-club.

ORIGINAL OWNER
Don José Fernando Vidaurri, grandson of the original Borrego grant owner, who built the village and the fortified structure

LOCATION
Less than 200 yards from the Rio Grande on the north bank of the river, 23 miles south of Laredo along Highway 83 in Zapata County, Texas

SIGNIFICANCE
Represents the genesis of ranching endeavors in Texas and the Southwest

NO DONOR
A replication of the original San José de Los Corralitos

DEDICATED
Sept. 9, 1999

A bread paddle was used outdoors with the *horno*.

Gun ports were funnel-shaped and wide enough to permit the gun handler to lean in and move from side-to-side as he attempted to protect his family.

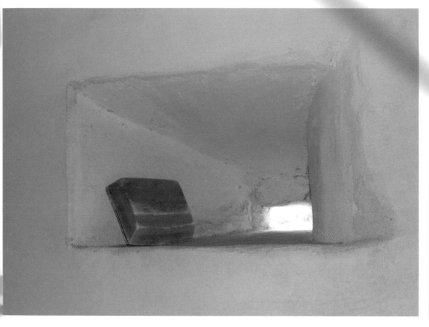

Grinding stone– *mano* and *metate* – and plate

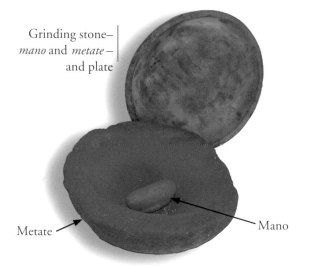

Metate

Mano

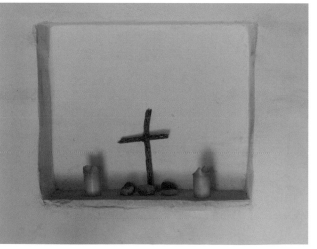

A *nicho* held religious items.

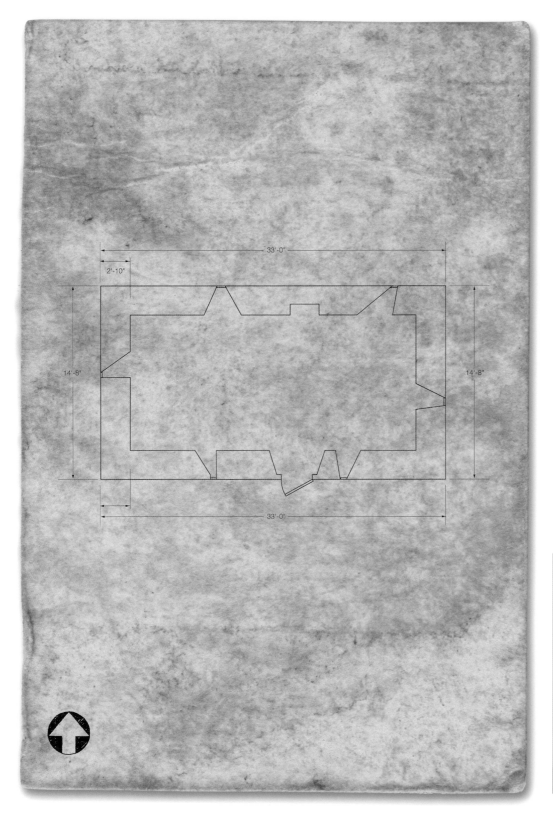

LOS CORRALITOS
up close

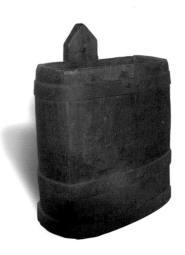

Wine cask |

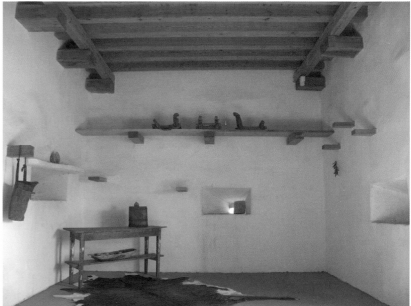

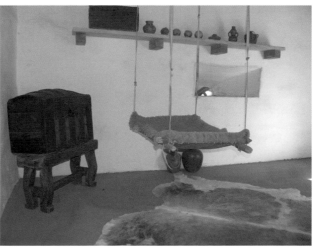

The child's cradle, which hangs from the ceiling, was used as both a protected bed and a swing.

basic requirements of living, such as crocks, cooking devices and religious items. A child's cradle hangs from the ceiling as both a bed and a swing to keep the infant up off the floor, cool and comforted. Made from sheepskin and rawhide, it was lined with wool. Family members slept on the floor, and clothing was kept in trunks.

Although Los Corralitos was fortified against human attacks, the open gun ports and door, often ajar for ventilation, provided an entry for others—snakes, tarantulas and scorpions. The door was likely hung with simple looping hinges and latched with a wrought iron hasp. A wooden bar secured the door from the inside.

The structure's roof was a very important part of the home and served several purposes. Its surface sloped slightly to the back of the structure so rainwater would be channeled through five equally spaced wooden roof drains, called *canales*. As a fortification measure, the roof was built inside a parapet, or wall, behind which the family could crouch and return gunfire. Access to the roof was most likely by an exterior ladder. (A roof hatch and interior ladder would have been logical but difficult to keep watertight.) These fortification efforts provided the settlers with some peace of mind as they attempted to make lives for themselves and their families in dangerous times.

Ranching was an important way of life for the Spanish settlers, many of whom saw it as their heritage. Driving cattle into what is now the American Southwest began in 1598 when 7,000 head were pushed north from Durango, Mexico, as part of Juan de Oñate's colonization of New Mexico. Records show that settlements on the Rio Grande from 1659 to 1682 established the first *ranchos* in what is now Texas. The climate, terrain and vegetation sustained their herds, which grew in number. Men who worked the ranches often had no formal education, but they possessed highly developed instincts about cattle and horses. Called *vaqueros*, they were skilled horsemen. In later years, vaqueros passed along to Anglo cowboys their knowledge of how to break wild *broncos*; gather cattle; fashion leather and metal into saddles, cinches and tools; and use their instincts. Vaqueros helped make it possible for ranchers in Texas to create an important way of life that spread throughout the new country.

Los Corralitos represents that story. Translated "Little Corrals" in English, Los Corralitos dates from 1753 when Colonel José Escandon dedicated a 350,000-acre Borrego grant, a portion of which would eventually become the village of Corralitos. The fortress was part of an effort to hold title to the Borrego family grant known originally as Nuestra Señora de los Dolores. Dedicated on Aug. 12, 1750, it was the oldest Spanish colony on the north banks of the Rio Grande south of Isleta (near El Paso).

When Indian raids eventually subsided, the family built another

home—this one with windows—and moved next door. Los Corralitos was kept as a fort to be used when needed and to protect more than the living members of the family. Court records indicate that the original structure may hold beneath its floor the bodies of at least five members of the land grant family. The home and property stayed in the hands of Vidaurri descendants for generations.

In 1917, Everett Love of Laredo, Texas, bought Los Corralitos, and in 1939, Harvey Mecom of Liberty County purchased all 5,000 acres from Love. Mecom was not aware of the sepulchre. Wanting to use the building for storage, he poured a concrete floor over the packed dirt.

When Indian raids eventually subsided, the family built another home—this one with windows—and moved next door. Los Corralitos was kept as a fort, to be used when needed, and it protected more than the living members of the family.

One of the Ranch Headquarters Planning Committee members said, "Nobody knows how much it cost Mecom to accommodate the family for having covered their ancestors with cement."

With knowledge of the burials, the committee decided to construct a reproduction of the fortified house for interpretation at the National Ranching Heritage Center and not disturb the old building. In the late 1970s, the Texas State Historical Survey Committee identified Los Corralitos as a significant site during efforts to survey historic architecture throughout the state. The building is a testament to the bravery and determination of early Spanish land grant holders who pioneered the Southwest cattle industry.

A water pouch hangs from a wooden block.

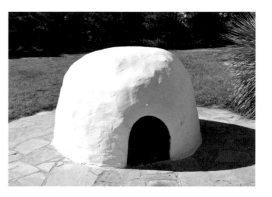

FOR THE RECORD

The most incorrectly identified structure at the National Ranching Heritage Center is the *horno*, an outdoor oven used by the family for baking. Many young visitors have commented, "Look! They had a dog house!"

original location
LOS CORRALITOS

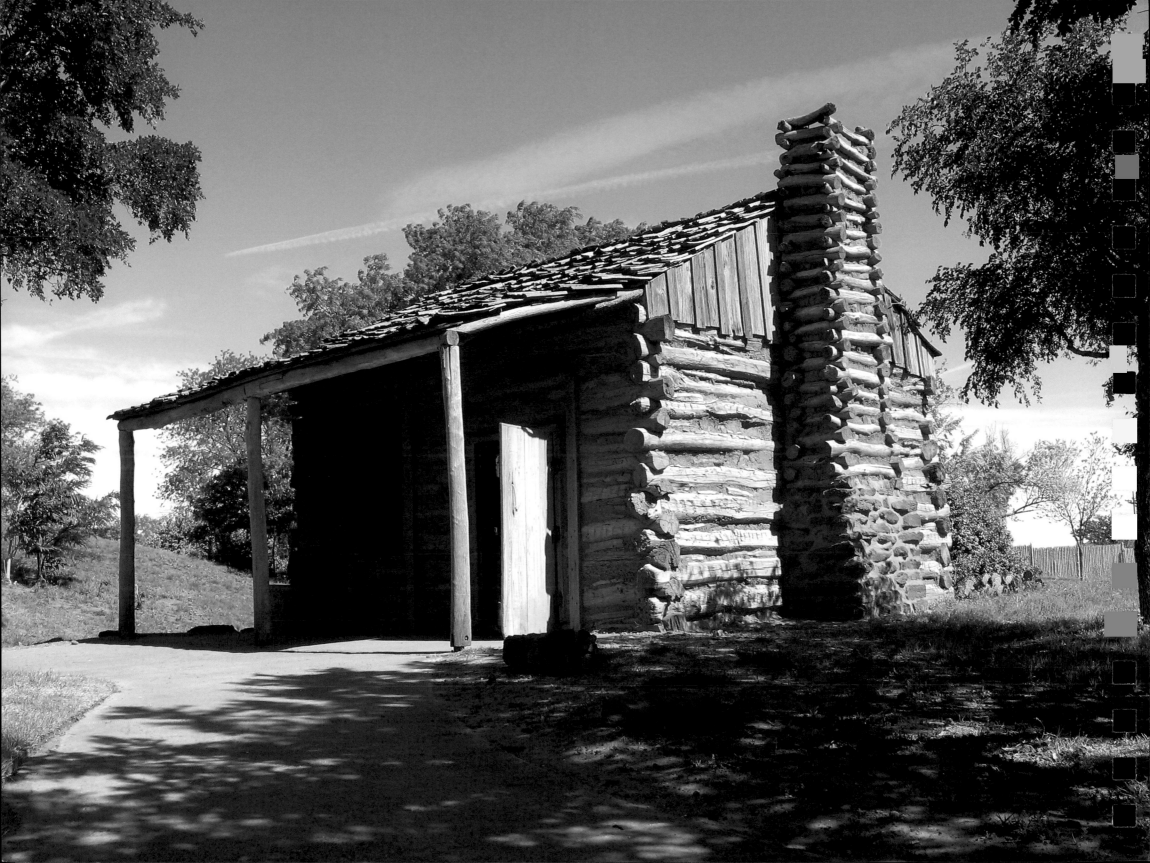

CHAPTER FOUR
EL CAPOTE CABIN
c. 1838

The one-room El Capote Cabin was built near the Guadalupe River bottom country where pecan, elm, hickory, oak, cypress, cottonwood and walnut trees grew. The rustic dwelling was part of the Capote Six Leagues, a stock farm located on a plateau between the Oakville Escarpment and the Austin Chalk Cuesta. Spanish for "the cape," El Capote was named for the nearby hills that spread out like a flowing cloak.

Only speculation exists about the cabin's builder and whether it was ever used as slave quarters. Only the last occupant is known—Oliver Collins, a black sharecropper who helped tend the cattle and trained oxen to pull plows in the cotton fields. After he died, his family moved away in 1934. Their departure left the cabin to the effects of time and weather.

The cabin was built in one county that split into two—Gonzales and Guadalupe—right through Capote property. In addition, the cabin existed under the governance of three flags: the Republic of Texas, the United States of America and the Confederate States of America. El Capote's owners engaged in dangerous lifestyles, including trail drives and wars with Indians and factions from Mexico, England and Cuba. The old cabin's story contains more adventure and mystery than any other structure at the National Ranching Heritage Center.

The first of the colorful characters to lay claim to El Capote Cabin was a captain in the American Revolution from Avignon, France, Joseph (later changed to José) de la Baume, eldest son of a French count. After the war, de la Baume received from the Mexican government six leagues (26,568 acres) in Green DeWitt, a Texas land grant colony. Throughout the duration of his ownership, de la Baume maintained his home in San Antonio, never residing on El Capote soil.

> El Capote has been linked with royalty, politicians, war heroes and a future United States President.

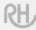

ORIGINAL OWNER
Heirs of José de la Baume, original Capote grant holder

LOCATION
East of Seguin near the Guadalupe River in what is now Guadalupe County, Texas

SIGNIFICANCE
Constructed during the Republic of Texas (1836-1845), El Capote represents the architecture of early frontier cabins

DONOR
Gilbert M. Denman Jr.

DEDICATED
Oct. 26, 1975

Dedication at the NRHC

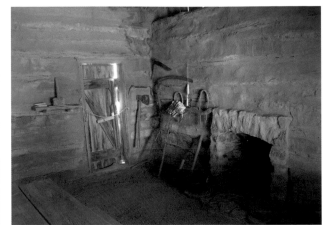

The pecan trees east of El Capote have been called pecan "bushes," because of their lack of pruning. The trees were left to grow as they would in a natural, untended setting. Without pruning, they grew to resemble bushes. One of the pecan trees was given to the National Ranching Heritage Center by the State of Texas for the official opening in 1976 during the nation's Bicentennial Celebration.

A broadax was an important tool to the settler.

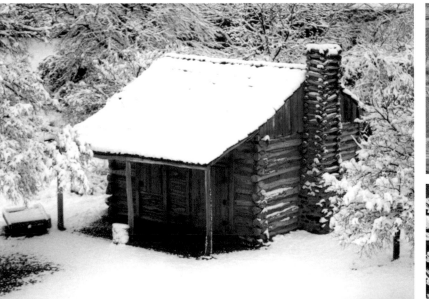

The primitive door hinges were made of leather.

A cornhusk broom reflects the modest means and ingenuity of early occupants of El Capote Cabin.

EL CAPOTE
CABIN

up close

A drawknife was one of the few tools needed by a settler to build a cabin.

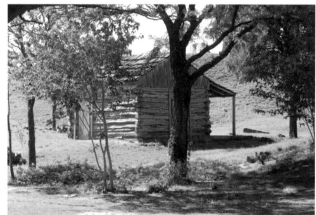

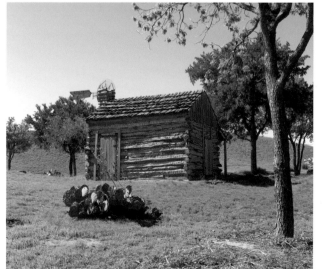

"V" joints were notched to form the cabin's corners.

This small cabin had three doors.

In his will, dated April 4, 1834, the Capote land was divided among his children. Witnessing the will were John W. Smith, the first Anglo mayor of San Antonio, and Erasmo Seguin, one of the most influential men in pre-Revolutionary Texas.

John W. Smith was a well-known person in the Republic of Texas era. An Indian fighter who also faced Mexican forces, Smith became a popular political figure. A story has been told that he was in a party sent to rescue three women taken by Comanches in the Linnville Raid. Indians shot the women, but one survived when her steel corset stay deflected the bullet. John Smith died at Washington-on-the-Brazos on Jan. 12, 1845.

The de la Baume heirs maintained ownership of the Capote property but rented it to French Smith. He made improvements to the land, adding various structures and outbuildings. Some have speculated that he could have built El Capote Cabin during this time.

After a few years of ownership, the de la Baume children were forced to sell out in 1844 after failing to pay land taxes on their inheritance. Michael Erskine, who was an early cattleman in Texas, acquired the land and moved with his family to the Capote property in 1843. The Erskines were typical of families from the South who combined farming with raising livestock and called their outfits "stock farms." If French Smith did not construct the cabin, Erskine is the other likely candidate, perhaps building it for slave quarters or for laborers.

In 1854, Erskine mortgaged El Capote land to put together a cattle drive to the gold fields of California. Because he replaced lost cattle with strays he found along the way, Erskine arrived in California with 1,054 cattle, the same number that left Texas. Erskine invested his significant profits in mining ventures, all of which failed. He returned to El Capote five years after he had left and spent the remainder of his life putting together trail drives to Louisiana. Erskine died in 1862 as he made his way home from a cattle drive to New Orleans.

It may not have been as glamorous a pursuit as trailing cattle or gambling on mines, but Erskine was very successful in his experiments with strawberries, seed potatoes and other crops. One year, because of his work, a record 12,000 bushels of corn brought in $5,400 in mid-19th century currency.

After Erskine's death, heirs eventually sold El Capote to an investment syndicate that included Gen. Daniel Tyler of Connecticut, a West Point graduate and Civil War veteran. Tyler's son-in-law, Alexander Moore, fought in the Battle of Gettysburg and served in the Army until 1879 when he resigned and moved to Guadalupe County, Texas, to oversee development of El Capote. Tyler bought out the interests of other syndicate members, took an active interest in the ranch and was a part-time resident until his death in 1882. Moore continued to oversee the ranch and to represent the interests of the Tyler estate until the property was divided among the heirs, including his wife Mary Tyler Moore.

When Gen. Tyler died, he bequeathed the ranch to his daughters, Gertrude E. Carow and Mary Moore. At her death, Gertrude gave her ranch interests to her two daughters, who, in turn, gave their claim to their aunt, Mary Moore. One of those daughters was Edith Kermit Carow Roosevelt, wife of Teddy Roosevelt.

Moore raised livestock and horses in Guadalupe County and gave two of his horses to Roosevelt to take to Cuba during the Spanish-American War. The horses were named Rain-in-the-Face and Little Texas (not Seguin, which was a Roosevelt horse another time). Rain-in-the-Face drowned in the Cuba landing, leaving Little Texas as Roosevelt's mount when he rode with the Rough Riders.

The property later was sold to Judge Leroy Gilbert Denman, who was appointed as associate justice of the Texas Supreme Court by Gov. James S. Hogg. It was Judge Denman's grandson who made a gift of El Capote Cabin to the National Ranching Heritage Center.

The modest cabin, once part of a 26,000-acre stock farm, was originally constructed of winged elm logs chinked with thick mud from a stream bed. The roof was made of hand-split pecan shakes, and the cabin floor was compacted earth. A fieldstone fireplace featured a "mudcat" chimney, so called because of the mud and sticks from which it was built.

Windows and three door openings were cut into the logs after the cabin was built. Leather patches hinged the doors, and rope was affixed as door handles. Square-headed, handmade nails held the cabin together. Two sides of each log were flattened to repel water and prevent rot.

The cabin's orientation is to the south to take advantage of cool summer breezes. In much of Texas where the weather is hot, daily chores and activities were performed outdoors. A porch was added for protection from the sun and rain. In El Capote Cabin, the fireplace was used for cooking and heat when needed. Furniture likely consisted of a handmade table and benches or chairs. The family's few garments were hung on wall pegs or folded and placed in a trunk. Wooden boxes were nailed to the wall for storage space. Family members slept on the floor on blankets or buffalo robes.

At the NRHC, pecan trees were planted around the cabin in the ongoing effort to use plants indigenous to the original location of each building. It should be noted that initial restoration work on the cabin came to a halt because pecan logs were not available to the NRHC in the quantity needed. Wallace and Maurice Harrell of the Harrell Cattle Co. in Gonzales County stepped up and provided 20 tons of pecan logs of various sizes cut from near the Guadalupe River—on the same land grant where El Capote Cabin was originally built.

Hand-made, square-headed nails

FOR THE RECORD

A story is told about the Runaway Scrape that occurred after the fall of the Alamo. As Anglo settlers headed east with their possessions to avoid the advancing enemy, it is said the army of Santa Anna camped near El Capote Cabin the Saturday before Easter in 1836. There they waited for the flooded Guadalupe to recede so they could cross into Gonzales. In reality, researchers pinpoint the camped army as 20 miles from the cabin, which is not exactly "near" it. Such stories exist throughout history, turning facts into colorful and much-repeated legends.

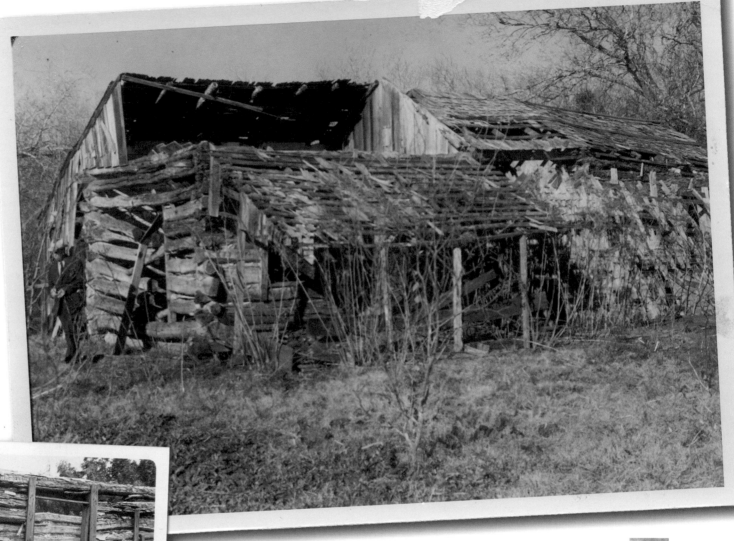

original location
EL CAPOTE CABIN

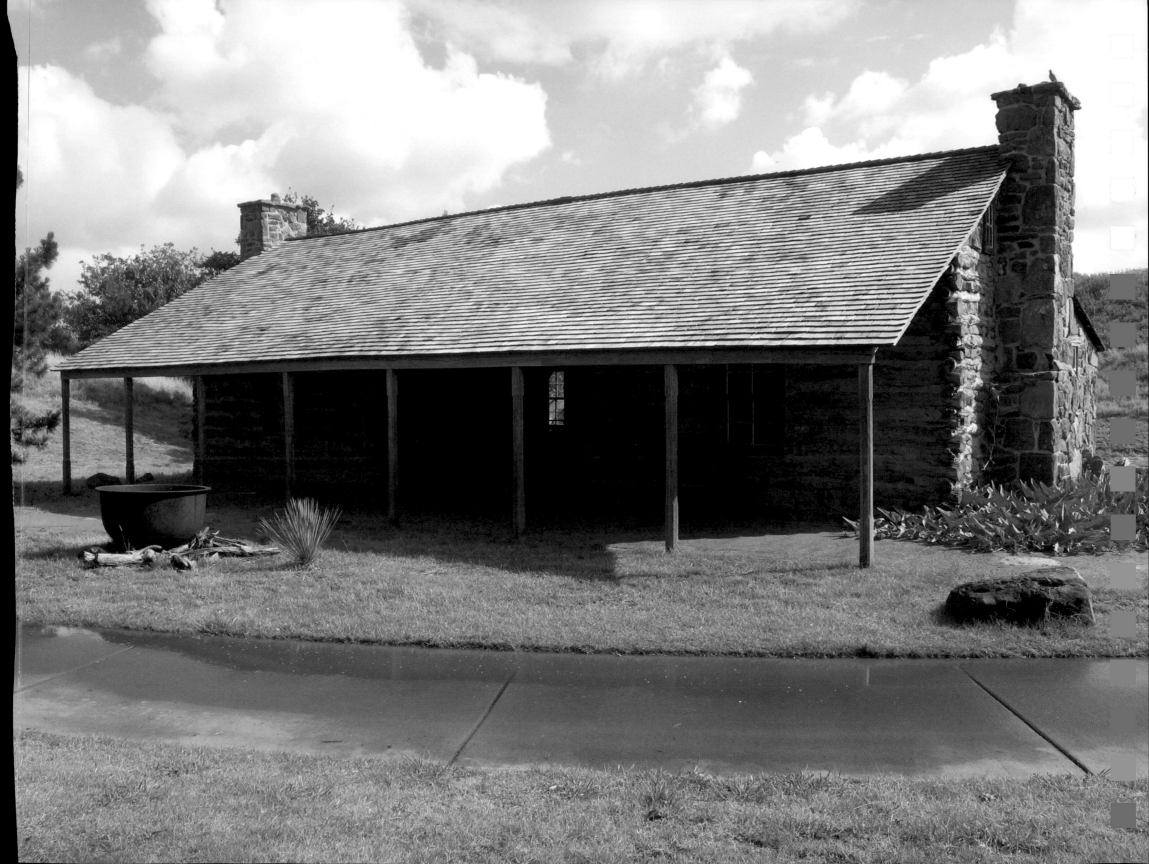

CHAPTER FIVE

HEDWIG'S HILL DOGTROT HOUSE

1855-56

The Old West is a story with many chapters, each one comprised of the people who played a role in the settlement of the new frontier. The log house from south of Fort Mason, Texas, represents one of those chapters. It's a story of German immigrants to Texas, an unsolved murder and the transformation of a building as the times called for a change.

The beautiful Hill Country of Texas beckoned to settlers with its Llano River running clear and forests of cypress, pecan and oak trees growing thick throughout the river valley. Louis Martin was among the first of some 7,000 Germans who traveled to Texas in 1844 as part of an agreement between the government of the Republic of Texas and German officials. Martin worked as a wagon freighter and trader, acquiring wealth and prominence in the German community that grew rapidly in the new state. (Texas joined the Union on Dec. 29, 1845.)

A man of political influence, Louis Martin served as sheriff of Gillespie County. He also sold goods to nearby Fort Mason. In 1853, Martin moved his family to the north bank of the Llano River, where he operated a general supply store and built a house, naming the location Hedwig's Hill for his mother and his daughter, the first white child born in Fredericksburg, Texas.

In 1855, Martin bought for $1,000 several sections of land in what was then Gillespie County. For an additional $1,200, he purchased livestock, a wagon, farm equipment and household items. Records indicate he is the builder of a second home, the dogtrot-style house, preserved at the National Ranching Heritage Center. In 1858, he bought the store at Hedwig's Hill operated by American settler John Kline and, on June 29, 1858, Martin established the earliest rural post office in the county.

The county was predominantly comprised of skilled German craftsmen.

Hedwig's Hill was on the route of trail drives. Some of the cattle from Mexico headed north right by the settlement. Its location was also on a trade route that served the Hedwig's Hill area. Mason County was established from a portion of Gillespie County, where

ORIGINAL OWNER
Louis Martin

LOCATION
One-quarter mile from the Llano River just off U.S. Highway 87, five miles south of Art, Texas, in southern Mason County

SIGNIFICANCE
Illustrative of the German ethnic tradition in frontier Texas and the multiple functions of a structure in the wilderness

DONORS
Arthur Esser and Allen Haag families

DEDICATED
Oct. 5, 1974

pinning wheel

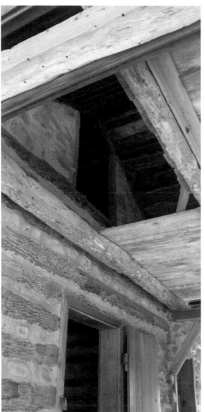

Loft, where the children slept

The tiny window brought light to the loft.

Wooden bowl or "dough trough"

Pie safe

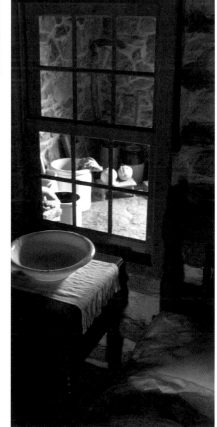

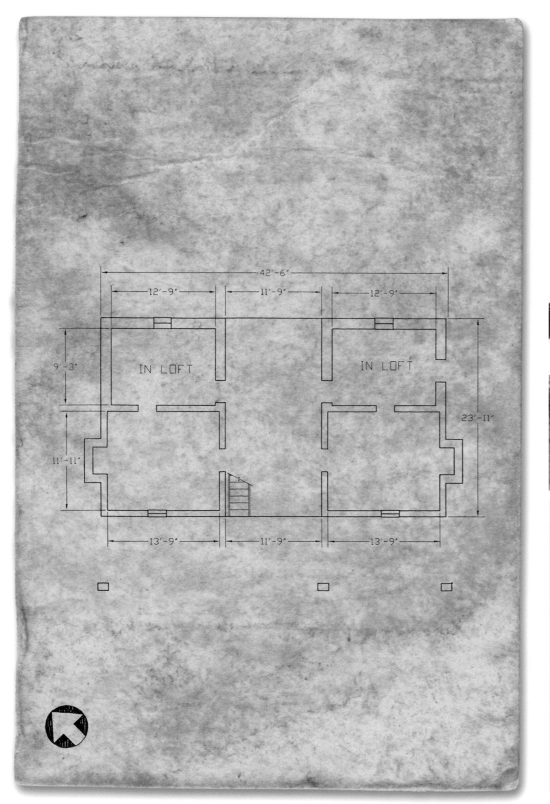

42'-6"

12'-9" 11'-9" 12'-9"

IN LOFT IN LOFT

9'-3"

23'-11"

11'-11"

13'-9" 11'-9" 13'-9"

HEDWIG'S HILL DOGTROT HOUSE

up close

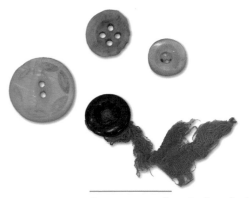

Buttons were found when the house
was moved from its original site.

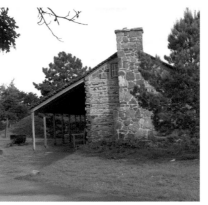

A child's marbles were
found under the house,
a long-lost plaything
now preserved.

Martin served as postmaster and freighted goods throughout the Hill Country, East Texas and to and from Mexico.

With their growing family of five children, whose ages spanned twelve years, Martin and his wife Elizabeth lived in the house only briefly before moving to a house on Elm Creek. It was renamed Martin Creek after the drowning of the youngest Martin child, Alexander, age 7, in 1863. Louis rented the house to John and Kathryn Keller, who turned it into a store before moving the business to another building about 30 feet away. The county, which was predominantly comprised of skilled German craftsmen, had a cooper, beer brewer, soap and candle makers, tinner, sawmills, saddle and harness makers, grist and flour mills, wheelwrights, blacksmiths and furniture makers.

The house at Hedwig's Hill, under both the Martins and the Kellers, was a hotel of sorts, with one of the rooms reserved for paying guests. The breezeway was available for travelers, some of whom slept on bedrolls. Robert E. Lee probably was familiar with Hedwig's Hill, since the settlement was near a military route he traveled while commanding Fort Mason. He arrived at the fort on Dec. 23, 1860, as a 54-year-old lieutenant colonel and left in mid-February for San Antonio and the Civil War history books. When the Hedwig's Hill Dogtrot House was excavated for removal to the historical park, brass military buttons and a bag of glass marbles were found.

Sympathy for the Confederate cause was prevalent in Texas, but Louis Martin, like other German immigrants in the Texas Hill Country, had not experienced slavery. Martin was more interested in succeeding as a rancher and farmer, and, to do so, he sold produce to Mexican merchants who eventually sold it to Union ships in the Gulf of Mexico).

During one of those trips in June 1864, Martin and his niece's husband, Eugene Frandzen, were hauling 2,800 pounds of bacon to Mexico. Evidence indicates that gold for the purchase of supplies at Piedras Negras was hidden under the bacon.

Along the way, the men were stopped near Eagle Pass, Texas, by what has been variously reported as "embittered Confederates" or "Confederate deserters." Using Martin's rope, the group hanged the two Germans. Although robbery was probably the motive, it is speculated that Martin was thought to be a Union sympathizer and was murdered for his beliefs. The killers rode to Hedwig's Hill, where, on June 20, 1864, they informed Elizabeth Martin of the hangings.

With their guns held on her all the while, she killed chickens and cooked them as a meal for the men. Elizabeth never pressed charges against the murderers, fearful that harm would come to her children. In December, she took a wagon to Eagle Pass to recover the bodies of Louis

and her niece's husband. Stopping in Fredericksburg on the return trip, she recorded only "Two coffins. Two dollars and fifty cents."

Elizabeth and her children continued living in their home until the fall of 1867 when the family moved back to Fredericksburg and reburied Martin's body. She never divulged the identity of her husband's killers.

Hedwig's Hill Dogtrot House was there for it all, serving at various times as a dwelling with a combination of uses, including post office, store, tavern, boarding house, church and polling place. How the structure was used is well documented, but speculation still exists about who, in actuality, may have constructed it. Some indications point to the American John Kline as builder, selling it and the several tracts of land to Martin in 1858. The building type is characteristic of many built by Anglo-Americans throughout the Southern states. But, it is also possible that Martin built the house because many German settlers did not duplicate their home country's architectural traditions. They favored, instead, homes that were typically American.

Hedwig's Hill was built initially as two cabins under a common roof separated by a breezeway called a dogtrot or dogrun. Terry Jordan, social geographer and log structure expert, explains that a log cabin has one room. Multi-room facilities, even if they are made from logs, are not cabins, but log houses. It is very likely the two limestone rooms, one behind each of the cabins, were added later, perhaps as the family grew or as more space was needed to accommodate travelers or supplies. Evidence that this house began as two log cabins includes the roof line, which does not extend to cover the stone additions. All four rooms were constructed to open onto the dogtrot area. This style of architecture allowed the home to be cooled in warm, humid weather by the air flowing through the breezeway. The sleeping loft, accessed by a wooden ladder that opened above the dogtrot, was cooled by the breezes and warmed in winter by the heat from two downstairs fireplaces moving up through the chimneys.

The builder used a broadax to notch, plane and fit each native live oak log so exact that no nails were used except on door facings and other details. To lay the floors, he hewed logs for floor joists and laid planks over them. All the logs in the house are original; they were treated with a wood preservative before the structure was reassembled at the historical park.

"V" joints were used to fit the logs at the corners. Gaps were chinked with limestone rocks from the original site then filled with a mixture of sand, lime and earth. The inside walls were originally covered with

muslin. Later, the fabric was removed, and the walls were plastered with mud and grass. The inside walls were eventually covered with lime wash tinted pink. A limestone open-hearth fireplace was constructed at each end of the house.

The builder used a broadax to notch, plane and fit each native live oak log so exact that no nails were used except on door facings and other details.

In the house, the northwest room was used for bulk food storage. The family's hired man, Christian Johnson, a Danish farmer, probably slept on a bedroll in that room. Upstairs the Martin daughters slept on one side of the loft, while the other was for the boys and their live-in teacher, Mr. G.H. Fuchs.

The last person to live in Hedwig's Hill Dogtrot House was Ike Henry, who ran a service station. He moved out in the 1930s when U.S. Highway 87 came through only 400 yards from the house.

The back of a man's pocket watch was found when Hedwig's Hill was excavated.

FOR THE RECORD

While the early Hill Country settlers of what became Fredericksburg were negotiating with the Indians over land, the natives established signal fires around the early town to warn, if necessary, of German treachery. When German children became concerned over the fires, they were told that the Easter Rabbit was at work cooking eggs in great pots and dyeing them with wild flowers gathered in the hills. An annual Fredericksburg pageant developed and was observed for generations celebrating the story. The Germans and the area Comanches soon entered into a treaty based on friendship, alliance and trade. The Indians identified the German men from other settlers by their caps, beards and pipes.

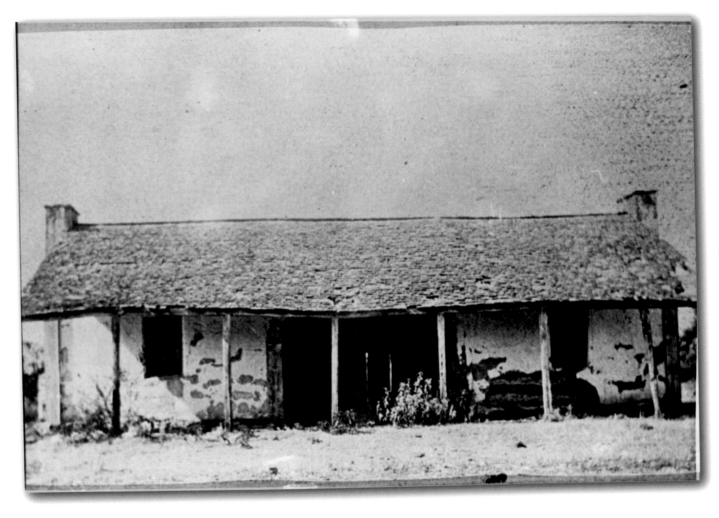

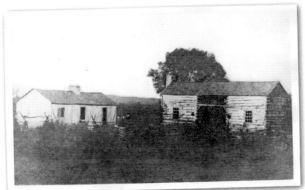

Structures at Martin Creek

original location

HEDWIG'S HILL DOGTROT HOUSE

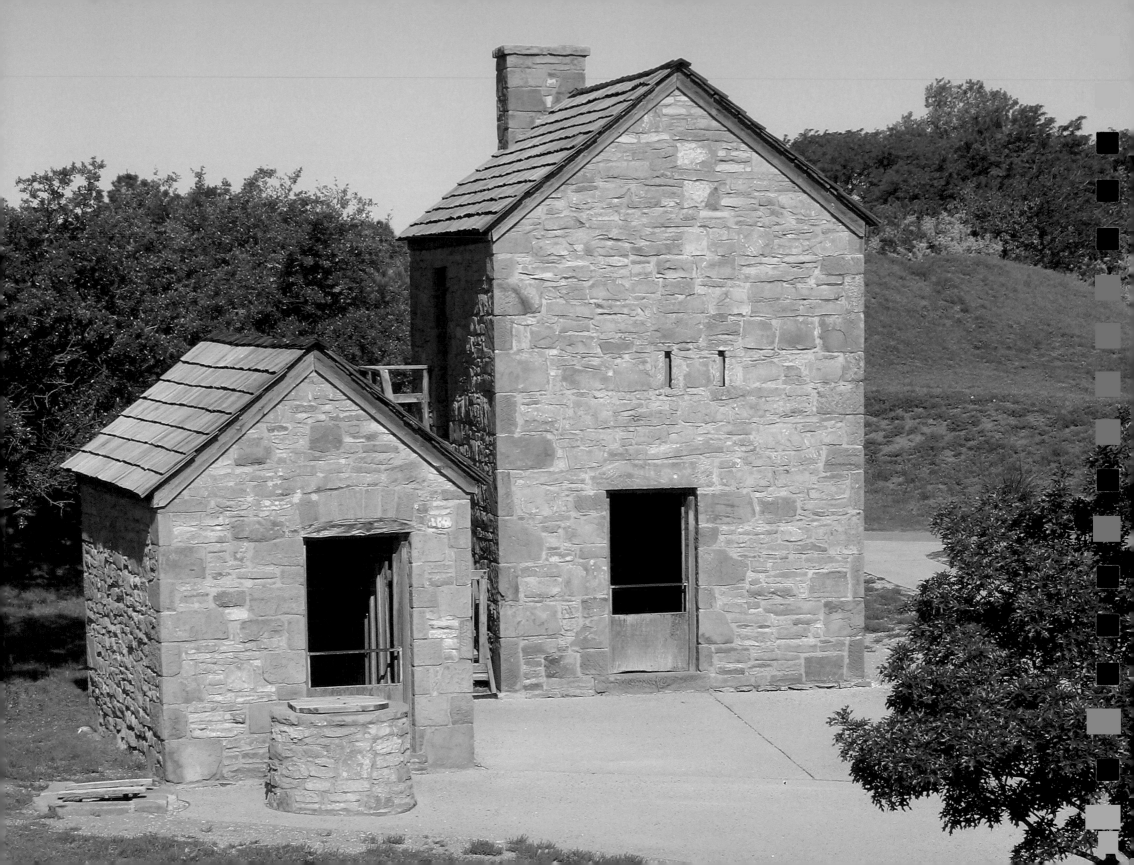

CHAPTER SIX
JOWELL HOUSE
1872-73

Stories of Indian attacks, cattle drives and the women left behind to tend the ranch have been recreated in movies and other works of fiction. The prototype for those stories could have been created by the family who lived in the stone house on the JOLY Ranch in Palo Pinto County, Texas.

The Texas frontier had advanced steadily until 1861 then pulled back 100 miles. Soldiers who had patrolled between a line of frontier forts withdrew to fight in the Civil War, some for the Union side, some for the Confederacy. The retreat of civilization strengthened the determination of Indians who pillaged almost at will and supplied *Comanchero* markets with stolen cattle and horses. Longhorns that evaded capture escaped to the brush and multiplied. Men returned from the war to find their herds gone.

For the strong-willed, by 1865 wild Longhorns were there for the taking. Cattle drives to railheads in Kansas brought a fortune, if the cowman made it through bad weather, outlaws and raiding Indians. Knowing the settlements were not well-protected with the men gone, Indians often targeted the families rather than attack the trail drivers. Raiding parties in the full moon hit along the Texas frontier, taking horses and cattle left for home

> ## Cattle drives to railheads in Kansas brought a fortune, if the cowman made it through bad weather, outlaws and raiding Indians.

use. Sometimes they took captives, and often they took lives. Families hid in their cornfields after dark, especially in the time of the "raiding moon." Lookouts watched for Indians at night and sometimes even by day. When the lookout took to his horse, settlers headed for shelter. Because of the danger from Indians, some cattlemen took their families along with the herd when they went to seek new grass. Open-range herding was hard, but it made living more of a certainty. Staying home was out of the question for the cowman because cattle demanded the space farther west where grass grew thick. To raise cattle, he had to trail herds into unsettled land.

The lifestyle and all it entailed is reflected in the story of George Radcliffe Jowell. The Jowell name was prominent in Texas history.

ORIGINAL OWNER
George Jowell

LOCATION
On Bluff Creek, 16 miles northwest of Palo Pinto on the southwest edge of Possum Kingdom Lake near Mineral Wells in Palo Pinto County, Texas

SIGNIFICANCE
Example of a fortress home meant to protect a wilderness family from Indian attacks and other dangers

DONOR
L.E. Seaman Estate

DEDICATED
Aug. 4, 1979

Hoe

Stove

hurn

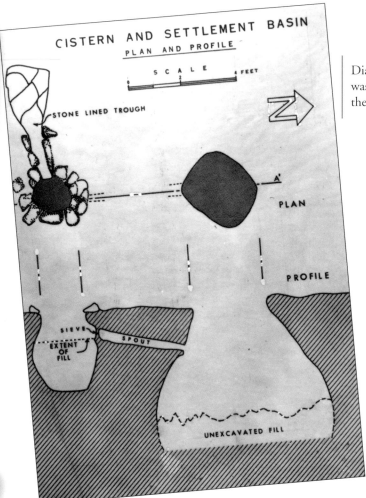

CISTERN AND SETTLEMENT BASIN
PLAN AND PROFILE

SCALE 4 FEET
0 2

STONE LINED TROUGH

N

A'

PLAN

PROFILE

SIEVE
EXTENT
OF
FILL

SPOUT

UNEXCAVATED FILL

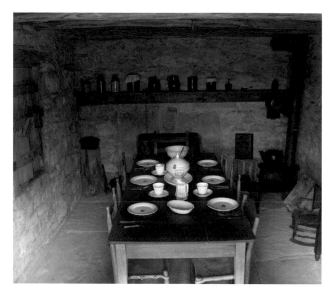

Diagram shows how water was gathered and filtered for the family's use.

First floor room

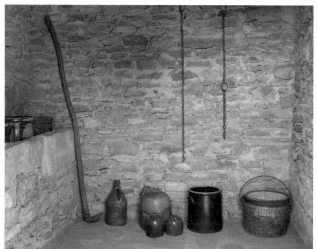

Inside the cool room

Headstones were given to the NRHC when the family replaced the grave markers with new ones.

LONA BELLE
BROOKS,
BORN
MAR. 13, 1880,
DIED
AUG. 30, 1889

UPPER LEVEL

17'-10"

15'-2"

12'-8"

9'-10"

15'-0"

17'-8"

LOWER LEVEL

17'-10"

15'-2"

12'-8"

9'-10" 12'-6"

15'-0"

17'-8"

JOWELL HOUSE
up close

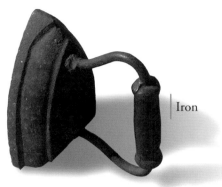

Iron

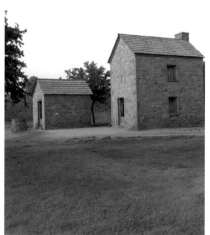

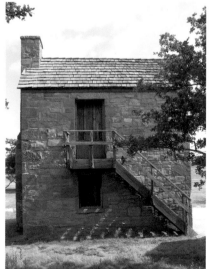

The original craftsman's tool markings can still be seen in the corners and sides of windows and doors in the Jowell House.

Cynthia Ann Jowell (sister of George) was the wife of Texas cattle baron C.C. Slaughter, whose Long S cattle roamed a million acres; a Jowell introduced rodeo to Europe and South America; a Jowell was wagon boss for Charles Goodnight; and other Jowells served in various county and city capacities.

George Jowell, according to a history of north and west Texas published in 1906, was "a Texan of the purest water." His father, James Jowell, served with Capt. Jack Hays' Texas Rangers during the Mexican War. George served with the 14th Texas Cavalry during the Civil War. The young man came to the Republic of Texas at age 4 and was 15 when his family moved to Palo Pinto County in 1855. Spanish for "painted wood," *Palo Pinto* was a reference to the abundant red juniper that grew in the area. His problem with Indian attacks was a continuous affair from the time of his arrival until Col. Ranald S. Mackenzie and the U.S. Army pacified the Comanches and Kiowas in 1874.

Jowell often joined with townsfolk of Palo Pinto in a stockade across the street from the courthouse for protection when attacks were foretold. In 1870, he married Leanna T. Dobbs and moved 15 miles out of town. He pursued his ranching career and knew the situation his family might have to face when he took his herds to market.

The story is told that one night in 1872, while George was away on a drive, the horses began neighing and the cattle moved about restlessly. Leanna Jowell remembered her father, who had been killed and scalped earlier in the year, so the encounter with Indians was still fresh in her memory. Feeling uneasy, she stepped outside the cabin to check on the animals. Suddenly, a rock fell abruptly at her feet, and she shouted for the hired man to saddle their horses. She grabbed her baby, and the three of them rode hard to a neighbor's house, the Henry Beldings. When she returned, she found her home burned to the ground.

When Jowell saw what had happened to his cabin and family, he was determined to build a home that would withstand further Indian intrusion. While he and his family lived with neighbors, Jowell planned his next home. Legal records show that George Jowell bought a 494-acre tract of land on Sept. 16, 1874, to build his home. He purchased the land for $1,000 from J.J. Metcalfe, Palo Pinto County's first judge.

Jowell hired a stonemason to construct a two-story rock house on the Bluff Creek property 16 miles west of Palo Pinto. When completed, the two-room house had rifle slits above the main door to protect a horse corral in front of the house. These openings were cut on an angle so an arrow could not enter. A trap door was cut in the first floor ceiling and a ladder was kept nearby so the family could climb to the top floor, pull up the ladder and be safe. A wooden outer staircase was added after the threat of Indian attacks had passed.

The house site was surrounded on three sides by creeks. Stone and cedar provided material for construction. Limestone was likely quarried at Rock Creek, three-quarters of a mile northwest of the house. It was used for the lintels and the walls. Sandstone, softer and easier to cut and shape, was substituted when craftsmanship was important, such as in the corners and sides of windows and doors. The craftsman's tool markings can still be seen. The interior walls were covered with a plaster of lime, sand and horsehair.

Near the main house, archaeological investigation identified a support building (probably the kitchen), cistern, well, stone-lined paths, cemetery area and a rock wall. Nearby streams dried up in the summer months, so Jowell constructed the well and cistern, or spring house, to preserve perishable food. Elderly residents of Palo Pinto County remembered their parents and grandparents saying Indians were uncomfortable about approaching a house because many people might be inside with guns. It is possible the grouping of several structures may have been deliberate to give the appearance of an armed community to hostile Indians. Jowell had no way of knowing there would be no further attacks on his family. By the time the house was finished, most Indians in the area had been sent to reservations.

The family lived in the stone house until 1881, when George sold the property to I. W. Stephens who sold it in 1889 to the firm that became Ewen, Small and Taylor, founders of the SET Ranch. The open range lured the Jowells to Stonewall, Jones and Deaf Smith counties. Records show George was a founder of the city of Hereford and brought the first herd of registered Herefords to the county. After the death of his first wife in 1898, he married Ella Lowe Coston in 1906 and moved to a plantation in San Luis Potosi, Mexico, where he died in 1912.

The old Palo Pinto property changed hands through the years.

> Leanna Jowell remembered her father, who had been killed and scalped earlier in the year.

After 1900, the stone house stood unoccupied. Its last owner was L.E. Seaman, a prominent rancher, banker and merchant in Mineral Wells, Texas. He bought the property in 1910. His heirs donated the house and materials from the site to the National Ranching Heritage Center in Seaman's memory.

The problem with the two-story stone house, already partly destroyed, was how to move its 90 tons of hand-cut limestone and sandstone several hundred miles away to the National Ranching Heritage Center, then put it back together as if it had never been disturbed. To accomplish the task, stones in the walls of the Jowell House were carefully marked and tagged before it was disassembled to assure accurate restoration. Additional stones and cedar from the Palo Pinto area were used in the reconstruction of the upper part of the house and its roof. Willard Robinson, architectural historian and preservationist, said the workmanship indicated a skilled stonemason had built the house, or at least helped with the construction. Records show it may have been Joseph Harp, who lived for a time with Jowell's father.

Over the years, all the JOLY Ranch outbuildings fell into disuse and eventual ruin. Although vandals and the elements had left their mark, the old house remained standing as the fortress, the protector, it was built to be.

The saddlebags of George Jowell were personalized inside to prove his ownership.

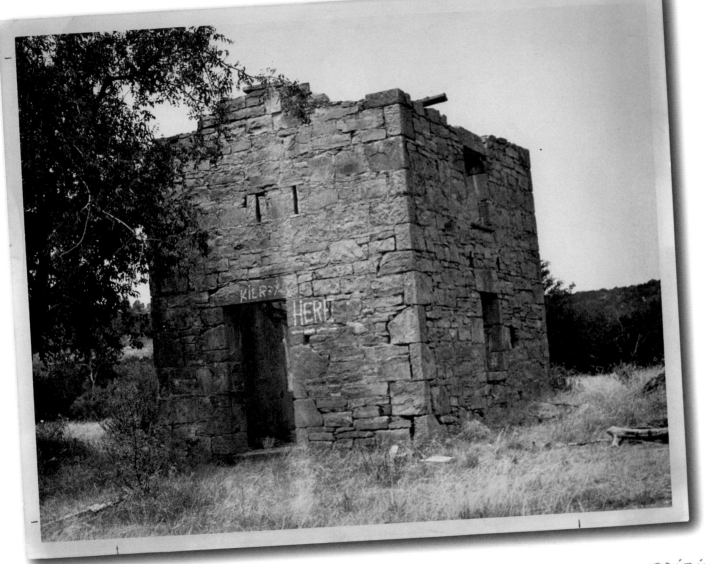

FOR THE RECORD

NRHC architectural preservationist Willard Robinson took a work crew and an archeologist to the stone house several times to make precise measurements and markings before moving the structure. At times, the area was accessible only by boat when rain washed out the roads and the creeks rose on the 20 miles of pasture road that led back to the Jowell House site.

original location

JOWELL HOUSE

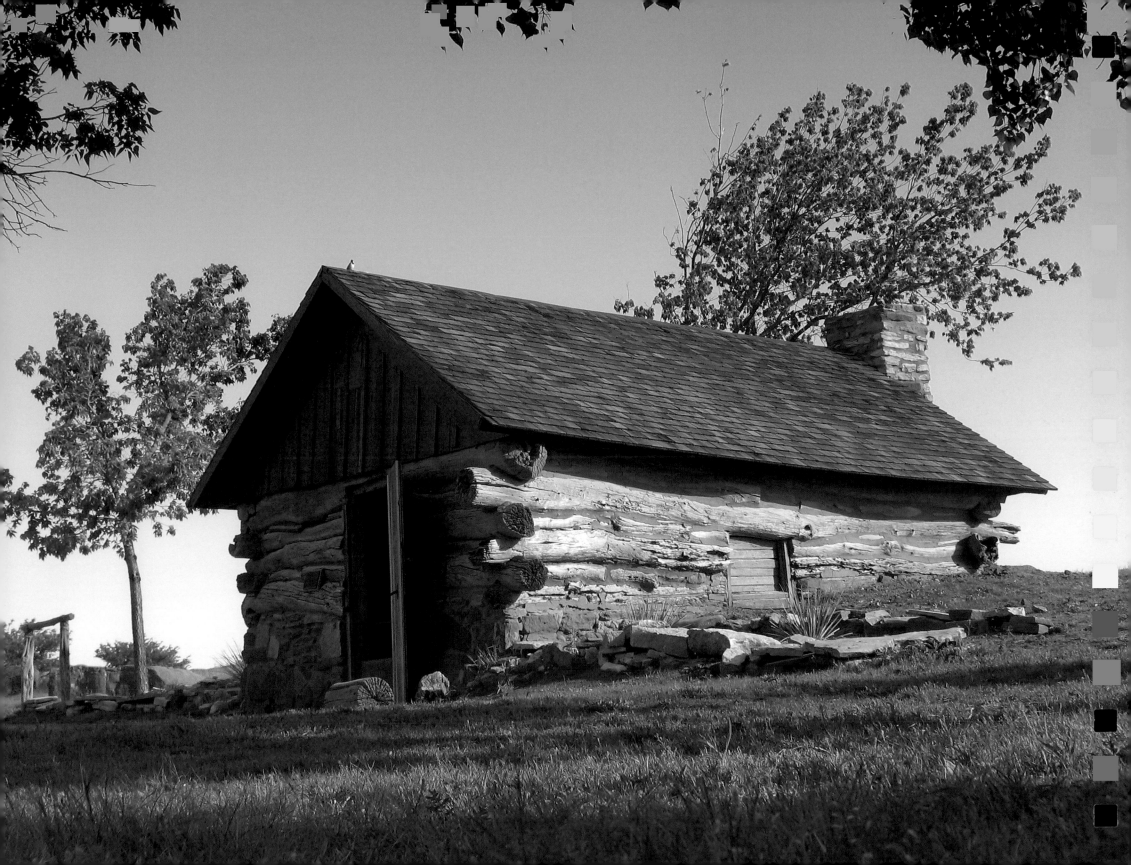

CHAPTER SEVEN

MATADOR HALF-DUGOUT
1888

"Around-the-clock, year-in, year-out, the greatest abominations to dugout life were the rattlesnakes east of the Pecos … west of it … it was centipedes, insects, scorpions, stinging lizards, tarantulas and vinegaroons."

Civilization pushed west of the Mississippi River, erecting homes as it went. It stopped short of West Texas, however, stunned by the arid, flat country. The land was said to be an "uninhabitable wasteland" by Army explorer R.B. Marcy. So most people avoided the area and moved elsewhere. True adventurers who saw West Texas as a place where cattle could get fat cautiously ventured into the Southern Plains. They encountered an environment void of anything to disrupt the endless horizon. For shelter, they scooped out a hole in the ground.

Most dugouts were constructed between 1875-1900. The earliest were built by buffalo hunters following the great herds. In 1876, Charles Goodnight constructed a dugout in Palo Duro Canyon to establish the JA Ranch. A dugout was also the original headquarters for C.C. Slaughter's Long S Ranch.

Dugouts typically were situated into embankments with their only door facing southeast to catch breezes in summer and protect the cowboy from cold weather in the winter. They were built of materials readily available—dirt, rocks and poles from cottonwoods that grew sparingly where there was water for cattle and from scrub cedars that dotted Caprock breaks. Roofs often were made of hides, sod or thatch.

Although it did provide protection from the weather, dugouts also attracted intruders. Accounts from two dugout dwellers describe their existence.

1) "Around-the-clock, year-in, year-out, the greatest abominations to dugout life were the rattlesnakes east of the Pecos … west of it … it was centipedes, insects, scorpions, stinging lizards, tarantulas and vinegaroons. Snakes might appear at any time above the roof, at either side on shelves on the wall, or below beds."

2) "Tales of gophers, mice, moles or rats in floors or walls, of rats biting children or dragging off clothes, of wolves and skunks running into dugouts and the people running out, of frogs jumping through open windows, goats and sheep on top of dugouts, particularly during heel-fly and lambing season, and little lambs falling down chimneys, and

ORIGINAL OWNER
J.C. Davis, Davis Ranch

LOCATION
Saunders Hollow, Northern Dickens County, Texas, on the original Matador Ranch

SIGNIFICANCE
Representative of the sheltered spaces that served as the first homes of ranchers on the plains where timber and stone were not available

DONORS
Mrs. E.E. Moss and sons in memory of Ennis E. Moss

DEDICATED
July 21, 1972

The hole on the upper left of the door facilitated "alarm clock" the cowboys.

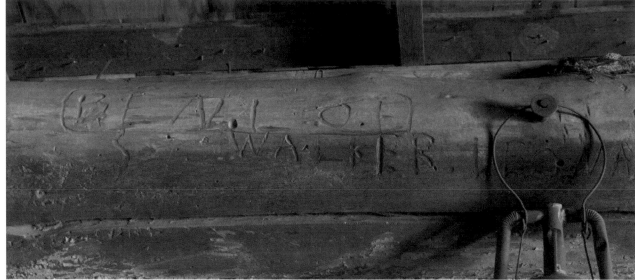

Carvings fill the walls of the dugout.

The fireplace provided a fire for cooking and heat for the long winter nights.

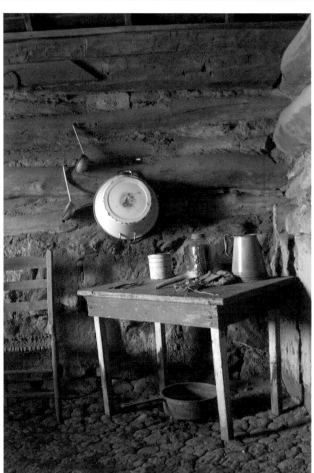

The interior of the dugout was rustic, at best.

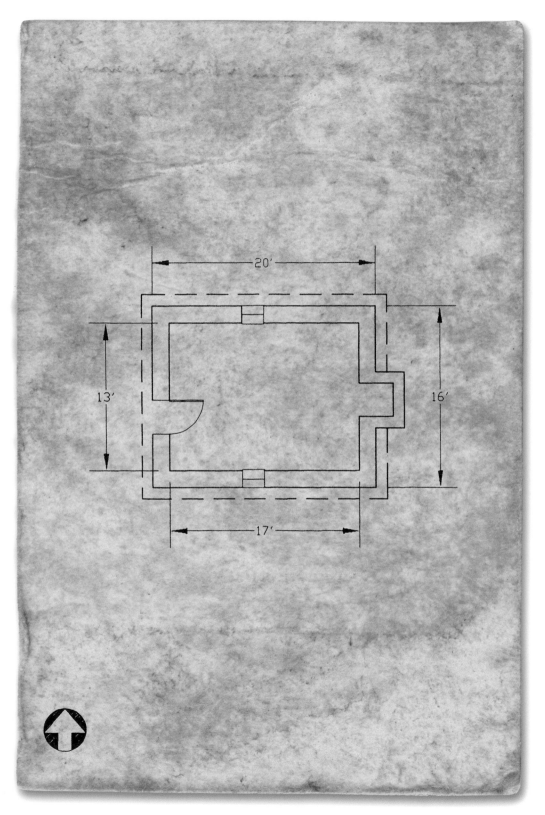

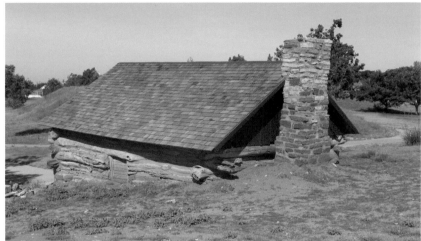

The dugout was a temporary home to many cowboys

centipedes, insects, mice, slick, slimy water dogs, spiders and tarantulas dropping into milk and water pails, breakfast, dinner and supply dishes, or at night on people."

A man who once lived in the half-dugout now at the National Ranching Heritage Center said, "One night I came into this dugout, and right over there in that corner was a big rattler coiled up tight. I just pulled out my gun and shot him."

Dugouts didn't last long as family dwellings. Settlers moved into more conventional homes when materials became available. Dugouts remained in use on the plains as cowboys in bunkhouses or outposts formed a human fence around the rancher's herds in years before barbed wire. A dugout could be a lonely place. Few men looked forward to months of solitude in the middle of nowhere. Jim Christian, a hand for the JA Ranch, said he "always took plenty of novels and tobacco, and usually a cat. A cat and a brier pipe were lots of company when a fellow spent months shut off from the world."

The Matador Half-Dugout was a bunkhouse. J.C. Davis started his ranch in 1887 east of present-day Lubbock. He constructed a half-dugout in 1888 on school land he patented a year later. The dugout was about 50 feet east of the family house, and it was intended as a place where his four boys could sleep. Davis built the dugout from cottonwood trees that grew along Plum River (the South Pease). He built a fireplace with rocks and rubbed the inside of the dugout with red clay. The roof was made of shingles.

After the Davis boys had grown and moved, the half-dugout sheltered two or three cowhands who worked on the ranch. Con C. Davis (J.C.'s grandson) and his cousins visited the cowboys at the dugout. He said, "You will find a lot of brands on the face of the fireplace. As children and teenagers, we were responsible for many of those brands up until 1910. Of course, my grandfather's brand was AK

The ever-important coffee pot heated over an open fire.

The cowboys left carvings, drawings and bullet holes in the red clay walls.

Bar…. This brand is prevalent on the face of the fireplace and on some of the logs. As kids we adopted a brand whether we registered it or not. My brand at that time, which I put on a few cattle, was TE combined together. That will be found on the face of the fireplace."

J.C. traded the property to the Matador Ranch in 1920 for land elsewhere. The Matador Land and Cattle Co. was owned by investors based in Dundee, Scotland. It was managed by Scottish-born Murdo Mackenzie, who had been hired in 1890. Under his supervision, herd improvements were made and costs were cut. It is recorded that one employee said, "We never buy a hobble rope on the Matador but they know about it in Dundee." The ranch had 17 line camps across its ranges. By 1933, it had 900,000 acres.

The ranch used this half-dugout for their cowboys, who called it the Old Red Line Camp (one account had it as the Old Red Lake Camp). In the winter, when the chuck wagon was brought in, as many as nine cowboys shared the space. The cowboys left carvings, drawings and bullet holes in the red clay walls. Some of the carvings are visible; others have deteriorated. For example, at the back of the dugout on the left side of the fireplace, up near the roof, was an inscription no longer visible that stated: "Booger Red Loves Fat Mary." It was found by John F. Lott Sr. and other members of the Ranch Headquarters Planning Committee before the logs were taken down for moving. Records also mention memories of a "Red Hog Rachel" left on the half-dugout's walls.

One Matador cowboy who spent the winter of 1937 in the half-dugout explained the two-inch hole by the door. He said a pipe ran from the hole to the foreman's house nearby. Every morning around 4 a.m., the foreman beat on the pipe like a hotel wake-up call. Another cowboy told how a bell had hung just inside the door operated from the camphouse about 50 feet away. When a meal was ready, the boss pulled the cord to ring the bell.

The sparse furnishings of the dugout were often built by the cowhand using packing crates, boxes, boards and wagon seats. The cowboy slept on a bedroll stretched across the iron bed or on the floor. Lighting was provided by kerosene or coal-oil lamps, and cooking was done in the fireplace in a skillet or Dutch oven. Saddles were hung up to prevent pest damage. The mud to rechink the cottonwood logs at the NRHC was dug and transported from the original site.

In 1951, the Matador sold its holdings to an American syndicate. The Rev. Con C. Davis bought the land on which the half-dugout was erected and then sold it to Ennis Moss, whose family donated the dugout to

the National Ranching Heritage Center. The half-dugout was taken apart for removal to the historical park, but the roof and chimney were kept intact. A former resident from 1937-1941 said the fireplace had originally been framed with wide oak boards that "were covered with ranch brands of ranches where different cowboys had worked, and just about every cowboy who came into the bunkhouse had carved or burned his initials in those oak boards." That same cowboy, Russell Lundberg, also told about a surprise visitor he had one night.

"The bunkhouse had only one door with no screen. In the summertime, it was quite hot in there, so I left the door open. One night, shortly after I had gone to bed, I heard an old rattler crawl in the door. It was pitch dark, and my kerosene lamp was across the room from my bed. I had no flashlight, and I didn't dare step off the bed, so I just waited until time to get up. That was one time when I was glad to hear that old four o'clock bell ring. When Joe rang the bell for breakfast, I yelled for him to bring a gun. Joe had a flashlight when he came with the gun. We looked all around and couldn't see the rattler, but I knew he was there. We lit the kerosene lamp and began rattlesnake hunting. He had crawled behind some magazines that were stacked on the floor under a lamp table. He never rattled until we poked those magazines with the fireplace poker. I shot him on the spot. We saw a rattlesnake almost every day when we were riding. Joe and I pulled 86 rattlesnakes out of a big hole in a bluff where they had been hibernating" (in spring 1939).

The half-dugout was restored as a classic example of a typical small bunkhouse introduced to the frontier and cutting up the open range. With the end of that colorful era of ranching also went the remote bunkhouse, an important chapter in the story of the Old West.

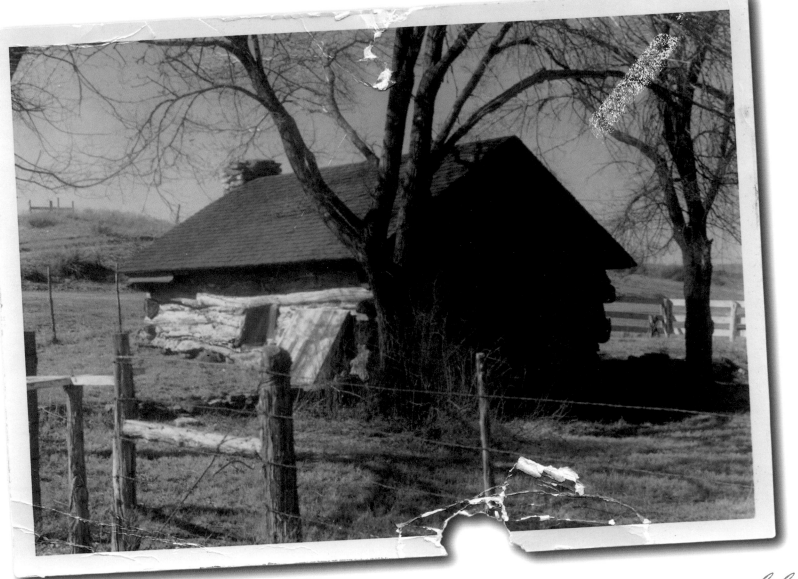

FOR THE RECORD

The Matador Ranch management wouldn't allow games of chance among their cowhands in an effort to avoid violence. One of the worst arguments at the Matador stemmed not from a disputed poker hand but from a poorly sung song. One cowboy asked another how he liked his singing of "Yankee Doodle." On being told how bad a singer he was, the cowboy shot his critic, who shot back. Both men died.

original location
MATADOR HALF-DUGOUT

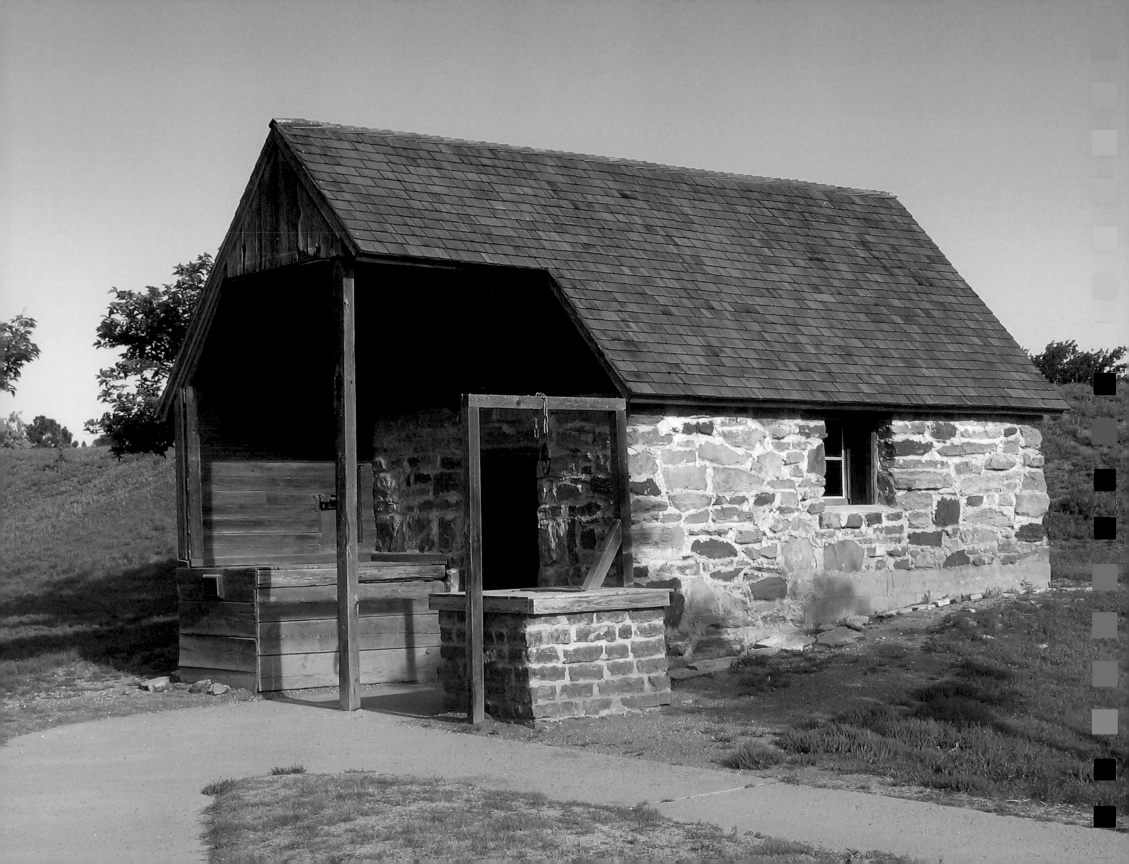

CHAPTER EIGHT
WAGGONER RANCH COMMISSARY
c. 1870s

The commissary was an integral part of large outfits. Their vast size plus the long distances to a town created the need for ranches to purchase food and supplies in bulk.

The Waggoner Ranch Commissary represents the large ranch that provided for its own during the growth and development of the cattle industry in the West. It stands for family continuity over the generations and for the impact of oil discovery on ranch land.

The Waggoner Ranch story began when 20-year-old Daniel Waggoner traveled from Tennessee to Hopkins County, Texas, in 1848. He married Nancy Moore and, two years later with a 14-year-old boy as help, Dan trailed 242 head of cattle and six horses into Wise County. He established the Waggoner Ranch in the early 1850s and continued adding to his herd and landholdings.

The couple's only son, William Tom, or "W.T.," was born in 1852. Nancy died soon after, and Dan married Syclly "Ann" Halsell in 1859. He and his young son grew close, sharing a love of ranching and horses, ambition and hard work. Dan formed a partnership known as D. Waggoner and Son, a name W.T. kept for several years after his father's death in 1902. Their big break came when they wintered a herd in Clay County and in the spring drove the Longhorns to market in Kansas, making a profit of $55,000.

With the frontier moving westward, father and son used their money to move the ranch headquarters to the junction of China Creek and the Red River in northwestern Wichita County, just north of present-day Electra. The town was named for the first Electra, W.T.'s pampered only daughter. Around 1885, he built loading pens for his cattle near the Beaver Depot (later a part of the town of Electra). He also constructed houses for his employees and hands, a large wooden store and the stone commissary (now at the National Ranching Heritage Center), which was sometimes called "the stone house." It held supplies needed by the ranch cowboys. The building was located on the road to the Red River, where cattle drives had moved from Texas into Oklahoma.

ORIGINAL OWNER
Dan and W.T. Waggoner

LOCATION
North of Electra in Wichita County, Texas, two miles south of the Red River crossing

SIGNIFICANCE
Representative of the supply stores used by ranch cowboys and drovers during the early days of the Western Trail

DONORS
Mr. and Mrs. Dan Flippin

DEDICATED
Sept. 19, 1981

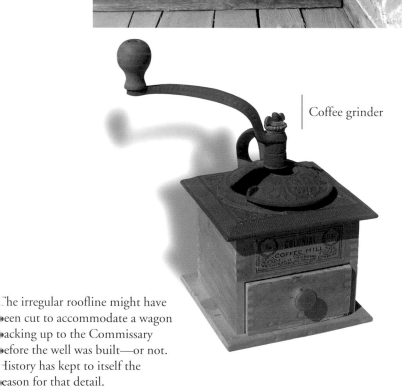

The reason for the precisely cut opening in the west wall of the commissary remains a mystery.

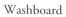

Bulk supplies

Washboard

Coffee grinder

The irregular roofline might have been cut to accommodate a wagon backing up to the Commissary before the well was built—or not. History has kept to itself the reason for that detail.

Shelves held some of the items stocked by the ranch's commissary.

WAGGONER RANCH COMMISSARY

up close

13'-6"

17'-7" 17'-7"

24'-8"

7'-1"

4'-6"

13'-6"

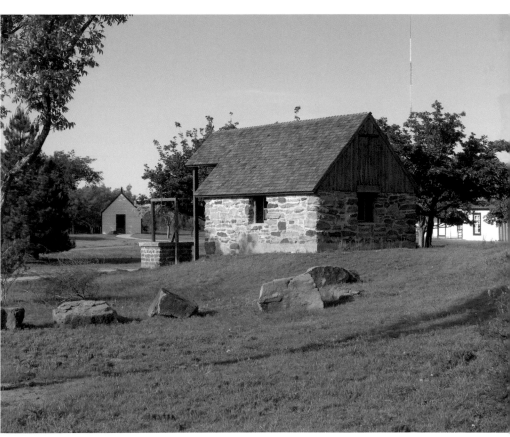

The commissary was an integral part of large outfits. Their vast size plus the long distances to a town created the need for ranches to purchase food and supplies in bulk. They were dispensed by the cook or foreman at no charge to the cowboys, who stayed in distant line camps. Most of the time the building was kept locked, and the cook maintained the key. Built similar to a half-dugout, the stone walls kept the structure cool in the summer and protected items inside from freezing in the winter. Since the Waggoner Commissary was a storehouse, or warehouse, it held only supplies in bulk, such as huge sacks of flour, barrels of sugar, tins of salt, coffee and lard, plus canned vegetables and dried fruits. These were freighted in by wagon from Decatur, some 200 miles away. Generally, no perishables were stored in the facility. Likewise, no money changed hands at the commissary, nor was a ledger kept. Ranch hands took supplies as they were needed. The commissary was not utilized by the general public.

Stones for construction came from China Creek, no more than three-fourths of a mile away. The structure was built so a freight wagon could pull up in front or behind it and unload supplies using a block and tackle in the loft area. Other items were carried into the building and set on the floor or on rough shelving around the single room. The loading dock area contains a couple of mysteries. How was the unusual cutout in the west wall used? And why is the roofline on the east side so irregular? Some speculate that the roofline might have been notched to accommodate the well cover or a windmill derrick. The angular cutout in the west wall is anybody's guess. Some say it may have held a scale for weighing out quantities of supplies. Since the storehouse was locked and unmanned most of the time, the angular cutout may have held a box for delivery notices or requests from cowboys needing supplies.

The only conclusion drawn by those who have made a study of the Waggoner Ranch at China Creek is that the architectural mysteries might have had to do with the structure being part of a complex of buildings that were present in the area, including a bunkhouse and store. Nearby was a white house, which might have been the headquarters. One oral history documents the structures and how, as a young boy, the teller and other children ran around the three buildings as if they were one. Perhaps the roofline and the notched-out west wall had to do with the other structures and how they fit together. The answer may never be known.

In 1902 or '03, the commissary was sold along with the ranch land between the Pease River and China Creek to be farmed in a development called the Waggoner Colony. The main headquarters was moved near Vernon, Texas. At some time before 1906, a concrete floor was poured so the commissary could be used by new owners as a bunkhouse and, at other times, a storehouse for cured meats.

In 1909, while drilling for water during a severe drought, W.T. discovered oil on his land. The Electra field was found nearby in 1910 and became the most productive oil field on the ranch. He was reported as saying, "Oil, oil. What do I want with this damn oil? I'm looking for water. That's what my cattle need." But his opinion changed as one well came in after another. The money allowed him to build his own refinery, establish a chain of gas stations, restore the family's mansion in Decatur and build a racetrack in Arlington, Texas.

W.T. enjoyed Thoroughbred horse racing, and the oil income supported his hobby. Arlington Downs was a huge track between Dallas and Fort Worth, built at a Depression-era cost of some $2 million. This was in addition to a Thoroughbred horse-breeding farm at Arlington, which cost him another $1.5 million. It was equipped with a brood barn and three heated rooms designed for foaling in cold weather.

W.T. was a second-generation rancher and a first-generation Texas oilman, but he was literally and figuratively "rancher first and oilman second," according to Dr. David Murrah, a Texas Tech Southwest Collection archivist who spoke during the 1981 NRHC dedication of the commissary. Before W.T. died in 1934, he placed the family holdings into a trust for his children, who continued to run the prominent ranch. (His daughter, Electra Waggoner Biggs, was named for her aunt and was regarded as a talented sculptor, even at a very young age).

The Waggoner name was associated with people who pioneered ranching and devoted their energies and finances to the development of the society in which they lived. The ranch grew to more than a half-million acres spread over six Texas counties. It was the largest contiguous ranch in Texas. Waggoner descendants sold the historic ranch in 2016 for $725 million.

The Waggoner Ranch Commissary represents an exciting era in the history of Texas and in the life of this well-known ranch. Funds for moving it were provided by the W.T. Waggoner Estate.

Since the Waggoner Commissary was a storehouse, or warehouse, it held only supplies in bulk, such as huge sacks of flour, barrels of sugar, tins of salt, coffee and lard, plus canned vegetables and dried fruits.

Tobacco for pipes and rolling-their-own cigarettes was a commissary staple.

FOR THE RECORD

Across the road, about 100 yards north of the commissary, was a large, red barn. About 1909, a male teacher stayed in the barn while his house was being built. On April Fool's night, the Waggoner cowboys hooked their ropes onto his buggy and pulled it up to the top of the tall barn, where it was left straddled over the peak of the roof. The teacher got up the next morning and went outside to leave for school. Not finding his buggy anywhere, he saddled his horse and went hunting for it. He knew somebody had played a joke on him. Finally, someone pointed up, and there the teacher saw his buggy on top of the tall barn's roof. It is said he threw a real fit. The cowboys got their ropes and horses and lowered the buggy back to the ground. Just a little cowboy fun.

original location

WAGGONER RANCH COMMISSARY

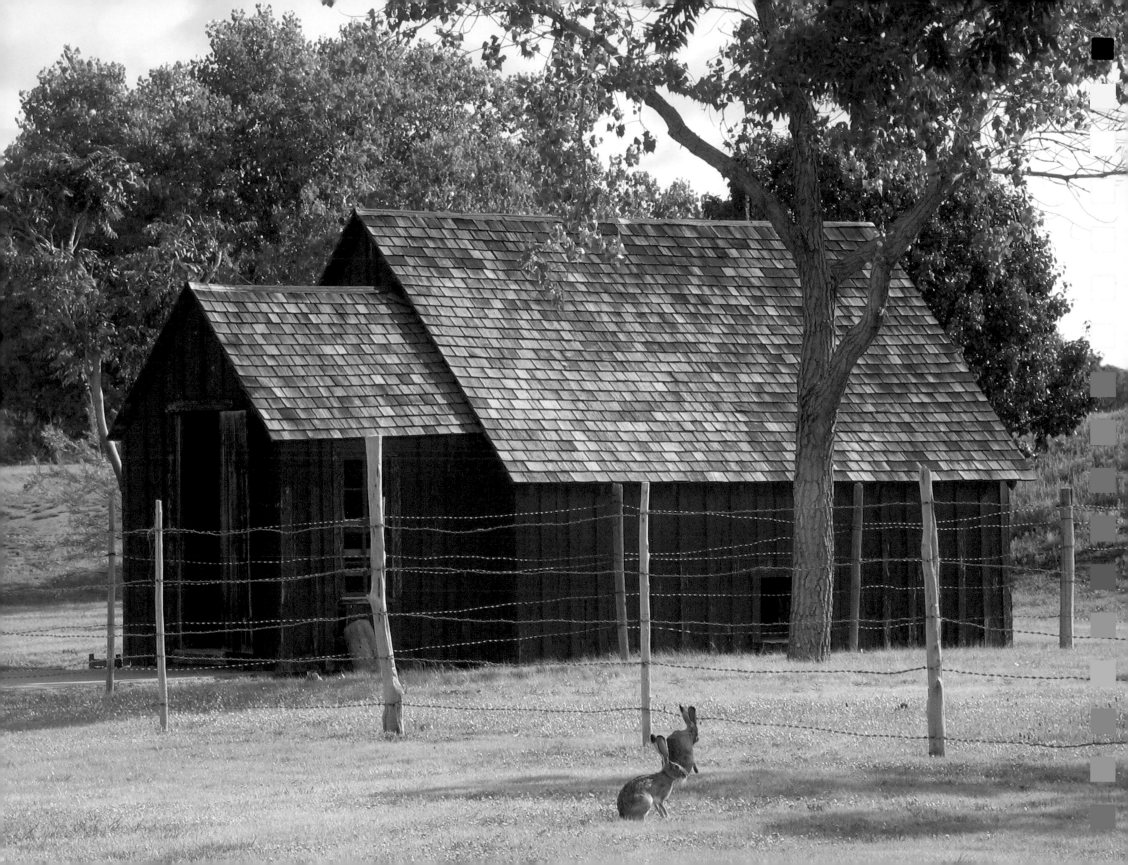

9

CHAPTER NINE

LONG S WHITEFACE CAMP
1901, 1905

Almost anything was possible in the American West when determination was behind a goal. Christopher Columbus (C.C.) Slaughter (1837-1919) is a perfect example of such a story. When Slaughter started in the cattle business, he rode and worked his cattle bareback because he couldn't afford a badly needed saddle. By 1906 he owned more than 1 million acres and 40,000 head of cattle, yet all his ranch headquarters started as a hole in the ground. His Long S Whiteface Camp demonstrates the link between the simplest of dugouts and later homes and additions when railroads made lumber accessible.

Frontier life was not for everyone. Only the strong could endure living in a hole in the ground, cooking with a Dutch oven over an open fire and sharing the long, lonely hours with nothing more than a cat or a lizard for company. Many settlers turned tail on the plains and headed back to their previous, predictable lives.

C.C. Slaughter stayed the course and became a cattle king in Texas. He was born a year after the Texas Revolution. William Slaughter, head of the family, came to Texas in 1830 while it was still Mexico. He began the cattle business, and his son, George W., increased its size and wealth. When civilization began to close in, the Slaughters moved northwestward and made a fortune driving cattle to distant markets in the years immediately after the Civil War.

ORIGINAL OWNER
C.C. Slaughter

LOCATION
Four miles north of Whiteface, Texas, in Hockley County

SIGNIFICANCE
A link between the early dugouts and the later homes built of lumber above ground

DONORS
Nelle De Loache Davidson and James De Loache in memory of Nelle Slaughter De Loache

DEDICATED
Oct. 19, 1971

Frontier life was not for everyone. Only the strong could endure living in a hole in the ground.

A 4,000-pound steer, born and raised at the Whiteface Camp, 1914.

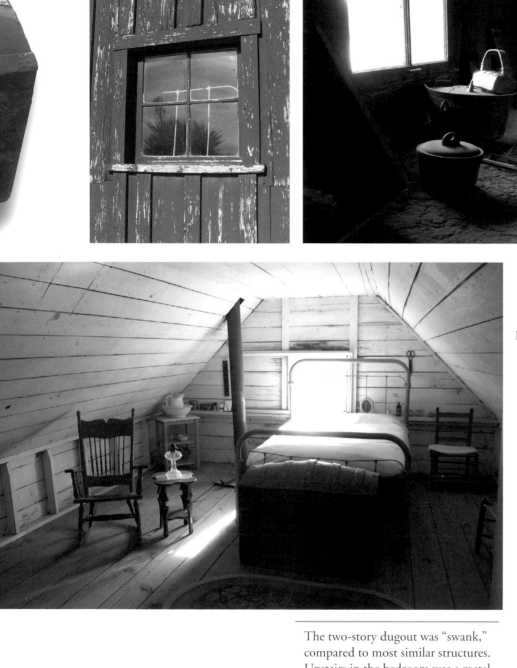

In the kitchen was an Agricola stove. The pipe provided heat for the upper story.

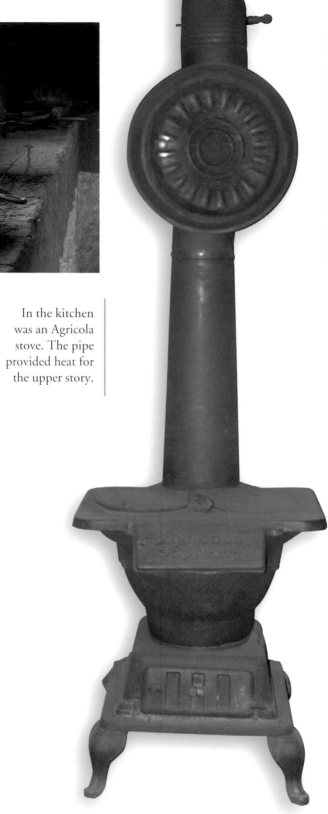

The two-story dugout was "swank," compared to most similar structures. Upstairs in the bedroom was a metal bed, rocker, trunk for storage, small oak stand, books and lighting fixtures.

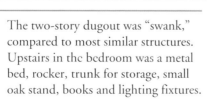

LONG S WHITEFACE CAMP

up close

UPPER LEVEL

13'-11"

17'-10"

LOWER LEVEL

14'-3"

12'-9"

18'-2"

16'-8"

25'-8"

7'-6"

4'-11" 8'-0" 1'-0"

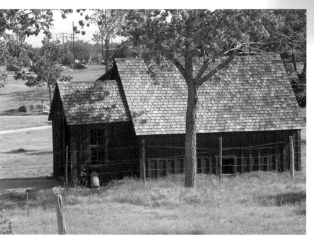

The Long S
Whiteface Ca
began as a ho
in-the-ground
dugout.

C.C. and John B. Slaughter and their brothers came from hardy stock. Their father was George W. Slaughter, Palo Pinto preacher and rancher, known for delivering a sermon with his firearms by his side. His sons went out on their own to find water and land for their small cattle herds. All of the brothers but C.C. stopped below the Caprock; he ventured on to the broad, desolate, dry and flat Llano Estacado, the staked plains area of West Texas. There, he met Fount G. Oxsheer, who survived by digging line water wells for his cattle. These watering sources were critical to the ability of man and beast to live on the arid plains. One of the line wells was at the site of what became the two-story dugout now at the National Ranching Heritage Center.

In 1897, Oxsheer encouraged Slaughter to buy purebred Hereford cattle and breed them. Slaughter bought 2,000 head from another prominent rancher, Charles Goodnight. The cattle were kept on Oxsheer's Diamond Ranch in Hockley County for three or four years at $1 per head per year. Oxsheer, who would also receive one-quarter of the herd, began calling the division the "Whiteface Camp," for the stocky, white-faced cattle. Slaughter bought land in Texas and New Mexico for his ranch divisions. By 1900, C.C. had proved to be a shrewd businessman, a great cattleman with uncanny ability to judge breeding stock, and a very wealthy rancher. Slaughter was a founder of the Texas and Southwestern Cattle Raisers Association, and he ran one of the largest ranch operations in Texas managed by an individual.

Among the vast areas of land he purchased was the portion of Oxsheer's Diamond Ranch that included the western pasture line well. In 1901, C.C. had his son and ranch manager, George, build a "cheap and small" structure at the well site to serve as a line camp. George built a dugout to serve the Whiteface pasture, 13 miles from its headquarters in Cochran County.

A traditional dugout was built into a hillside. Because no hillside existed for a dugout, George shoveled a hole out of the level plains and covered it with brush. The box-and-strip upper story was added in 1905 as living quarters for the section manager and his family. On the plains, ranchers used precious lumber for fencing and windmills, not housing.

Hiley Boyd Sr. was a line camp manager who lived in the Long S dugout. He planned and built the second floor. With lumber difficult and expensive to obtain, Boyd told the freighter to bring a few extra boards along when he brought the windmill lumber. He saved the wood for several years until enough was accumulated to build the second floor addition.

Traveling mostly in pairs, cowboys made a moving fence to loose-herd their cattle to water, to pasture, to branding and to market. A cowboy was accustomed to

sleeping on the ground as the cattle roamed across the plains, and bedrolls were spread wherever night found them. With luck, the ground was soft enough to scoop a hole out to accommodate their hips. A few items carried on a pack horse or mule made a camp site comfortable—a lantern, frying pan, sack of flour, bacon and coffee.

But, there was "no place to get behind" when the sand blew or rain fell, cowboys said. Cleanup on the trail meant finding a windmill for washing. Ranch hands living this life for the Slaughter Long S near Whiteface were glad for any excuse to go into camp. They still had to sleep on the ground, but they ate meals cooked on a stove by the wife of the camp cowboy. It tasted really good to cowboys who had been doing their own mundane cooking over a fire of of prairie kindling.

The kitchen in the two-story dugout contained an Agricola stove, which had an oven attached to the chimney pipe.

A rocking chair was a highly valued possession of pioneer families.

Bedrolls were spread (by cowboys) wherever night found them. With luck, the ground was soft enough to scoop a hole out to accommodate their hips.

The pipe carried heat to the upper story. Fuel was mesquite roots or cow chips. In a generally futile effort to curb dust and insects in the underground room, some pioneer women covered the packed earth walls and floors with flour sack cloth.

When the original structure was moved to the National Ranching Heritage Center, only the upstairs box and strip room was removed, since the lower level was just a hole in the ground. Workers did, however, dig a new basement and then lined it with concrete blocks, both for stability and to keep from having the same problems the settlers had with falling dust, bugs and snakes finding their way into the dirt-walled room. A number of the original shingles were reinstalled after the work was completed on the roof framing.

The site of the Long S Whiteface Camp began as a line water well and evolved to the two-story dugout. It was the predecessor of frame homes built entirely above ground when trains brought cheap lumber to the plains. Moreso, this house is associated with and represents one of the most well-known and highly successful ranchers in Texas history.

FOR THE RECORD

C.C. Slaughter, son of a Baptist preacher, built a ranch that at one time was second in size only to the famous XIT. He was named for Christopher Columbus in commemoration of his parents' wedding date on Columbus Day, Oct. 12, 1836. He was born a year after the Texas Revolution, in which his father, George Webb Slaughter, was a courier for Sam Houston and, legend tells, carried the order to retreat to William Barrett Travis at the Alamo.

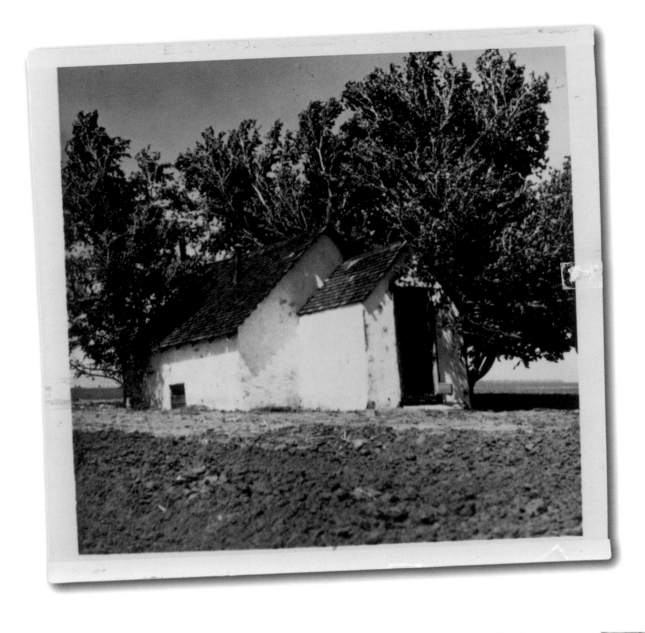

original location

LONG S WHITEFACE CAMP

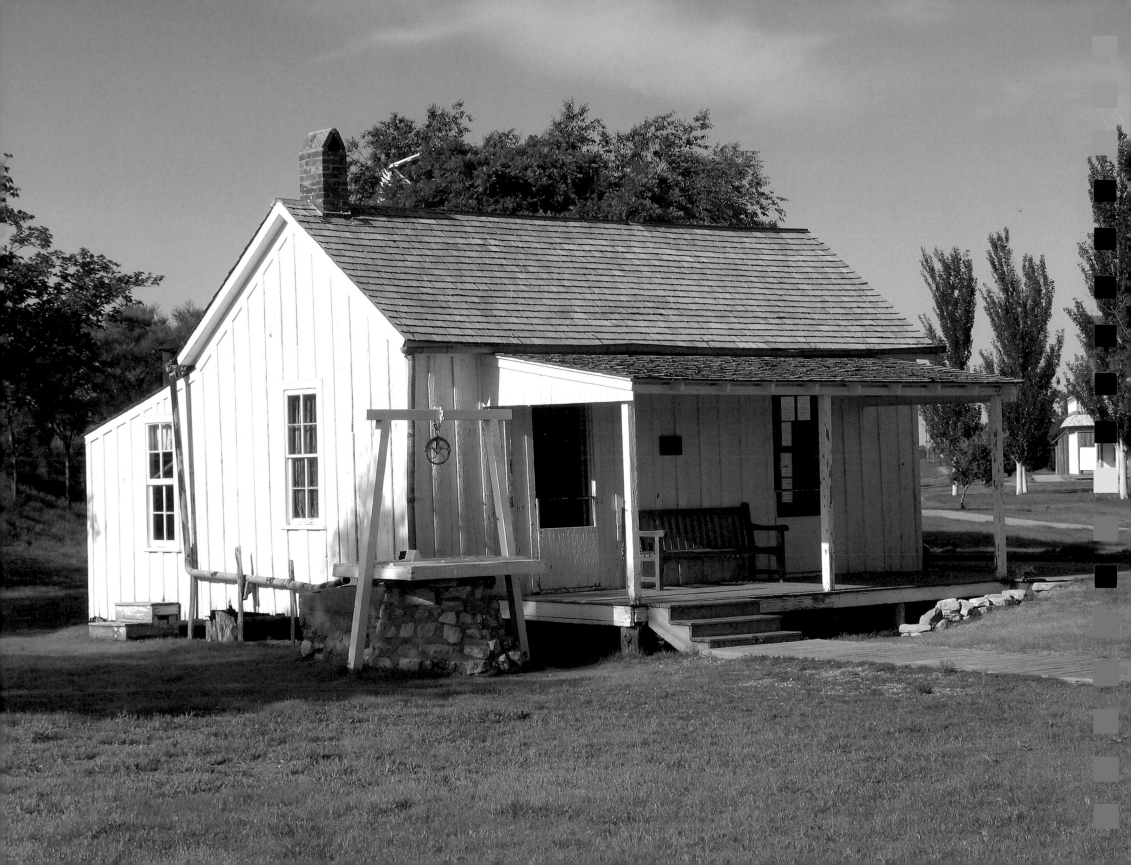

CHAPTER TEN
BOX AND STRIP HOUSE
1903, 1907

A ranch wife refused to move West with her husband until he promised to build her a frame house above ground. She told him, "I will not have dirt over my head until I die." So, he built her a box and strip house, which may or may not have made her happy. Although economical, these houses had no insulation. The walls moved in and out during a strong wind. In a snowstorm, streaks of snow that corresponded exactly with the cracks in the wall formed on bed quilts.

Even at the turn of the 20th century, wood was difficult to obtain in West Texas, but the railroads stretched into the isolated ranch country. With them came lumber from areas of the country where trees were prevalent. The box and strip house became a popular type of construction. It involved laying a wooden floor, then attaching a box-like frame on the floor, and placing one upright in each of the corners. Then 1-by-12-inch boards were nailed vertically to the frame. Thin, 1-by-4-inch wooden strips were nailed over the gaps where the uprights touched. Once the walls were in place, a shingle roof was added, and the house was ready for occupants.

In 1903, Charles Adams Goldsmith, a former hand on C.C. Slaughter's Long S Ranch, needed a south camp for his 65-section Goldsmith Ranch in northwest Martin County. So, he hired a carpenter named Boswell to build a two-room structure. The original house didn't have a kitchen and dining room.

> The cook in this small house had to provide meals for the ranch hands. Without wood for fuel, cooking with cow chips was a time-consuming task.

Goldsmith stationed one or two men at the house during the winter months. When it came time to round-up, brand and get the cattle ready for market, Goldsmith would assign up to 18 cowhands to the south camp. Only half the cowhands could fit inside the house to eat their meals, so Goldsmith added a kitchen and dining room in 1907.

The cook in this small house had to provide meals for the ranch hands. Without wood for fuel, cooking with cow chips

ORIGINAL OWNER
Charles Adams Goldsmith

LOCATION
35 miles north of Midland in northwest Martin County, Texas

SIGNIFICANCE
A method of construction that allowed settlers to abandon their "prairie dog existence" below ground; an excellent example of economical box and strip, or board and batten, construction

DONORS
Mr. and Mrs. J.B. McPherson

DEDICATED
Oct. 9, 1971

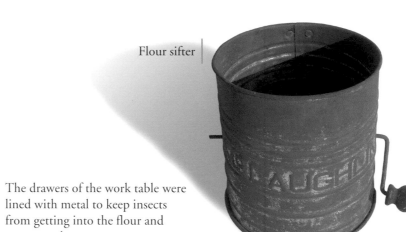

Flour sifter

The drawers of the work table were lined with metal to keep insects from getting into the flour and sugar supply.

Kitchen and eating area

Although it was a major step up from life in a dugout, houses of box and strip construction had no insulation, and the walls actually moved when the wind blew in a storm.

One pot-belly stove helped provide heat for the whole house.

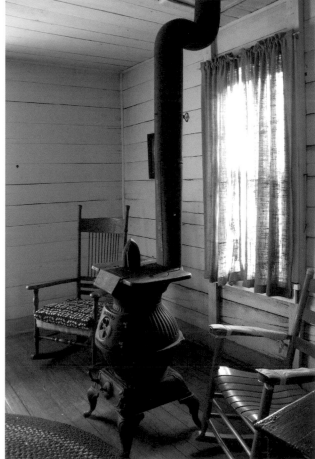

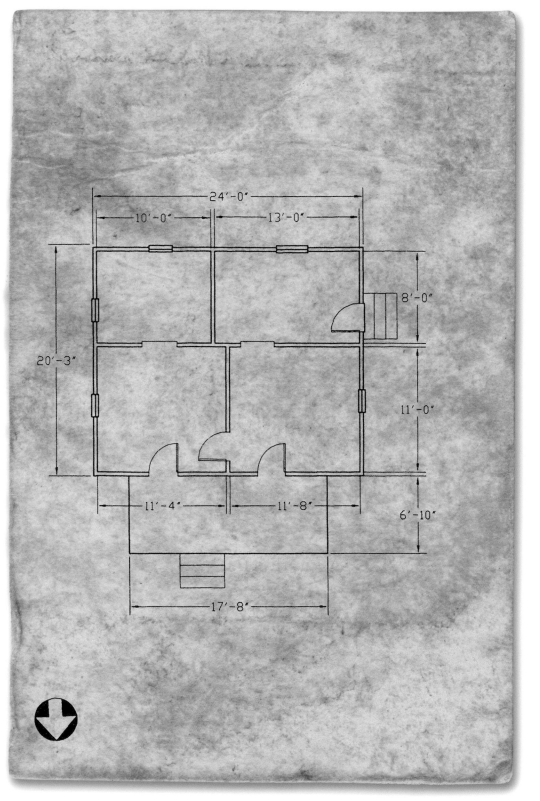

24'-0"
10'-0" 13'-0"
8'-0"
20'-3"
11'-0"
11'-4" 11'-8"
6'-10"
17'-8"

BOX AND STRIP HOUSE

up close

Breakable dishes
replaced tinware.

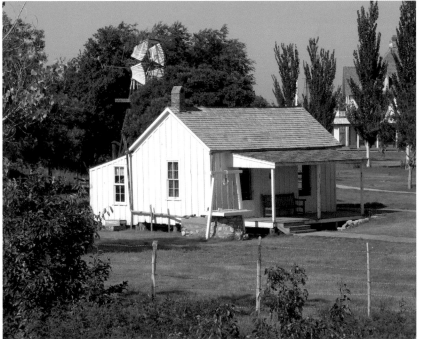

was a time-consuming task. A young man watched his mother make biscuits and later wrote: "Stoke the stove, get out the flour sack, stoke the stove, wash your hands, mix the biscuit dough, stoke the stove, wash your hands, cut out the biscuits with the top of the baking powder can, stoke the stove, wash your hands, put the pan of biscuits in the oven, keep on stoking the stove until the biscuits are done."

Preserving fruits and vegetables was also tedious, but necessary—the supply of produce had to last for a full year. The table in the kitchen had deep, metal-lined drawers for storage of flour and sugar. The pie safe had a pierced tin front to keep bugs out and foods fresh, to the extent possible without refrigeration. A pot-belly stove provided heat.

Most of the furniture in the house was bought by mail order and transported to depots in the West, where remote ranch families met the trains and brought their packages home in wagons. Some of the furniture, such as the rocking chair and bed, was brought with the family when they moved. The chest of drawers could have been brought along on the move or mail-ordered. Either way, it was the place where the woman's seldom-worn best dress was stored. Most of the time, her clothes had to accommodate her difficult chores and her maternal "condition."

Children were important to the settler, because the extra hands were needed to provide farm and ranch labor. Often, families on the plains included grandparents, an uncle or aunt and many children. Girls helped their mother and learned how to plant, put up and prepare food, sew, quilt, do laundry, "doctor" people and animals, and in the process become educated at a local one-room school, if there was such a luxury. Boys worked beside their fathers and grandfathers doing chores, carrying water, cutting wood, filling lamps, feeding livestock and helping with the branding. Most young boys desired

cattle work above farm work. Their toys and games reflected their ability to enjoy what they had. For example, a ball might have been yarn or string saved from raveling old knit socks.

Box and strip houses served as a connection between the dugouts and the more traditional architectural designs. The attractiveness of the Box and Strip included low building cost, little maintenance and the fact that it was above ground. Additional rooms could easily be built, as suggested by Goldsmith having the house enlarged in 1907. The biggest problem with the house was

actually the same problem that existed across the plains—adequate water for the family, the garden crops and the cattle. The property was sold in 1918 and was occupied periodically until the 1950s, proving the simple house's durability.

> Children were important to the settler, because the extra hands were needed to provide farm and ranch labor. Often, families on the plains included grandparents, an uncle or aunt and many children.

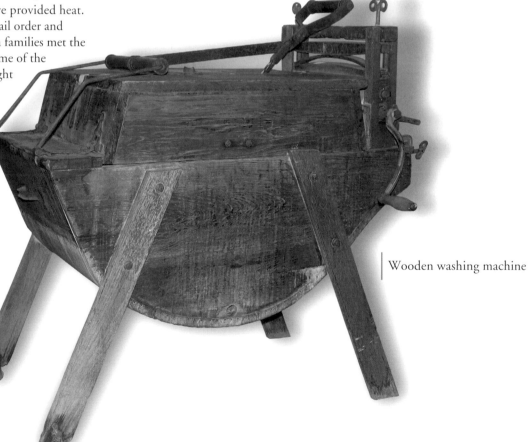

Wooden washing machine

FOR THE RECORD

Originally, windows in this house were not covered by curtains. Isolated as it was, who was around to look in? To put up curtains would have indicated the occupants were up to something "inappropriate." Plus, doors in those days were never locked. Even if no one was home, the traveler could come in and help himself to food and rest. It was the way of the Old West.

The house was brought to the NRHC on a flatbed trailer.

original location

BOX AND STRIP HOUSE

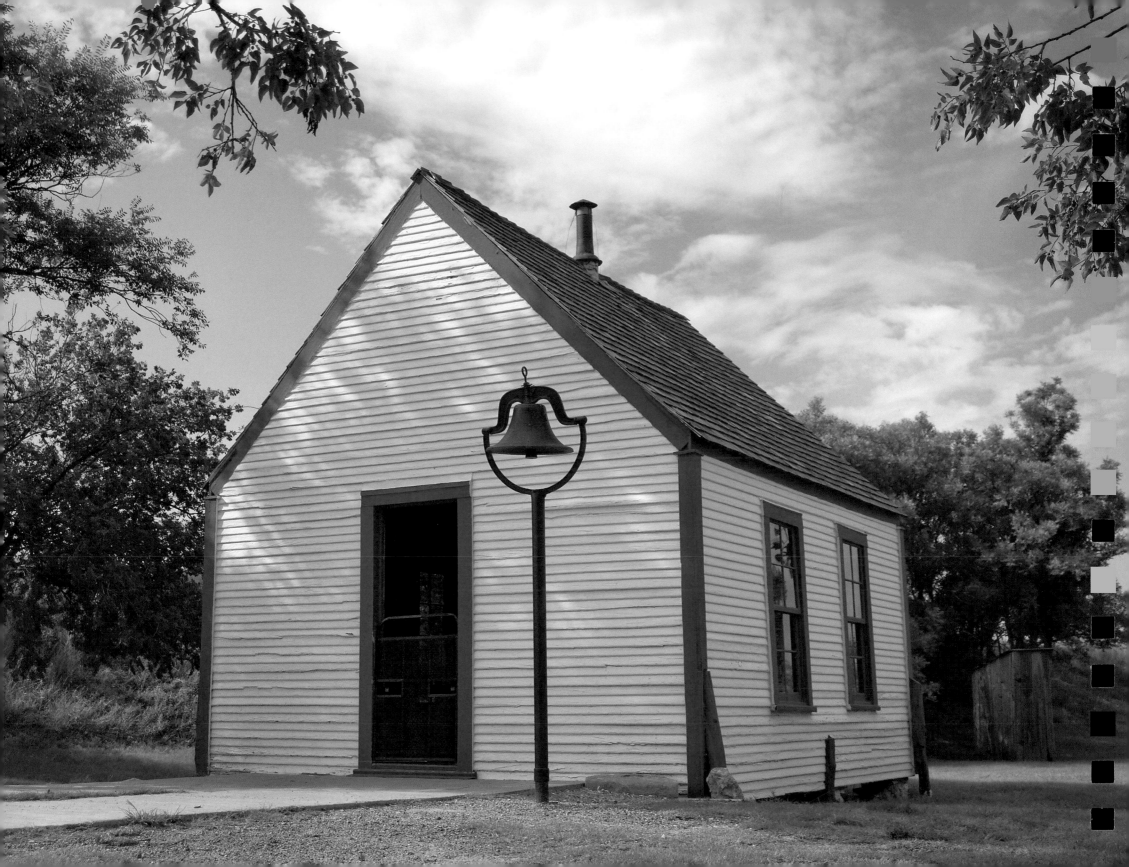

CHAPTER ELEVEN
BAIRFIELD SCHOOLHOUSE
c. 1890

The usual ranch schoolhouse was a one-room building named for the rancher or the ranch. Others had colorful monikers like Lick Skillet, Possum Trot, Cedar Ridge, Hell Roaring Holler and Chicken Foot. The Bairfield Schoolhouse was briefly called Polecat University, after an encounter with a skunk. Like the 16-by-16-foot Bairfield Schoolhouse from near Clarendon, Texas, the schools remained as long as children needed them.

The Bairfield Schoolhouse was built to serve the children of homesteaders Fred Wiedman, Jim Porter and Joe Beaty. Then called the Porter School, it was situated beside a little creek on the Beaty homestead. C.E. Bairfield's father, Wint, bought the Beaty claim at the turn of the 20th century. At some point, he put the schoolhouse on two wagons and moved it nearer to the Bairfield home.

Subjects taught to the students included arithmetic, geography, reading, writing, grammar and agriculture. Dr. Zell Rodgers SoRelle, later a professor of speech at West Texas State University in Canyon, Texas,

> If the weather was good, she had the children take their lunches with them as they walked to a nice spot to eat. Along the way, she taught them about history and the natural sciences.

Last day of school, 1917

ORIGINAL OWNER
Three homesteaders—Fred Wiedman, Jim Porter and Joe Beaty

LOCATION
Various sites, among them the C.A. Bairfield Ranch near Clarendon in Donley County, Texas

SIGNIFICANCE
An example of the rural, one-room schools that were typical in ranch country until urbanization and transportation facilitated mass education

DONORS
Mr. and Mrs. Charles E. Bairfield

DEDICATED
April 7, 1973

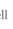

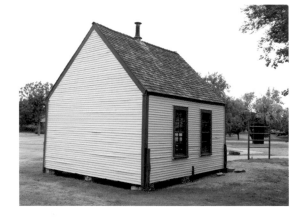

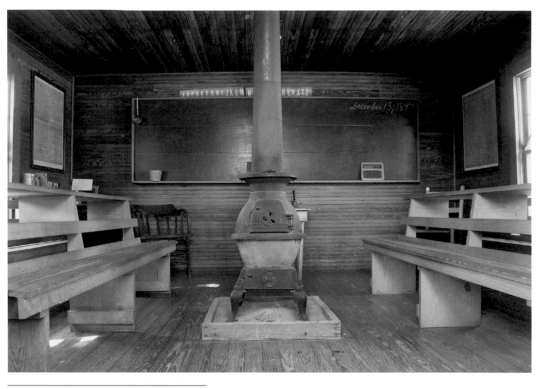

Many frontier children were educated in one-room schools.

Library shelf in the Bairfield Schoolhouse

The one-room frame schoolhouse is nailed to posts planted at its corners and to two sides to keep it from blowing away.

The outhouse was located behind the school.

Lunches were carried to school in pails and coffee cans.

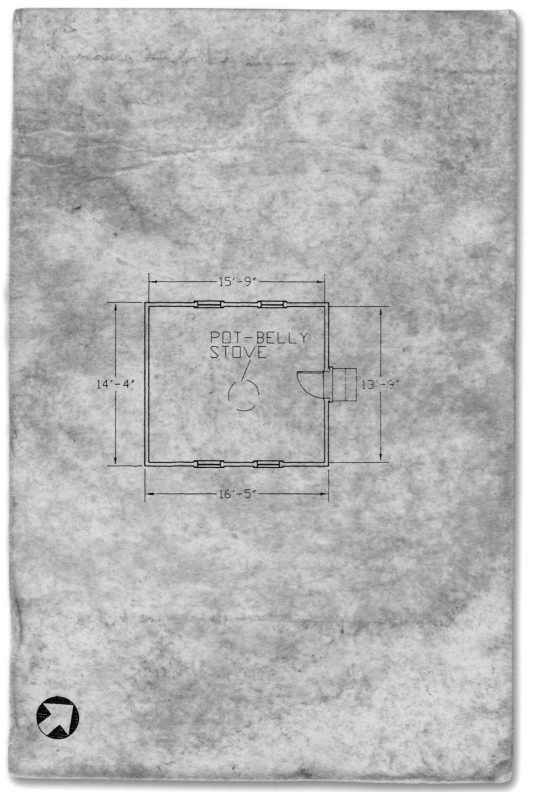

15'-9"

POT-BELLY
STOVE

14'-4"

13'-9"

16'-5"

Slate and chalk were more easily acquired than pens, pencils and paper.

8 + 4 = 12

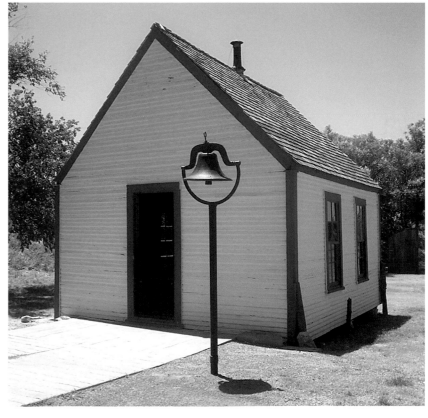

was the last to teach in the one-room school. She recalled that five taxpayers, all ranchers, supported the school when she was there.

"The happiest children I have ever seen," Mrs. SoRelle called them. If the weather was good, she had the children take their lunches with them as they walked to a nice spot to eat. Along the way, she taught them about history and the natural sciences. "We learned every Texas flower and everything that grew," she added. Sometimes they saw wild turkeys or other animals, and they always had to watch for snakes.

She said the ranch kids were "hardy, and they knew how to get around the country. We would take long walks. There was a real nice waterfall, and it was one of our favorite places to go. It was always our science lesson when we went. We gathered rocks and flowers and even found Indian arrowheads on some days. They could imagine all the buffalo that roamed the country."

The school was built to serve the families of cowboys, ranchers and homesteaders. The older kids helped the younger ones with their studies. It was a challenge for the teacher to prepare complete lessons in each subject for each pupil, because there seldom was more than one or two children per grade in as many as nine grades. For the eager student, though, it was an additional learning opportunity for him or her to listen in as the older boys and girls recited their lessons. C.E. Bairfield was five in 1907 when he started school. He said he enjoyed listening to the others as they talked about history.

Students in the Bairfield Schoolhouse sat on wooden benches. The surfaces in front of them held their books, slates and chalk. When it was one's turn to read or recite, he or she sat in the front bench, which didn't have a desktop. All the classroom furniture was homemade. A cast-iron stove to warm the room was set upon stones so sparks wouldn't land on the wooden floor and burn the schoolhouse. During cold months, one boy was appointed to come to school early and start a fire in the stove. Coal was purchased under school contract. If it was not available, cow chips collected from the area ranches were used. An open window cooled the school in hot months.

The walls were decorated with maps of the United States and Texas, and a 46-star flag was attached to the wall so students could say the Pledge of Allegiance every morning. The school had a library; actually it consisted of a corner shelf on which books were placed for the students to read or the teacher to read to them.

They were not above playing a prank or two—like the time they locked the teacher in the outhouse.

Usually, no money was available for paper or pencils, so the students used chalkboards. These were wide, wooden boards painted black. A chalkboard covered the wall behind the teacher's desk. Textbooks were few, so the children were accustomed to sharing. Lard and coffee cans in which the students carried their lunches were placed on a shelf in front of the room. A bucket, filled each morning from the stream or well, provided drinking water for the children. The whole class used the same water dipper, so as might be imagined, disease spread rapidly among the children. Youngsters then, just as they do now in the 21st century, looked forward to recess. And they were not above playing a prank or two—like the time they locked the teacher in the outhouse.

School buildings historically were utilized for social gatherings, meetings, plays, parties and church services. One-room schools often were found on isolated ranches, but they fell into disuse as towns consolidated for the education of their residents' children.

The schoolhouse was brought to the NRHC in 1972 after being donated by Bairfield in memory of the pioneers of Donley County, Texas. M.H.W. Ritchie, president of the J.A. Cattle Co., and his daughter Cornelia Adair Ritchie provided for moving and restoring the building. Children from the JA Ranch once attended the Bairfield School.

Class attendance at the Bairfield School, 1905-1906

FOR THE RECORD

In the schoolhouse's locations in Armstrong and Donley counties, never were there more than six or seven students in any one year. In 1937 before the school closed permanently, it had one student and one teacher, causing the Bairfield School to be mentioned in Ripley's "Believe It Or Not."

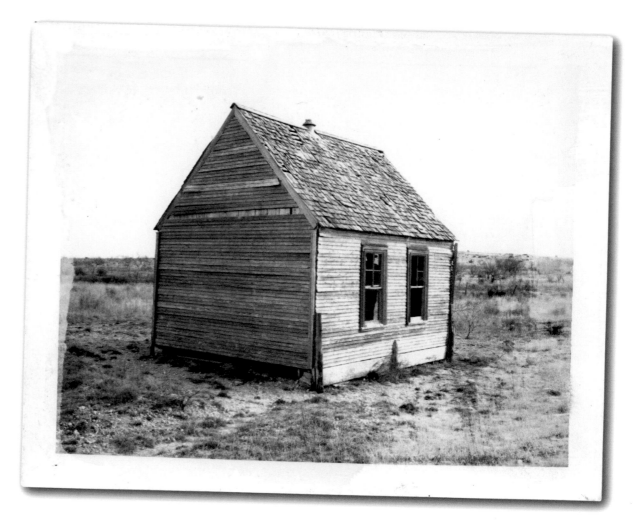

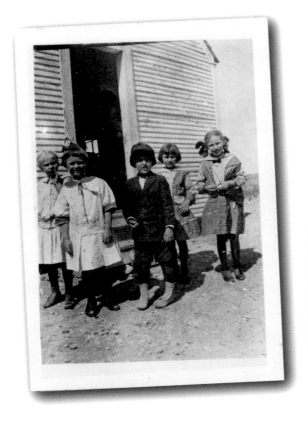

Children presented an end-of-school pageant for their parents. It was titled "The Pencils and Pens Are on a Strike."

original location

BAIRFIELD SCHOOLHOUSE

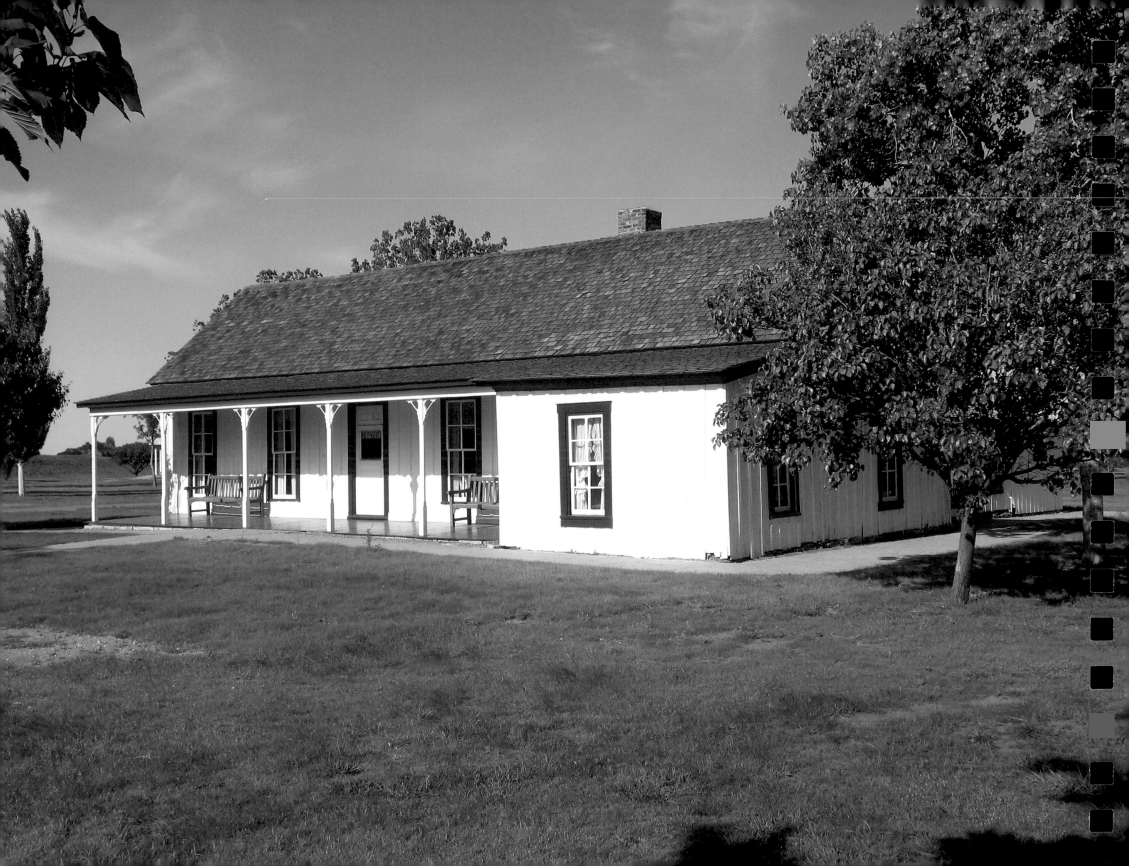

CHAPTER TWELVE
HARRELL HOUSE
1883, 1900, 1917

It took four owners and 34 years to build the house that was situated in a quiet draw beside Hackberry Creek in Scurry County. But it only took the sisters Fay and Myrtle Harrell, plus "a jackleg carpenter," a little more than a year to restore it from near total dilapidation. The dwelling sheltered families during the era that began with free-range ranching and ended with barbed wire and agriculture. The Harrell House is typical of home expansion. The rancher or farmer could ill afford to discard any building. As families grew and fortunes improved, houses, likewise, expanded.

The structure began as a single stacked-rock room built by Fred Williamson, who sold it to R.T. Mellard, who added two box and strip rooms to the east side of the stone house. Mellard sold it to Lon and Lillie Smith, who added the remaining rooms and porches. They sold the house to Phineas and Roseannah Reynolds in 1917, who sold it and the ranch to Charles J. Harrell in 1934. The Harrells continued to live in Snyder rather than in the old house.

Over the years, the dwelling and its varied additions fell into a state of ruin while Charles Harrell tended the ranching operation. His unmarried daughters, Fay and Myrtle, earned degrees from Hardin-Simmons University and worked as school teachers.

Neither stayed in the profession long and returned home to help with the ranch. When their father became ill, they took up ranching seriously. They continued to live in Snyder but drove the pickup to work on the ranch or for a little time away for peace and quiet.

Some years later, the sisters began looking for a place farther away from town, a retreat less accessible to visitors who might interrupt their quiet respite. They wanted a project as well, a home to restore and decorate in the style of early West Texas. The one that attracted their attention was located on their ranch, three miles down a road past a locked gate. It was in a draw, protected

> They wanted a project, a home to restore and decorate in the style of early West Texas. The one that attracted their attention was located on their ranch, three miles down a road past a locked gate.

OWNERS
Fred Williamson, R.T. Mellard, Lon Smith, Phineas Reynolds, Charles J. Harrell

LOCATION
V Bar Ranch near Snyder, Texas, on Hackberry Creek in Scurry County

SIGNIFICANCE
An example of the growth of a ranch dwelling as the rancher's family grew and his fortunes increased

DONORS
Faye and Myrtle Harrell

DEDICATED
Oct. 7, 1972

Wall phone

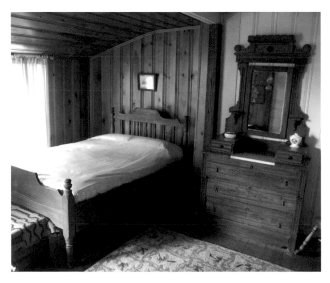

Parlor, bedrooms, dining room and kitchen

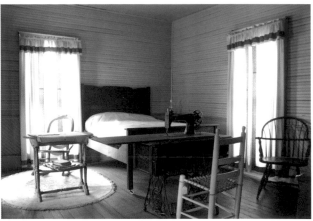

The hall tree

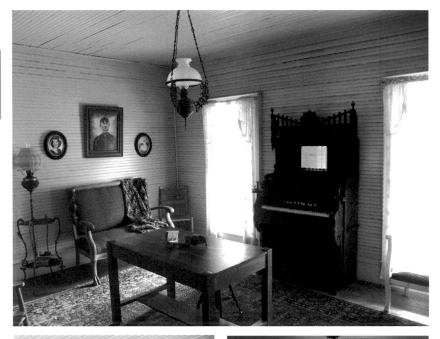

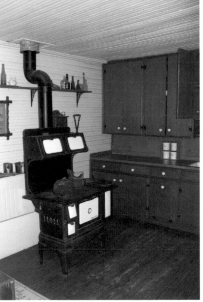

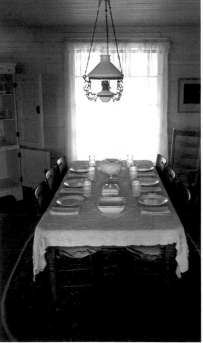

HARRELL
HOUSE
up close

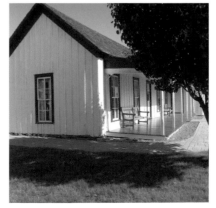

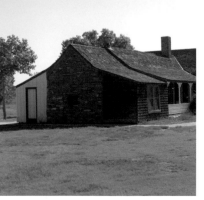

from the north wind, while a south breeze across Hackberry Creek cooled the summer heat. And it was old. The ladies liked old things.

Construction experts insisted the house couldn't be reclaimed. But, the Harrells found a carpenter willing to help them. What couldn't be repaired was duplicated from old houses being razed in Snyder. The chimneys had collapsed and were completely rebuilt. It took them more than a year (1961 62) before the house was ready for furnishing.

The sisters knew what they wanted—the house was to reflect a ranch family that was comfortable but not rich. The ladies found furniture in antique stores and their own family storage. They located an icebox, a Victrola (a hand-wound record player), a stereoscope, with its views of historic events and natural wonders. The telephone connected the isolated ranch family to the outside world. The dining room was likely a second parlor, and the oriental carpet was an indication of the family's prosperity.

When the sisters' retreat was ready, people who had heard about the restoration project swarmed the creekbed "in praise of the history preserved in the face of great odds" by the determined women. The house was a focal point of historical tours, which pointed out that restoration was possible even when it seemed futile. Then the unusual home caught the attention of the Ranch Headquarters Planning Committee. After much soul searching, the Harrell sisters decided to donate their project to the NRHC for preservation in the historical park.

The ladies missed seeing the old house when it was gone, saying when they topped the ridge and looked down on the Hackberry Creek banks, the site looked empty. So, they purchased another old structure to move to the site and restore. Despite missing the T-shaped home, the Harrell sisters liked the idea that future generations, who "grew up so far away from it and don't know about it" can look at what is now preserved as the Harrell House and learn how it came about, grew with each subsequent family who lived there, and how it was reborn through the efforts of the two determined women.

The Harrell House was intended to reflect a ranch family that was comfortable but not rich.

The stereoscope gave people a glimpse of the world outside their own.

FOR THE RECORD

When Fay and Myrtle Harrell started work on the house, it was a mess. The ceiling buckled from the weight of hunters who tromped through the attic looking for raccoons that nested there. Light filtered in through large holes that gaped in the roof and sides, while porch roofs sagged down to the foundation. The rock walls had collapsed from the pressure of cows pushing into them for shelter, and porch columns laid on the ground.

The stone room was the original house.

original location

HARRELL HOUSE

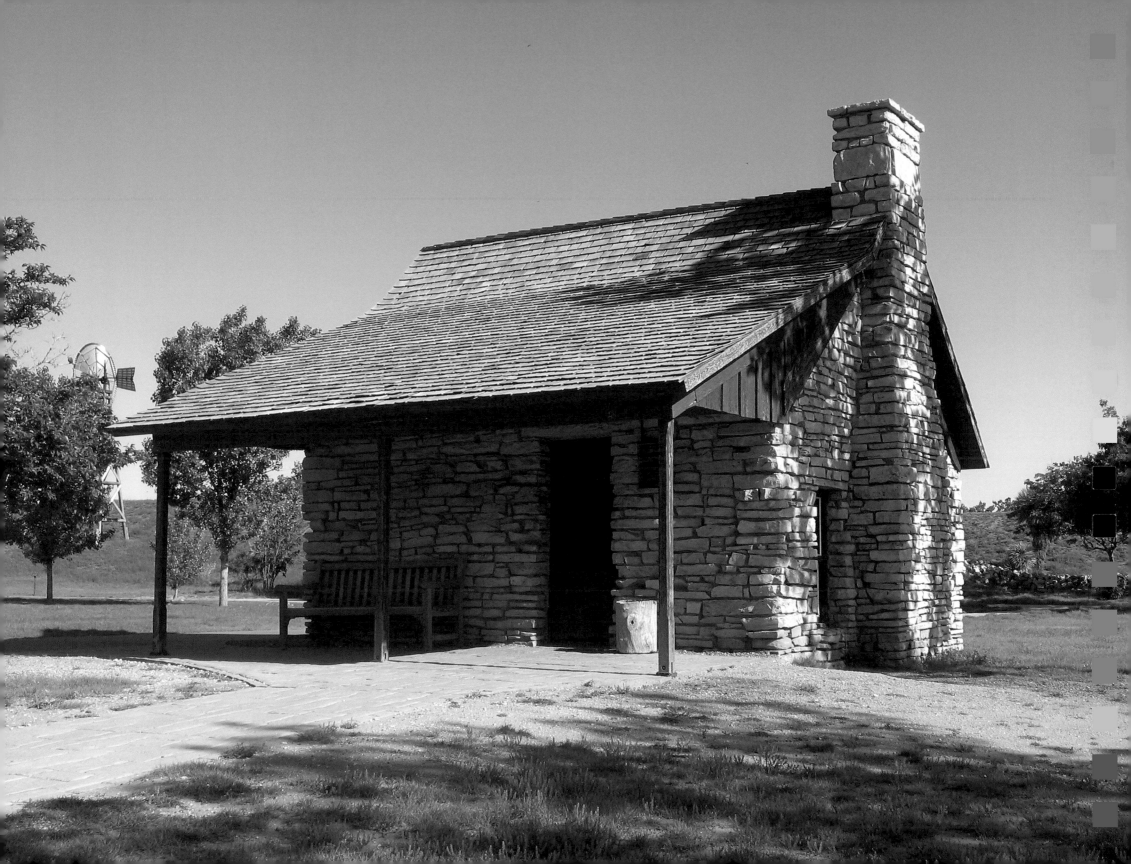

CHAPTER THIRTEEN

MASTERSON JY BUNKHOUSE
c. 1879

"Home was wherever a cowboy hung his hat." The cliché had truth to it. Cowboys of the American West were vagabonds, roaming from place to place. At the ranch headquarters, the bunkhouse was their home until they moved on again.

Cowboys were young, many having left their homes to sign on with a cow outfit in hopes of seeing the country and working with horses. Theirs was a poorly paid and dangerous job, whether they were on the trail or at the ranch. Many of these cowhands had very little education and few possessions, but they had horse sense, so to say. They were characterized as having a wild streak, being uninhibited and fun, and liking women. They were also considered hard to tame, much to the dismay of some young ladies. And most cowboys had a good sense of humor. For example, they enjoyed dragging a rope over a sleeping man's blanket and shaking snake rattles in his ear. The sleeping man awoke with heart pounding. Hearing the laughter, his temper flared, face reddened, and the episode ended until the next unsuspecting "rattlesnake" victim came along.

A sense of humor helped cowboys cope with the responsibilities of his job. Cowboying has gained a questionable reputation as being "romantic," when in reality, it was very hard work. In some situations, the responsibilities were accompanied by long months of boredom and loneliness. Work for some cowboys included watching for signs of screwworms in the cattle they tended.

Screwworms were larvae hatched from the eggs of blow flies in the open wound of a cow. To kill the worms, a mixture of carbolic acid, axle grease and any number of other things was rubbed into the wound. Dehorning cattle was dangerous work, as was pulling a steer or mother cow from quicksand, which was prevalent around rivers and streams. Cowboys fought prairie and ranch fires and were always on the lookout for trouble, whether

> The sleeping man awoke with heart pounding. Hearing the laughter, his temper flared, face reddened, and the episode ended until the next unsuspecting "rattlesnake" victim came along.

ORIGINAL OWNER
8 Ranch

LOCATION
West of Truscott on the 8 Ranch, northwest of Benjamin, Texas, in eastern King County

SIGNIFICANCE
Housing for cowboys in the time of open range

DONOR
Ed A. Lowrance

DEDICATED
June 22, 1974

Fuel can

The trap door gives access to the large basement-like area under the bunkhouse, supporting the idea that the structure had begun life as a dugout.

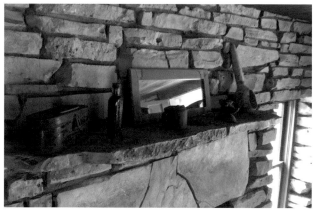

A Dutch oven was used for cooking everything from stew and cobbler to biscuits.

← The date stone

Green tags indicate where the stones were located in the bunkhouse wall. The date stone was 2-feet 7-inches from the north corner and 4-feet 8-inches from ground level in the west wall. The stone was found when the bunkhouse was relocated to the NRHC. The date coincides with that of a major renovation: Feb. 8, 1887.

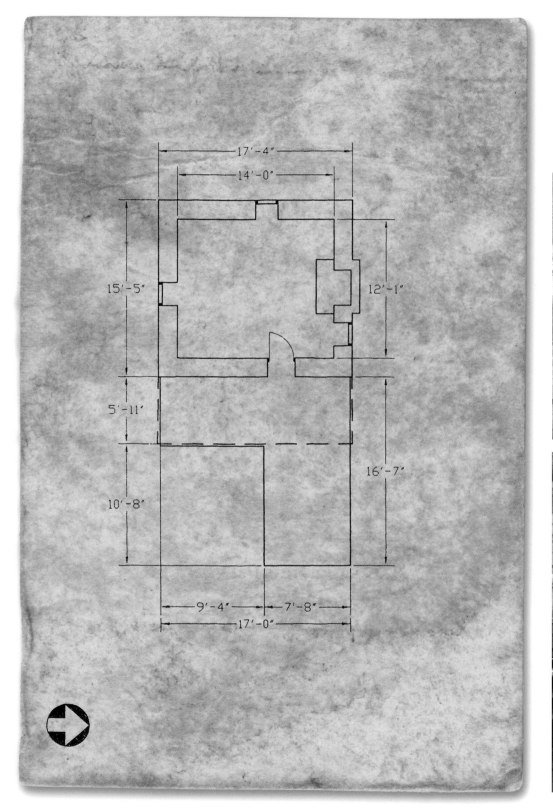

17'-4"

14'-0"

15'-5"

12'-1"

5'-11'

16'-7"

10'-8'

9'-4" 7'-8"

17'-0"

MASTERSON
JY BUNKHOUSE
up close

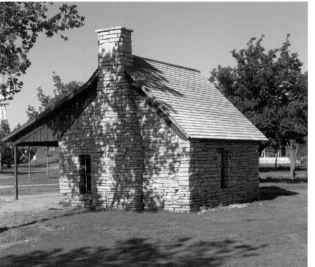

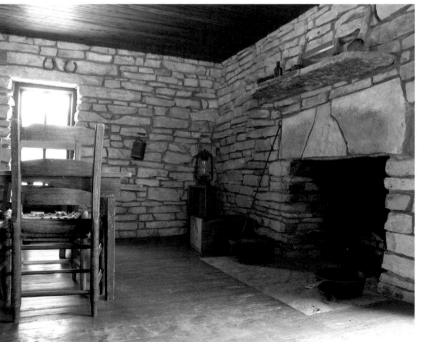

it was threatened by man or beast. Broken bones were the least of what occurred when men on skittish horses were thrown from their saddles into the path of running cattle—or pitched in the dirt by a bucking bronc.

At the end of the day, the bunkhouse looked good to weary cowhands. Most bunkhouses were crowded and smelled of sweat, cattle and tobacco. But it was a place where they could roll out their bedrolls, usually outside, which is where most of these roamers preferred to sleep. In bad weather, however, the bunkhouse floor was a welcome respite. Lighting was provided by a coal oil lantern or a lamp. The table was used for eating, of course, but also for playing dominoes or cards and writing an occasional letter home. Heat, when needed, came from the fireplace. Such sparse furnishings reflected the simple lifestyle and few personal possessions of these restless men.

In 1889, Robert Ben Masterson purchased 40,000 acres in Knox and King counties on which the bunkhouse was situated. His daughter, Mrs. D.S. Kritser, said the family lived in Fort Worth but spent summers on the ranch. Although girls were not allowed in the bunkhouse, she said she peeked in sometimes. She saw iron bedsteads with springs and

At the end of the day, the bunkhouse looked good to weary cow hands. Most bunkhouses were crowded and smelled of sweat, cattle and tobacco. But it was a place where they could roll out their bedrolls, usually outside, which is where most of these roamers preferred to sleep.

mattresses covered by the cowboys' bedrolls made of a tarpaulin with soogans—heavy wool or cotton quilts—and a pillow. She also saw dirty socks, a wooden table and chairs with cowhide seats and rugs made from the hides of lobos. On the porch was a bucket of water, a bar of soap and a drying towel hanging on a nail nearby.

The Masterson JY Bunkhouse was considered a good one by those who lived in it. Its walls and fireplace were made of limestone and the interior floor was wood. Beaded ceiling board was overhead.

Records suggest that in 1887, stone was added leveling the walls, and a gabled roof replaced a flat or slightly slanted roofline. The bunkhouse was further modified when a door on the west side was changed to a window. A covered porch was constructed, along with

Although girls were not allowed in the bunkhouse, she said she peeked in sometimes.

a tongue and groove floor. A trap door to the right of the door opens to a dirt cellar, which reinforces the likelihood that the bunkhouse was originally a dugout.

Information about the bunkhouse suggests it was built in 1879 on the same location where buffalo hunters had made camp in earlier years. The unmortared native rock bunkhouse originally was part of the 8 Ranch. (A large 8 is carved below the fireplace mantle.)

When Masterson acquired the property as part of his JY Ranch, sources suggest the building was used as both a bunkhouse and a cookshack. The ranch was passed to Masterson's son, R.B. Jr., then in 1956 it was purchased by Ed Lowrance. He and his family, in 1971, gave the bunkhouse to the National Ranching Heritage Center, where it represents all the structures that served as temporary homes for roaming cowboys.

Handmade
wooden chair

FOR THE RECORD

Each fall, cowhands who lived in the Masterson JY Bunkhouse had to contend with a den of rattlesnakes located beneath the fireplace. When the weather turned cool and the first wooden match flared after striking boot bottom or pant-leg, six-shooters and carbines were loaded and ready when the wood crackled and smoked in the fireplace. Within minutes, rattlers of all sizes appeared, mad at the intrusion and requiring prompt removal by the cowboys.

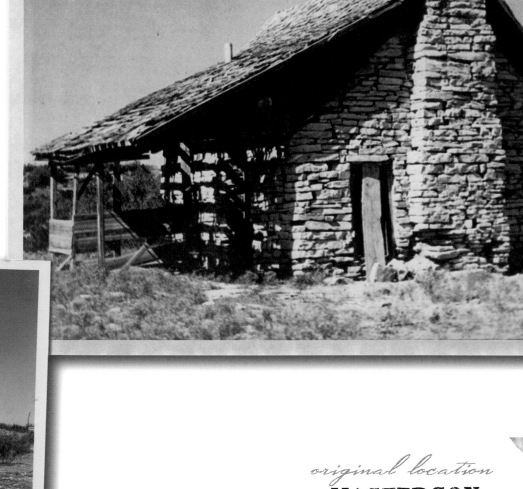

original location
MASTERSON JY BUNKHOUSE

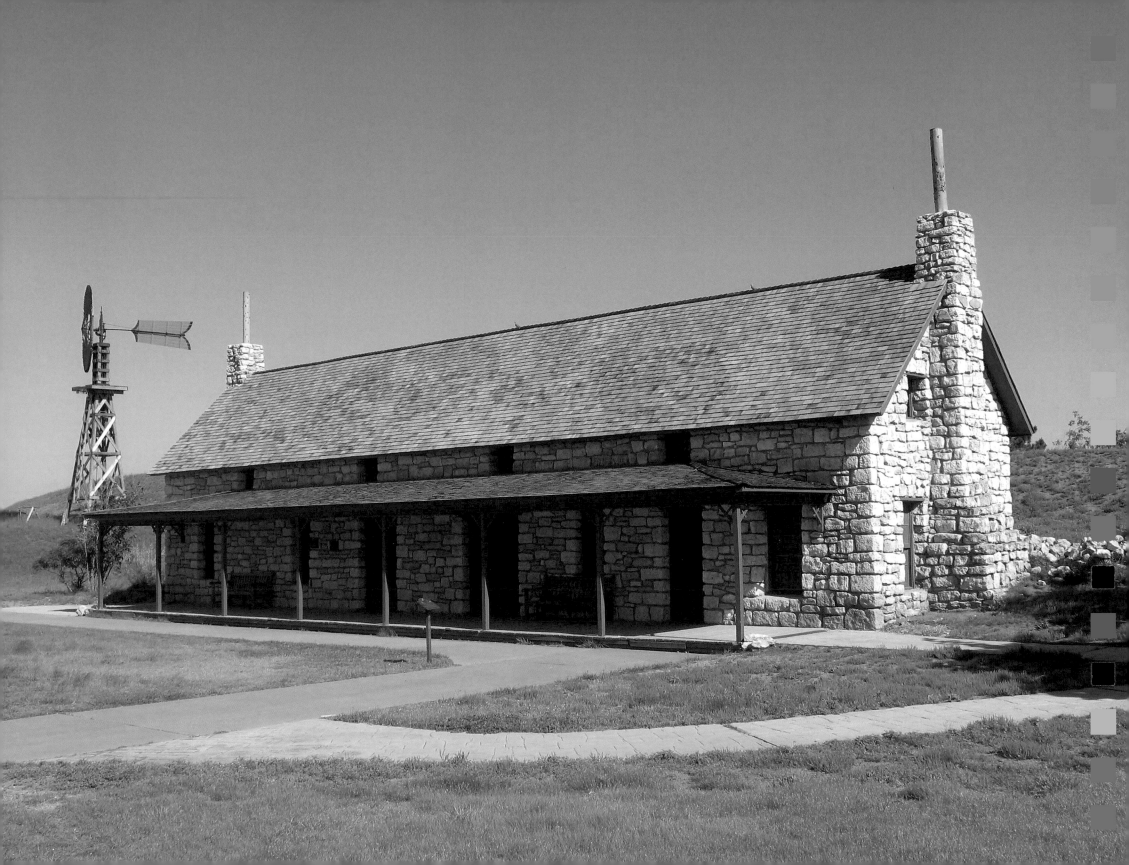

CHAPTER FOURTEEN

LAS ESCARBADAS

1886

The XIT, according to author/historian Joe B. Frantz, was the largest ranch under fence in the United States and probably the world. It was not a financial success, he said, but the ranch was significant. "It showed there need not be a conflict between now and the future. As civilization crowded in, the XIT made room for it and welcomed it, and so became a part of the folklore of history. The investors intended from the beginning to sell out, to become a great land development company to bring settlers in."

The XIT embodies the story of ranching on the plains of Texas—from the free range to enclosed grazing land backed by foreign capital and then development of small ranches and farms. Three million acres were awarded by the state to investors in exchange for construction of the capitol building in Austin. The land ran through 10 Texas Panhandle counties along the New Mexico border. The land arrangements were intricate, but the final result was that four men from Illinois with no ranching background took possession of land they had never seen to run a spread larger than any in the world. One of the men had been the chief contractor in rebuilding Chicago after the great fire a decade earlier. When stocking the ranch required more money than they had readily available, Abner Taylor, A.C. Babcock and John V. and Charles B. Farwell formed the Capitol Freehold Land and Investment Co. and sold bonds to the English. John Farwell, Chicago's largest dry goods wholesaler, became managing director of the ranch. Taylor, the man who rebuilt Chicago, built the new state capitol.

By summer 1885 when the first 20,000 heifers, steers and bulls arrived at the Buffalo Springs headquarters, trail driver Ab Blocker suggested the brand be an XIT, because it could be made with a bar iron and would be difficult for rustlers to modify. No basis in truth exists for the XIT brand meaning "Ten in Texas," despite the fact that the ranch, indeed, covered all or part of 10 counties. Truth was, the XIT was just a brand easy to make and hard to alter.

> No basis in truth exists for the XIT brand meaning "Ten in Texas," despite the fact that the ranch, indeed, covered all or part of 10 counties.

ORIGINAL OWNER
Capitol Freehold Land and Investment Co.

LOCATION
On Tierra Blanca Draw, 1 mile east of the New Mexico state line in Deaf Smith County, 35 miles west of Hereford, Texas

SIGNIFICANCE
Represents the transition from immense cattle operations to a combination of ranching and farming country

DONORS
Mr. and Mrs. Joe Reinauer Sr.

DEDICATED
March 27, 1977

Kitchen

ullet holes can
e seen in the
nokestacks.

Foreman Ira Aten painted the
windows of "Las Es" dark green so
rustlers couldn't make him their
target as he sat at his desk.

Eating area

Meat grinder |

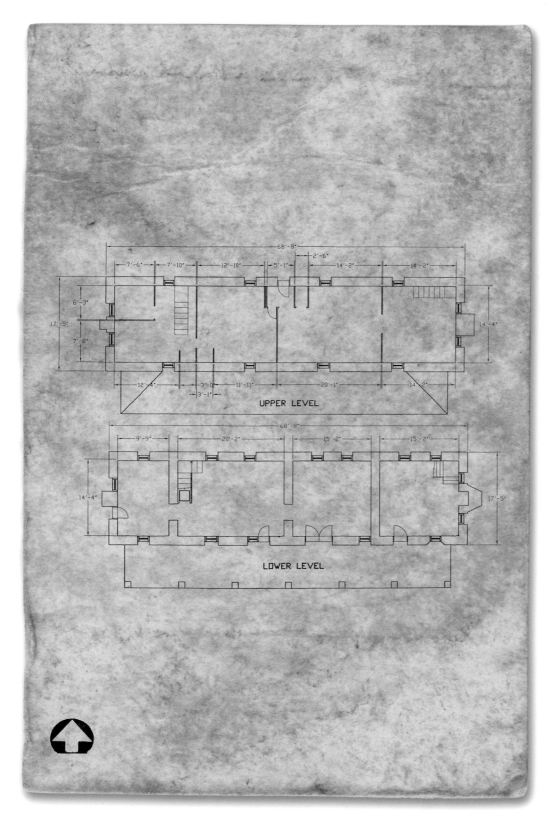

68'-8"

7'-6" 7'-10" 12'-10" 5'-1" 2'-6" 14'-2" 14'-2"

6'-3"

17'-5"

7'-8"

14'-4"

12'-4" 3'-0" 11'-11" 20'-1" 14'-2"

3'-1"

UPPER LEVEL

68'-8"

9'-9" 20'-2" 15'-2" 15'-2"

14'-4"

17'-5"

LOWER LEVEL

LAS ESCARBADAS

up close

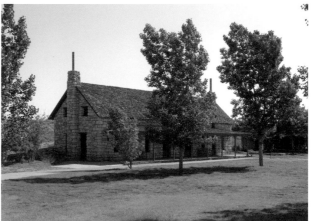

Water pitcher and bowl
for washing up

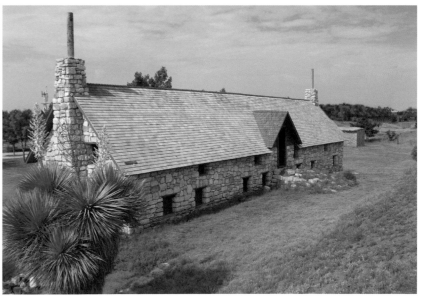

Second-floor
entrance from
the hillside

In addition to its size, the ranch topped the list of "mosts." It had the most windmills of any ranch—some 335. Among them was the tallest windmill tower of any known in the world, "lifting its wheel 130 feet above the canyon's floor to catch the wind sweeping across the Plains," wrote author J. Evetts Haley in "The XIT Ranch of Texas." Fencing the XIT range required more than 6,000 miles of barbed wire, the most on any ranch of that era. The wire was transported to the Texas Panhandle in five boxcars, and two additional freight cars carried staples and hinges. Unfortunately, another distinction was having the most destructive prairie fire. In the winter of 1894, some 1 million acres—a full one-third—of XIT grass was destroyed in that inferno.

The ranch's windmills helped fill 100 stock tanks to supplement the meager natural water supplies in more than 90 pastures spread across the ranch's divisions: Buffalo Springs, Middle Water, *Rito Blanco* (Little White River) *Ojo Bravo* (Bold Spring), *Las Escarbadas* (The Scrapings), Spring Lake and *Las Casas Amarillas* (The Yellow Houses). The *Alamocitos* (Little Cottonwoods) division was established later with headquarters in Bovina. The main headquarters for all of the XIT was in Channing. Each had a specific purpose. For example, the Escarbadas was strictly a breeding range. All of the divisions operated with their own equipment, horses and foremen, who answered to the general manager.

The XIT was enclosed in barbed wire in 1886, which hastened the end to the Open Range Era. At the same time, the fenced pastures made possible the development of improved cattle breeds. The XIT owners bought land near Miles City, Montana, for "double wintering." A calf from the Texas pastures, for example, could be moved 1,000 miles and be four years old before it was ready to be sold. Instructions given to men in charge of the Montana-bound trail herds were, "Keep your eye on the North Star and drive straight ahead until you can wet your feet in the waters of the Yellowstone." Cowhands moved 12,500 steers over the Texas Trail in 1896.

After the turn of the 20th century, the XIT began selling off large tracts of land to ranchers and farmers. The ranch's final cattle sale took place in 1912; the last land was sold on Jan. 24, 1963.

This era in Texas ranching is represented at the National Ranching Heritage Center by Las Escarbadas division head-

quarters, moved stone by stone from Deaf Smith County. "Las Es" was originally located along a popular Comanchero trail. Comancheros were New Mexican traders who made their living trading with Comanches, Kiowas and other Plains Indians. In the 1800s, these traders exchanged ammunition, beads and knives to Indians for captives and stolen horses and cattle. As the Comancheros traversed the arid plains, they dug shallow pits in a creek bed near Las Escarbadas in search of water. Las Escarbadas refers to "the scrapings" they left in the earth.

Measuring some 70 feet by 30 feet, the headquarters was built in 1886 of limestone brought from Tierra

Upstairs was a room on the east end, where as many as 60 cowboys could sleep at the same time.

Blanca Draw. The first-floor rooms opened onto a porch. The building was situated with its back against a hillside, so the slope provided ground-level entry to the second floor. Walls were two feet thick, providing adequate insulation against heat and cold.

The foreman, his family and the cowboys all used the dining room for meals. The east bedroom belonged to the manager and his wife; the central bedroom was that of the manager's sons; upstairs was a room on the east end, where as many as 60 cowboys could sleep at a time. The west and middle rooms on the second floor stored bulk provision, such as flour, cornmeal, dried fruit and molasses.

The covered porch ran the full length of the house on the southwest side, providing shade from the summer heat. The small windows could be removed and the big ones were double-hung to allow more air flow. According to architectural historian Willard B. Robinson, "The long narrow proportions of the building, its porch and its steeply pitched roof created a pleasing composition. However, function was the form determinant of the roof; the high rise provided headroom space in the second story, where the stone walls terminated only three feet above the floor line."

Cowboys were called to meals by the ringing of an iron bell, located northwest of Las Escarbadas headquarters.

The structure was home to a family, a place for cowboys to eat and sleep, an office for the ranch manager and a storehouse. When the owners visited, it served as the guest quarters. Las Escarbadas is furnished as it was in 1893-1904 when Ira Aten was foreman. A former Texas Ranger and sheriff of Castro County, Texas, Aten was hired to stop the cattle rustling that was rampant along the New Mexico-Texas line. The situation was so bad, Aten actually expected to be killed by one of their bullets. By the time he left the ranch (alive, by the way), large-scale rustling at the XIT had been eliminated.

The XIT was described by historian William Curry Holden as "where the action was and the history made." Today the capitol building in Austin and a place in history are all that remain of what was the largest ranch in the United States.

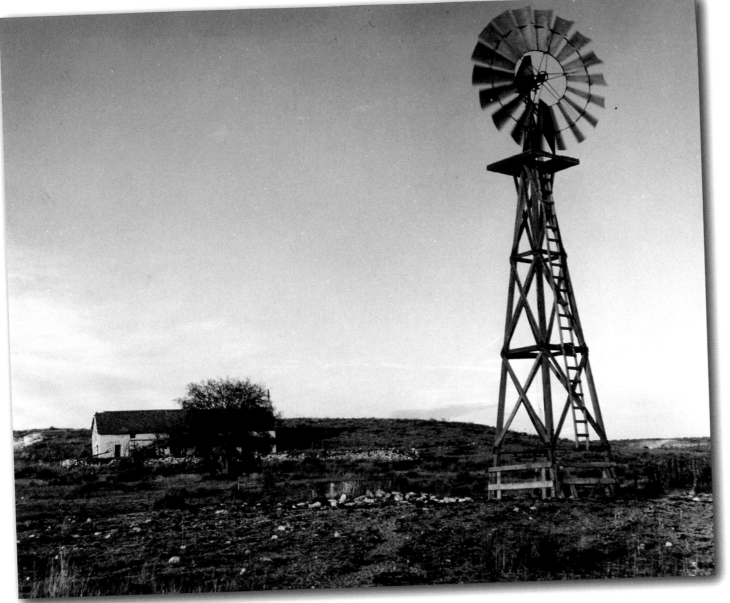

FOR THE RECORD

Ranch rules written in 1888 by ranch manager Abner Taylor established behavior for everyone associated with the XIT. Taylor especially provided for the animals: "The abuse of horses, mules or cattle by any employee will not be tolerated; and anyone who strikes his horse or mule over the head, or spurs it in the shoulder, or in any other manner abuses or neglects to care for it while in his charge, shall be dismissed from the company's service."

original location

LAS ESCARBADAS

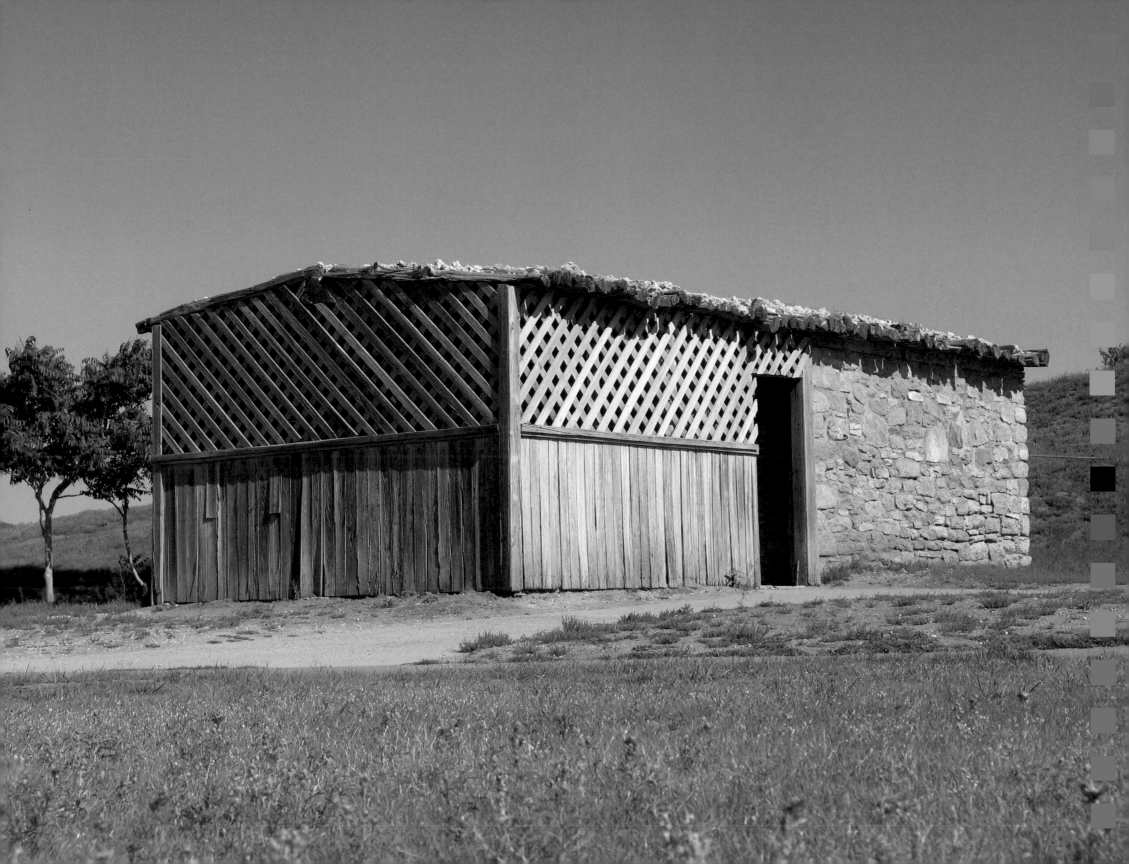

CHAPTER FIFTEEN
JA MILK AND MEAT HOUSE
c. 1880

The JA is among the best-known ranches in Texas and perhaps the entire Southwest. Well-run through more than 100 years, its good management plus the cast of players who owned and operated the ranch have propelled the JA into a prominent place in history. The people behind the formation of the JA Ranch were Charles Goodnight, John Adair and Cornelia Wadsworth Ritchie Adair, an unlikely partnership, or so many thought.

Goodnight was a hard-talking rancher, having been a scout for the Texas Rangers, a frontiersman and a trailblazer. He and his wife, Mary Ann, lived on their ranch near Pueblo, Colo. John Adair was an Irish investment broker, frugal, polished and well educated. Cornelia Ritchie was the daughter of a wealthy New Yorker. She had been left as a young widow in 1864 when her husband and the father of their son, Jack Ritchie, died in the Civil War.

She remarried in 1869 to John Adair, who owned investment brokerage companies in Ireland and New York. The couple traveled between Great Britain and the United States each year. During the 1870s, it was considered fashionable to make expeditions into the "Wild West" to shoot buffalo and other game. It was on one of those trips in 1874 that the Adairs fell in love with the American West. John set up another brokerage house in Denver in 1875.

Goodnight, at this same time, was driving his herd to Texas in search of good grass and watering sources he heard existed in the Texas Panhandle. He wintered along the way in New Mexico in late 1875. With the aid of an old Comanchero who knew the area, Goodnight settled his herd in Palo Duro Canyon in the fall of 1876. He established a camp and went back to Colorado, meeting the Adairs there in 1877. John Adair's sources had suggested Goodnight as the best man to run a ranch for them as an investment project. The men decided to visit the Palo Duro and discuss a possible ranch partnership.

The men, their wives, two cowboys and other necessary hands started out on their trip from Pueblo to Palo Duro. The group

> During the 1870s, it was considered fashionable to make expeditions into the "Wild West" to shoot buffalo and other game.

ORIGINAL OWNERS
John Adair and
Charles Goodnight

LOCATION
15 miles west of Clarendon
in Palo Duro Canyon at
JA Ranch headquarters,
Armstrong County, Texas

SIGNIFICANCE
A method of preserving
food before refrigeration
was common

DONOR
M.H.W. Ritchie

DEDICATED
Nov. 25, 1972

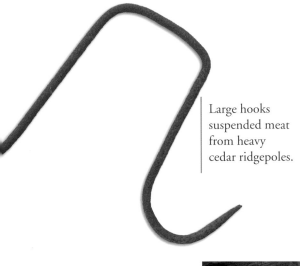

Large hooks suspended meat from heavy cedar ridgepoles.

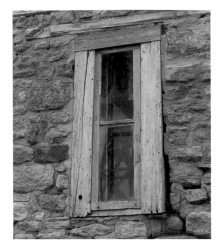

Sausage press

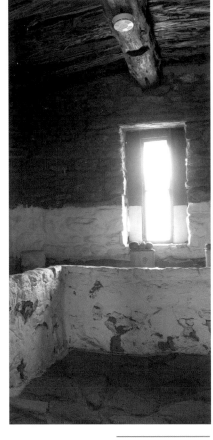

Darkened milk room

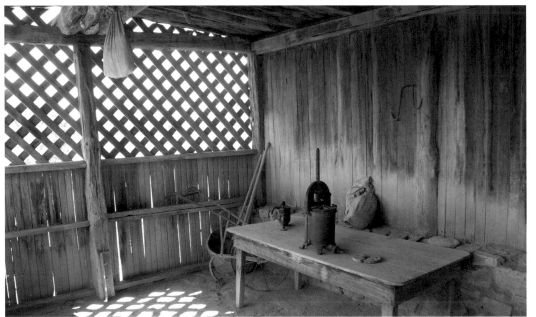

Meat preparation room

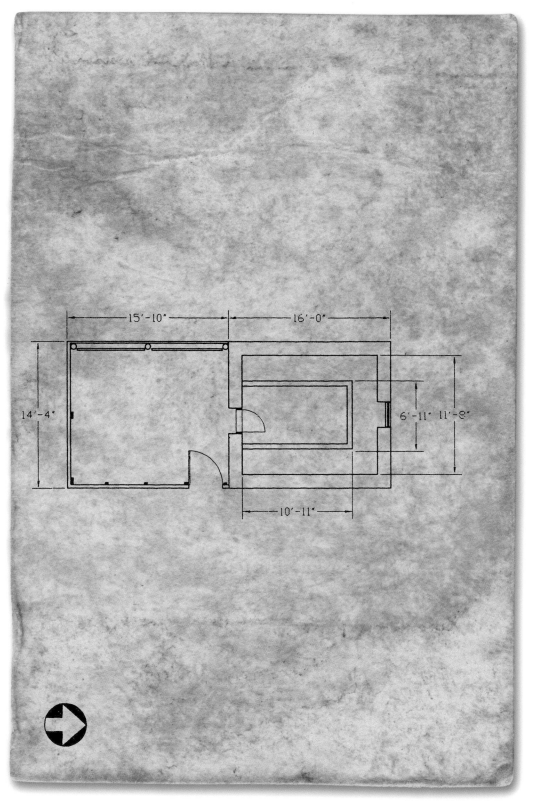

An adobe expert from Santa Fe, N.M., worked on the earthen roof make it waterproof.

arrived in Palo Duro in May 1877 and stayed in the two-room log house Goodnight had erected earlier.

On June 18, 1877, the two men formed a partnership in which Adair would provide Goodnight a salary and pay for all ranch expenses for five years. Goodnight was to manage the ranch and develop the herd. At the end of the five years in 1882, Goodnight would pay back Adair's investment plus interest and split the ranch so Adair would have two-thirds of it plus cattle and profits. Goodnight would get one-third. They settled on John Adair's initials for the brand. Some people thought it an unusual bonding of a tough character like Goodnight with a well-bred Irishman and his wealthy wife from back East. But cattlemen subsequently joined forces with businessmen in land and cattle ventures. The JA was among the first ranches in the West to be financed by business investors' money.

During the first years of the agreement period, the ranch did very well. Goodnight had dugouts made for his cowboys and the cook. A blacksmith shop, tinner's shop, water tanks, roads and a big bunkhouse/mess house were also built under his direction. Barns and corrals were constructed and eventually a large rock house was built, primarily for occupation by the Adairs. On one end of the house was the log house Goodnight had constructed years earlier. The milk and meat house was built around 1880 while Goodnight was manager of the ranch.

By 1882, Goodnight had purchased additional land and expanded the ranch herds, experimenting with cattle breeding and splitting the original ranch into two—the JA for the main herd and the JJ for the high-grade herd and bulls used for breeding the JA herd. The arrangement was running so well, Adair and Goodnight renewed their agreement for another five years. Adair, in 1885, made his third and final trip to the ranch. He died in St. Louis, Mo., on May 14, leaving his part of the JA to his widow. Two years later, Goodnight and Cornelia Adair dissolved the partnership, and Goodnight set up his own ranch near Quitaque from his third of the partnership division. Mrs. Adair kept the JA.

Cornelia spent most winters at the ranch and returned to England in the summers. She sent her son, Jack, back to England when he developed a strong interest in ranching while managing the Tule spread under Goodnight the year after John Adair died. Jack eventually established his home in England, married and had three children. One of them, Montgomery Harrison Wadsworth "Montie" Ritchie, was fasci-

nated by the ranch life his father had experienced. After graduation from Cambridge in 1931, Montie made his first trip to the JA and stayed to run the ranch until his death at age 88. The JA passed to his daughter, Cornelia "Ninia" Ritchie. With managing partner Jay O'Brien, she continued the operation of the highly respected ranch.

The JA Milk and Meat House, now at the National Ranching Heritage Center, represents the era when such structures provided an easier way to preserve food, particularly for the large ranches. Typically, these structures had a meat storage/workroom fitted with huge hooks, fastened to the rafters. From the hooks hung beef, elk, venison, buffalo, sheep and pork. The carcasses were covered with cloth or canvas sacks. On the JA, 50 people were fed daily, so the supply of fresh meat was always being replenished. Slatted walls on the meat room allowed air circula-

> Some people thought it an unusual bonding of a tough character like Goodnight with a well-bred Irishman and his wealthy wife from back East.

tion, yet were spaced close enough to keep out predators. Also in the room, lard was stored in large metal cans, and bacon was kept between layers of salt in wooden boxes.

The milk room was designed with thick walls, a double-glazed window and water trough. Water flowed from a spring or windmill into the trough where crocks filled with dairy products, eggs and other perishable foods were placed in the water. Wet cloths covered the crockery, and evaporation occurring in the dark room aided the cooling process.

The JA Milk and Meat House from the Palo Duro Canyon demonstrates a simple but clever method for keeping perishables fresh and represents all spring houses erected in the developing West.

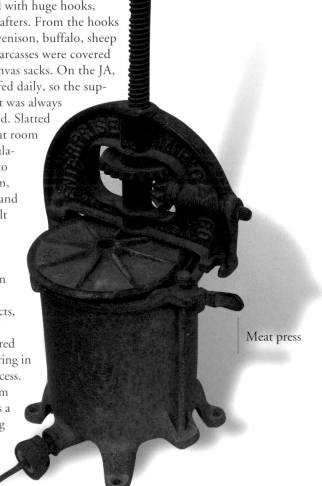

Meat press

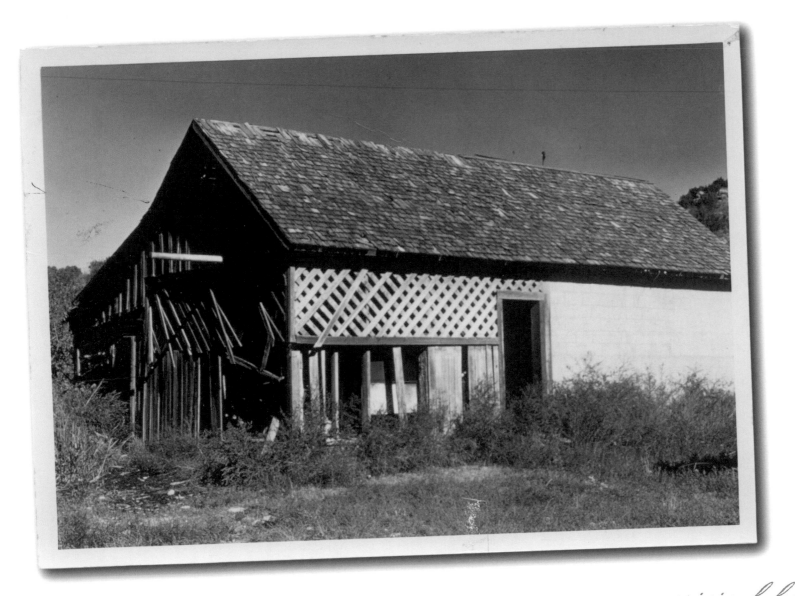

FOR THE RECORD

The JA Milk and Meat House was roofed with split wooden beams and topped with rocks and earth. Dirt was used in attempts to erect an adobe roof on the structure after it was moved to the NRHC. Several tries at recreating the original red color came out purple. Finally, red mud from the ranch was brought in and mixed with chemicals to help waterproof the roof. Shortly after the roof was completed, a seven-inch rain fell, but no damage occurred to the milk and meat house.

original location

JA MILK AND MEAT HOUSE

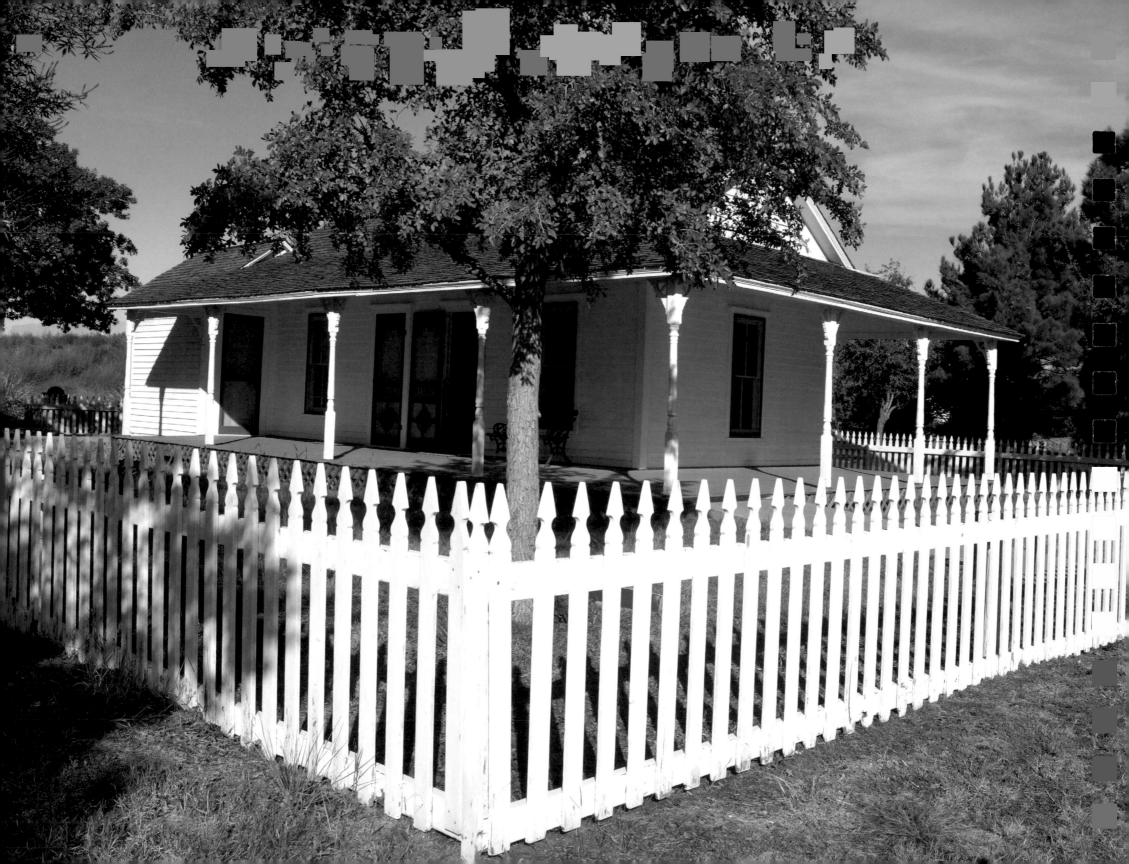

CHAPTER SIXTEEN
MATADOR OFFICE
c. 1880

The 400,000-acre Matador Ranch was one of several huge spreads owned or backed by foreign investors. Unlike some that were bought to be sold again as farm and ranch development property, the Matador was bought for the long haul. From the beginning, it was managed to be a profit-making, productive ranch. Because of close supervision by its Scottish owners of everything from cowboy etiquette to the books, the business was profitable far into the 20th century.

The Matador Ranch was established in 1879 by Alfred Markham Britton, Henry H. Campbell and their associates. They ran the operation from a half-dugout headquarters in Ballard Springs, Texas. With finances in limited supply, Britton and Campbell sought foreign capital. All across Texas, land was available for sale, but money was in short supply. A company scout contacted investors before purchase, calling the Matador the "best watered, sheltered and healthiest ranch in Texas."

In 1882, the outfit was purchased and became the Matador Land and Cattle Co., Ltd. Its headquarters were transferred from Ballard Springs to Dundee, Scotland. Britton was to serve as manager for five years and occupy a place on the board of directors. Campbell was retained as supervisor until Texas laws required that an on-site foreign manager run all foreign investments. In its 69 years, the Matador had only five managers—Britton, Campbell, Murdo Mackenzie, John MacBain and John Mackenzie. Long-term good management was considered another reason for the longevity of the Matador.

Only in times of severe drought was the company unable to pay large dividends to its stockholders. The board sent a Scottish bookkeeper to America to oversee the records, and directors audited the books themselves. In 1890, when Scottish-born Murdo Mackenzie became manager, he brought experience from the Colorado-based Prairie Cattle Co. He extended the ranch's boundaries through leased grazing land, improved its herds and cut costs.

> Because of close supervision by its Scottish owners of everything from cowboy etiquette to the books, the business was profitable far into the 20th century.

ORIGINAL OWNER
Matador Land and
Cattle Co., Ltd.

LOCATION
One mile south of Matador,
Texas, in Motley County

SIGNIFICANCE
Reflects the fact that ranching was, first and foremost, a business operation

DONOR
Matador Land and Cattle Co.

DEDICATED
Oct. 6, 1973

Some of the Matador's well-worn office furniture came with the building.

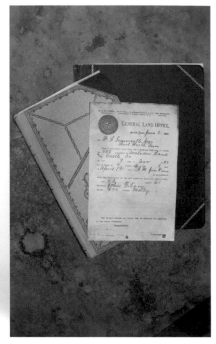

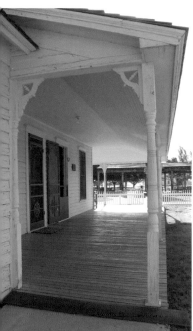

The west room was used as a bedroom.

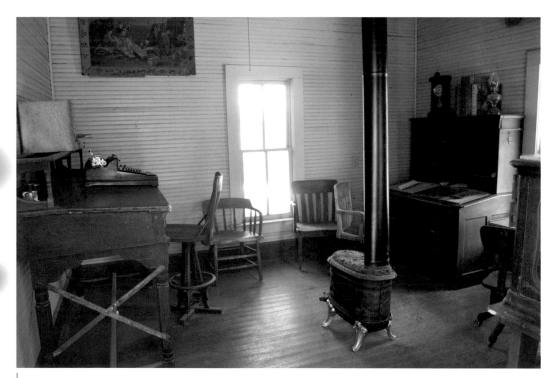

Office

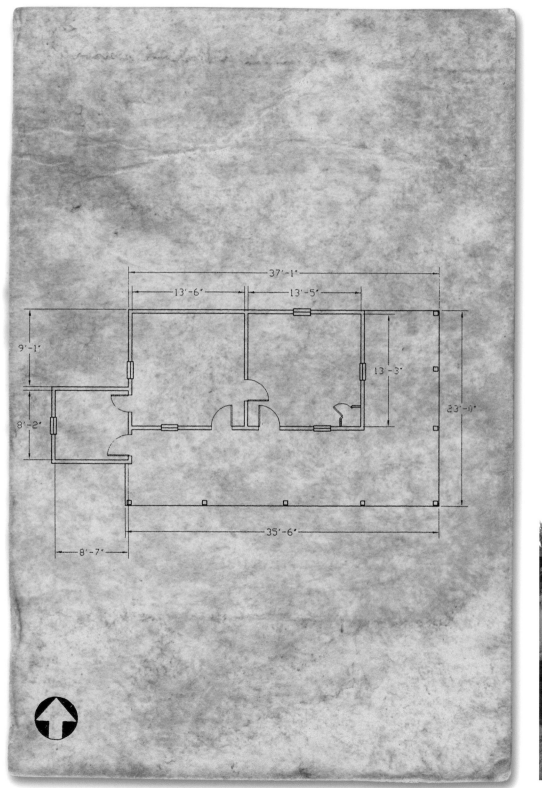

Stapler |

When the foreign owners visited the Matador, they stayed in a guesthouse built in 1880 called "Scotsmen's Dive" by the cowboys. As the operation grew and increases were made in herd size and acreage, the record-keeping requirements expanded. A bigger guesthouse was built, and "The Dive" was converted to an office for the Matador in 1923. Management of the operations was directed from this building, now preserved at the National Ranching Heritage Center.

The office holds two desks used by the manager and the accountant, who prepared the payroll, maintained cattle sale and purchase ledgers and monitored ranch finances. The office did not feature a cuspidor, so when tobacco-chewing cowboys picked up their paychecks each month, they had to go outdoors to spit—a great inconvenience. At the west end of the building was a space that served as a bathroom. The other room was used as a bedroom. Notches in the west room floor are evidence of some unknown cowboy's presence with a six-shooter. Some of the office furniture came to the NRHC with the building.

The structure was moved intact to the historical site, and very little renovation was necessary. It was built on a limestone foundation, the walls were clapboard, the ceiling beaded board, and the floor tongue and groove wood. The roof was covered with cedar shingles. A white picket fence enclosed the structure.

The Matador Office represents another aspect of the West in its early years of development. It stands as a reminder of foreign investment in a successful ranching venture and finally sold in 1951.

The office did not feature a cuspidor, so when tobacco-chewing cowboys picked up their paychecks each month, they had to go outdoors to spit—a great inconvenience.

Adding machine

FOR THE RECORD

The wife of Matador Ranch manager Henry Campbell loved to give parties. Her specialty was the annual Christmas dance, which began in 1882. Preparations started as early as the summer when she made gallons of plum jelly to replace cranberries. Mrs. Campbell and five other women, plus the ranch cook, baked and prepared food for the event, making dough-nuts, fried dried apple pies, turkey or venison, and a barbecued beef or two. The highlight was a dance, where women were outnumbered three or four to one. The party opened with supper in the mess hall, then food was set up in the bunkhouse for a come-and-go buffet. The party lasted 30 hours.

original location

MATADOR OFFICE

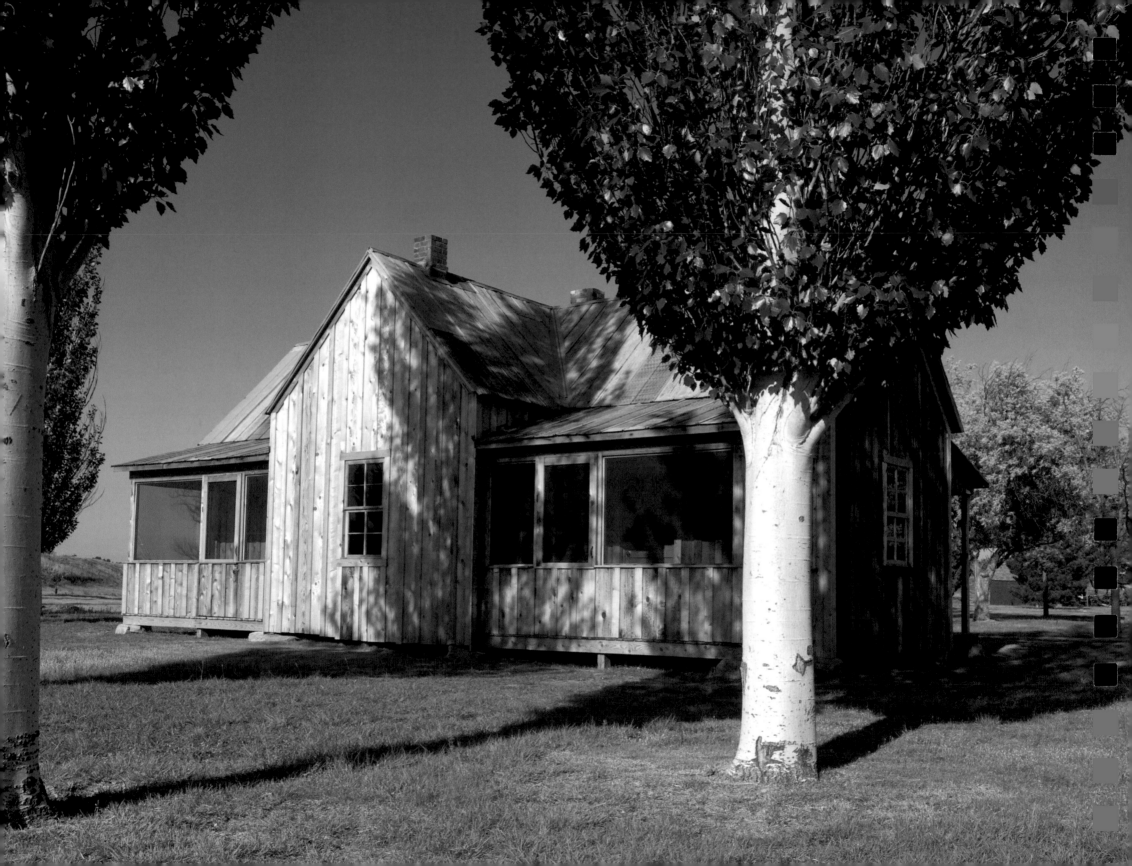

CHAPTER SEVENTEEN

80 JOHN WALLACE HOUSE

c. 1900

The old ranch house sat at the edge of a cultivated field and was surrounded by mesquite trees. The porches had been knocked down by cattle climbing up for a better view. Though weathered and gray, the wooden house was in remarkably good condition for a structure built more than 100 years ago.

With the exterior doors and windows gone, one could walk right in and see that the ranch house of 80 John Wallace of Mitchell County, Texas, had a good floor plan, allowing a nice flow of air through the uniquely shaped house. Built facing west, it is laid out like a cross with bedrooms on the north and south. The drawing room and kitchen are in between.

The house once had a kitchen stove for cooking, another stove for heat, and the chimneys were still intact. There were four covered porches—two of them screened—and a water well just to the west of the house. There used to be an old barn, but most of it had blown away in the West Texas sand and wind.

When this house was built, the land around it was grazing pasture owned by one of Texas' most successful black ranchers, Daniel Webster Wallace. The name may not be as familiar as his nickname—80 John.

D.W., as his family still refers to him, was born in 1860, the son of newly freed slave parents in Victoria County, Texas. He went to work as a cowboy when he was 15, eventually working on cattle drives and roundups for C.C. Slaughter, Isaac Ellwood, John Nunn, Clay Mann and several other big operation owners.

D.W. got his nickname from the Mann ranch brand. It was a large "80" used on both cattle and horses. Since he did the majority of the branding, D.W. became known as "80 John." The name stuck with him for the rest of his life.

D.W. broke horses, drove cattle to Wyoming and Kansas, helped set up large cattle ranches in Wyoming and Mexico and survived hostile Indian attacks. He used his wages to buy cattle and land, eventually setting up his own ranch on 1,280 acres south-

> **D.W. got his nickname from the Mann ranch brand. It was a large "80" used on both cattle and horses.**

ORIGINAL OWNER
Daniel Webster "80 John" Wallace

LOCATION
Loraine, Texas, in Mitchell County

SIGNIFICANCE
Cross-shaped design with four porches allows the house to take advantage of cooling breezes

DONOR
D.C. and Dorothy Fowler

DEDICATED
July 25, 2009

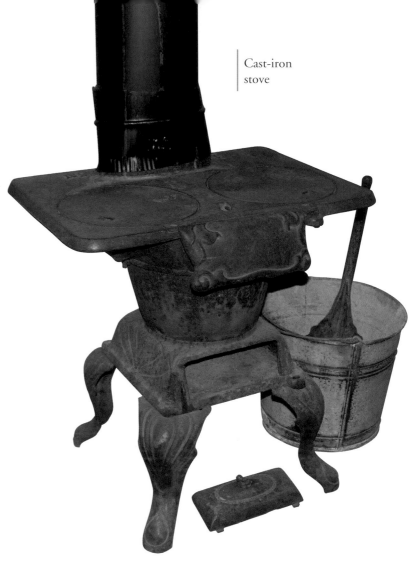

Cast-iron stove

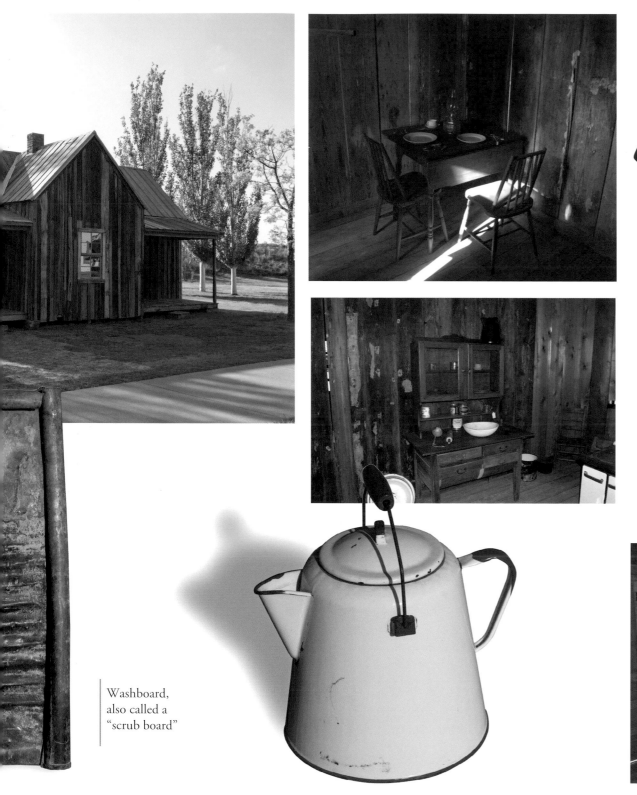

Washboard, also called a "scrub board"

80 JOHN WALLACE HOUSE

up close

Bedroom furniture was spare but comfortable

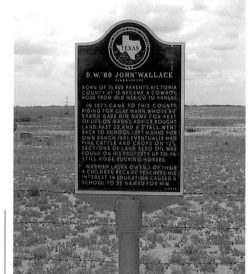

Historical Marker

east of Loraine, Texas, in Mitchell County. His land holdings grew to include more than 12 sections of ranch and farm land and several herds of Durham and Hereford cattle. He built a house for his family in what is now Colorado City so the children could attend school. Though he did not learn to read until he was 25, D.W. was such an advocate of education that a school in Colorado City was named for him.

His brands included a D triangle used on his Durham cattle. The Herefords were branded with a "D" on the right hip and a "running W" on the other. Another brand was an "LD" for his wife.

D.W. built at least one other board and batten house on his ranch to accommodate him as he fed cattle and tended to ranch matters. That structure was torn down and replaced by corrals and barns in the early 1900s. But the cross-shaped house remained and was used by the Wallace family for at least two more generations after 80 John's death.

When oil was discovered on the land, D.W. built a more substantial ranch house. A modern home was built nearby for D.W.'s grandson and his wife. D.W. continued to work the ranch every day, even breaking horses until he was 74 years old. His heirs still operate the Wallace ranch, though most of the land is now under cultivation and few cattle are run on it. He is buried in a family cemetery on his land, the graveyard marked by a Texas state historical sign.

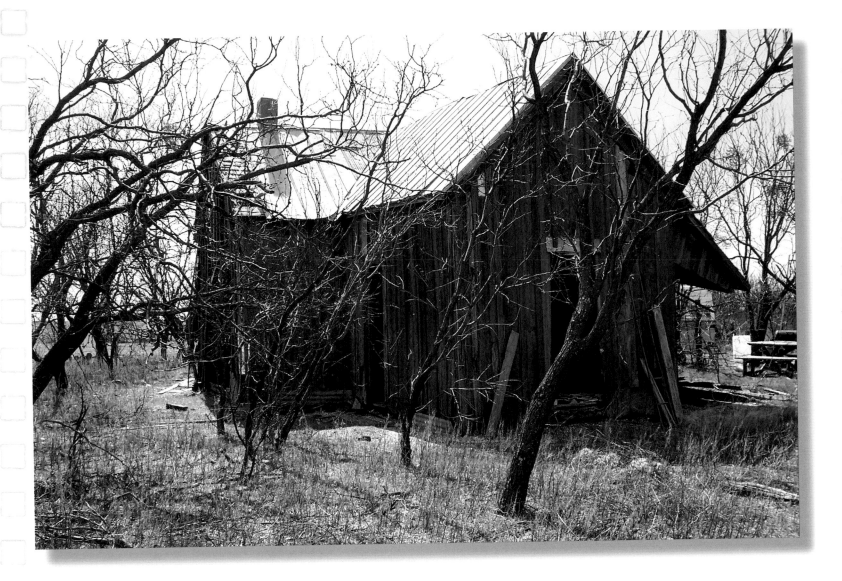

FOR THE RECORD

D.W. once dictated a short biography to a schoolteacher's daughter in which he stated: "I have grown up with the horse and the cow. I still like outdoor life. Very seldom a day passes that I don't mount my horse and ride for hours." When he died in 1939, the hard-working cowboy left an estate worth more than $1 million.

original location

80 JOHN WALLACE HOUSE

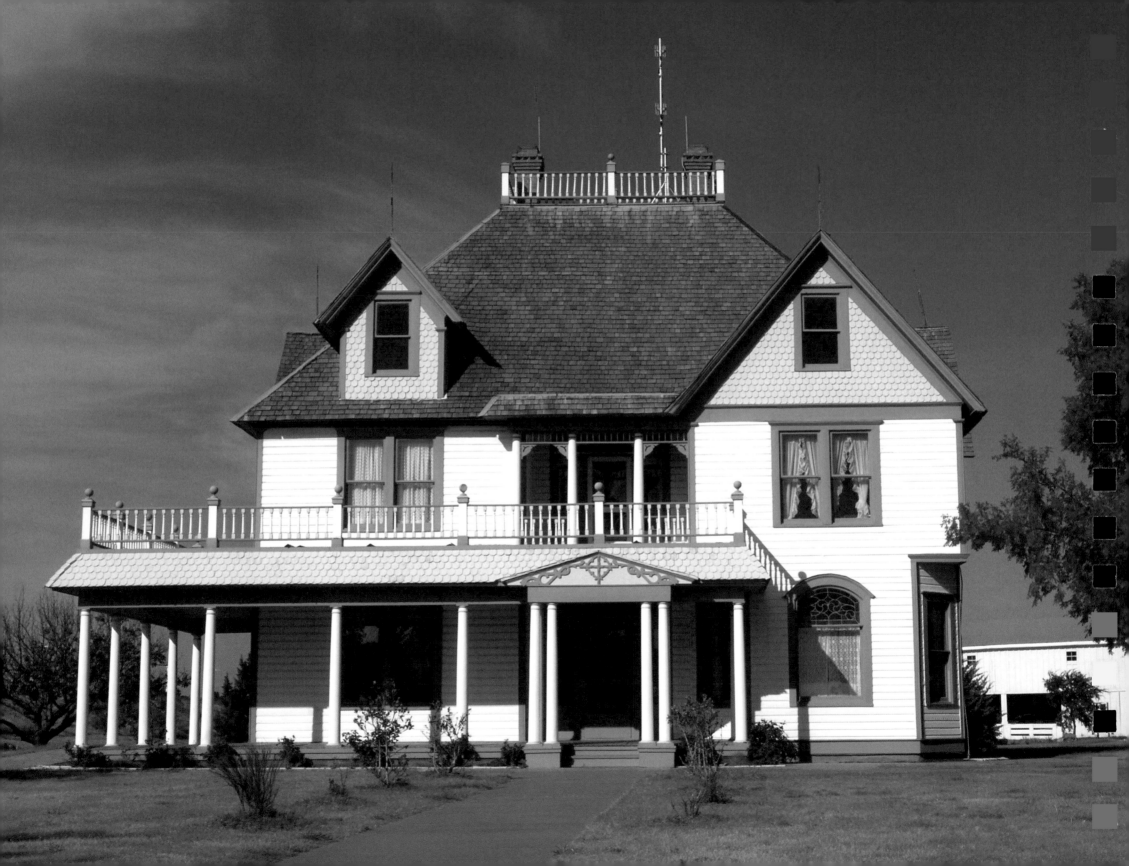

CHAPTER EIGHTEEN
BARTON HOUSE
1909

It was the dream of Joseph James Barton to have his elegant, two-and-a-half-story house anchor a new town that was secured by a railroad depot and train. Although with much effort to make the town a reality, it didn't last. The Barton home was the capstone of a planned community on a railroad line that never came through.

Joseph and Mary Barton moved with their family in 1891 to take advantage of low land prices in West Texas and advancing railroad lines. Barton and two uncles bought 50 sections of land and started their TL Ranch about 33 miles north of Lubbock. In 1897, Joseph stayed behind to tend the ranch while Mary moved to Plainview so the Barton children could attend school. In 1906, news came that a railroad line to connect the Santa Fe at Hereford with the Texas and Pacific line at Colorado City would pass through his TL Ranch property. By 1907 land values on the South Plains skyrocketed with acreage selling for 10 times what Barton had paid. The land boom gave him the idea to develop a town with a post office, lumberyard, mercantile, hotel, church, school and, as the centerpiece, a beautiful home. He started selling land to settlers and business people, and the town of Bartonsite developed.

By 1909, the town had attracted 250 people and was supporting a hotel, lumberyard, church and a school. Barton turned his efforts to building the elegant home he envisioned for his family. He purchased plans for the home for $45 from *Modern Dwellings*, a magazine published by the George F. Barber Co. of Knoxville, Tenn. The Queen Anne-style house the Bartons selected had five rooms on the ground floor, five rooms on the second floor,

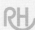

ORIGINAL OWNER
Joseph James Barton

LOCATION
Bartonsite, 6 miles north and 8 miles west of Abernathy, Texas, in southern Hale County

SIGNIFICANCE
Reflects the confidence of a prosperous rancher and town builder

DONOR
Mrs. Jack Sneed (Josephine Waddell) Barton

DEDICATED
May 14, 1983

The land boom gave him the idea to develop a town with a post office, lumberyard, mercantile, hotel, church, school and, as the centerpiece, a beautiful home.

Central stairway |

Boy's desk built from floor planks by Joseph Barton Jr., who was killed in battle just one week before the Armistice of World War I.

The three-day ride from Bartonsite to Lubbock on the back of a truck was so smooth a light bulb that had been removed to the stairway landing rolled to the floor only as the house turned past the Texas Tech Medical School construction site.

Sewing room on the second floor

Grooming aids

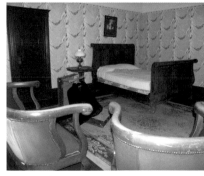

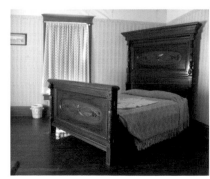

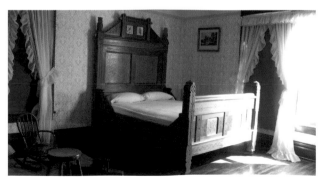

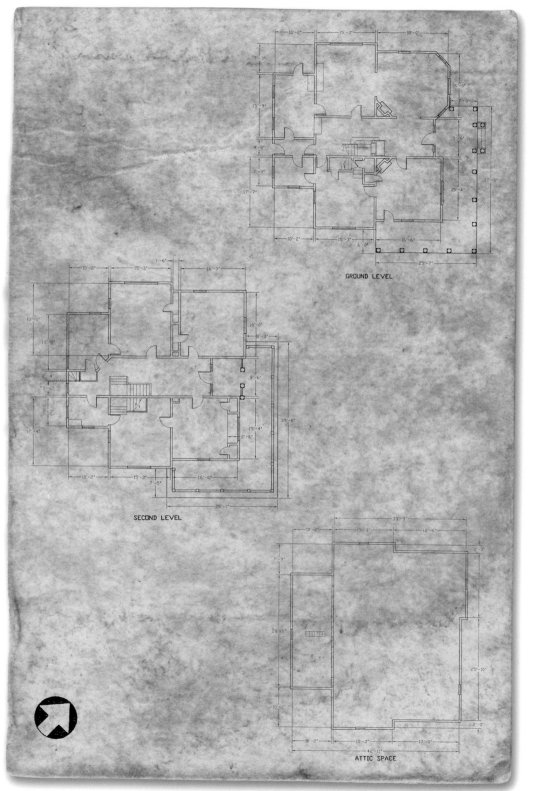

GROUND LEVEL

SECOND LEVEL

ATTIC SPACE

BARTON HOUSE
up close

A child's top (to

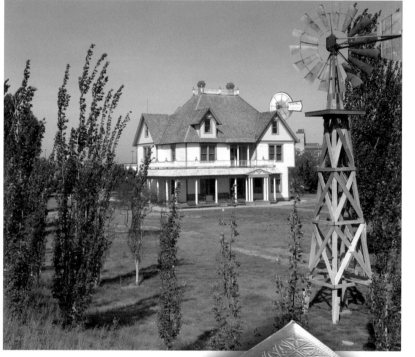

The Barton
four-poster be

Early toys and
personal items
fill the house.

plus two indoor bathrooms, a mansard-style roof and a widow's walk. A large porch, with Tuscan-style columns, wrapped around the front and one side of the house. The house plan featured four gables, a second-story porch, "gingerbread" wooden ornaments and a leaded glass parlor window. The Bartons chose white paint for the exterior and accents in two shades of green.

Most of the building materials were shipped by train to Amarillo from where they were hauled by wagon to Bartonsite. Other items were purchased at the Bartonsite lumberyard. Doorknobs, locks, mantels and mirrors were acquired from mail order companies. Modern features included running water in the kitchen, sliding doors, built-in closets, acetylene (carbide) lighting, and a milk and meat cooler at the back of the house. The tall, spacious attic was used for storage. The planned Barton house was unlike most others on the Texas South Plains.

At this same time, many of the ranchers who had survived drought, blizzards and the Panic of 1893 began moving out of the harsh region. They sought good grassland for their cattle and a less severe climate. Then, to make things worse, in 1909, the Santa Fe completed its line from Amarillo to Lubbock, running through Abernathy, about eight miles east of the town of Bartonsite.

Joseph Barton saw the inevitable demise of his planned community, and, no doubt with a very heavy heart, he helped move the town's businesses to Abernathy. The church went to Cotton Center; the store and post office remained in what was left of Bartonsite to serve settlers who bought and moved onto Barton land. The big house was the only home left. In 1921, Bartonsite dissolved when the post office shut down. The Bartons, like other ranchers, had to make changes to survive. The herd size was cut and crops were planted.

In the 1920s, Jack Barton, a son of Joseph and Mary Barton, went into partnership with his father raising sheep and cattle. The arrangement was abandoned in the early 1930s, and Jack and his wife, Josephine Waddell, bought the Barton homestead. Jack cultivated the land, growing cotton, grain and wheat. He leased other land on which to raise livestock. Jack Barton died on Oct. 20, 1967. After his death, Josephine, who appreciated the National Ranching Heritage Center's dedication to historic preservation, bequeathed the house to

the NRHC. She died in February 1974.

Moving the large home in 1975 was the job of W.K. Bigham and Sons of Snyder and Lubbock, working with Willard Robinson, restoration architect. Tunnels were dug under the footings to place the supporting 48-foot cross beams, and the house was lifted out of the ground and onto a flatbed truck. Steel rails and cables braced brick fireplaces. Only a porch was removed for the 40-mile trip to Lubbock. One hundred and eight power and telephone lines were lowered or lifted, and the Santa Fe Railway took charge of all crossing signals along the route of the house's three-day journey to the NRHC.

Among the furnishings in the house is an 1889 piano in the parlor, a gift from a father to his daughter. It was brought to Texas by covered wagon for the 15-year-old girl, who played it for her family as they moved West. In the large dining room are the Barton's oak table and chairs, and the four-poster bed is also original to the family. Scalamandre of New York reproduced some of the house's wallpaper from original samples taken from the house.

Peter Rippe, former executive director of the Harris County Heritage Society in Houston, a widely recognized authority on restoration and furnishings of historic structures in Texas, was secured to advise the Ranching Heritage Association representatives about appropriate furnishings and interior elements for the restored home.

"The Barton House, as an elegant West Texas ranch house, can stand its ground as a part of what social historians have called the American dream," he said. "The Bartons should be, and can be, symbolic of thousands of families whose roots reach back into

American history and whose accomplishments stand as monuments to their hopes."

Joseph Barton's dream may not have come true in his lifetime, but, ironically, when his house was moved from its original location in Bartonsite to the National Ranching Heritage Center, it was placed not far from a Santa Fe depot and locomotive. He might have been pleased to know that.

Kitchen stove and oven

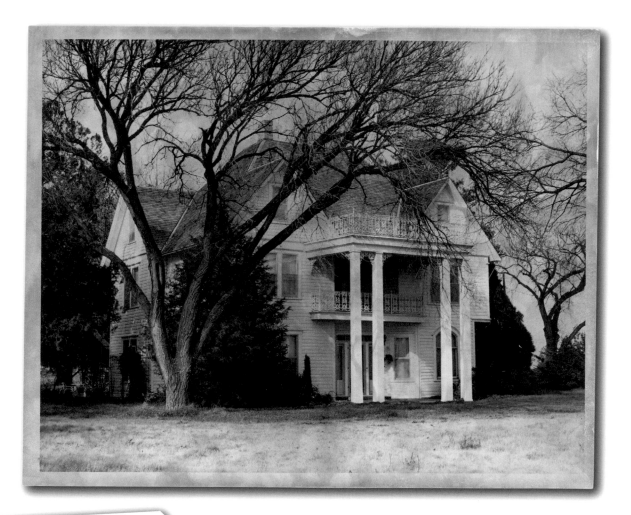

FOR THE RECORD

The Barton family, like other early settlers on the Southern Plains, faced droughts, wind storms, prairie fires and pestilence. Family members recalled hearing of locusts that "marched like armies devouring every edible thing in their pathway including saddle and harness." One particular prairie fire was doused by rain that started just before the blaze threatened the family home.

original location

BARTON HOUSE

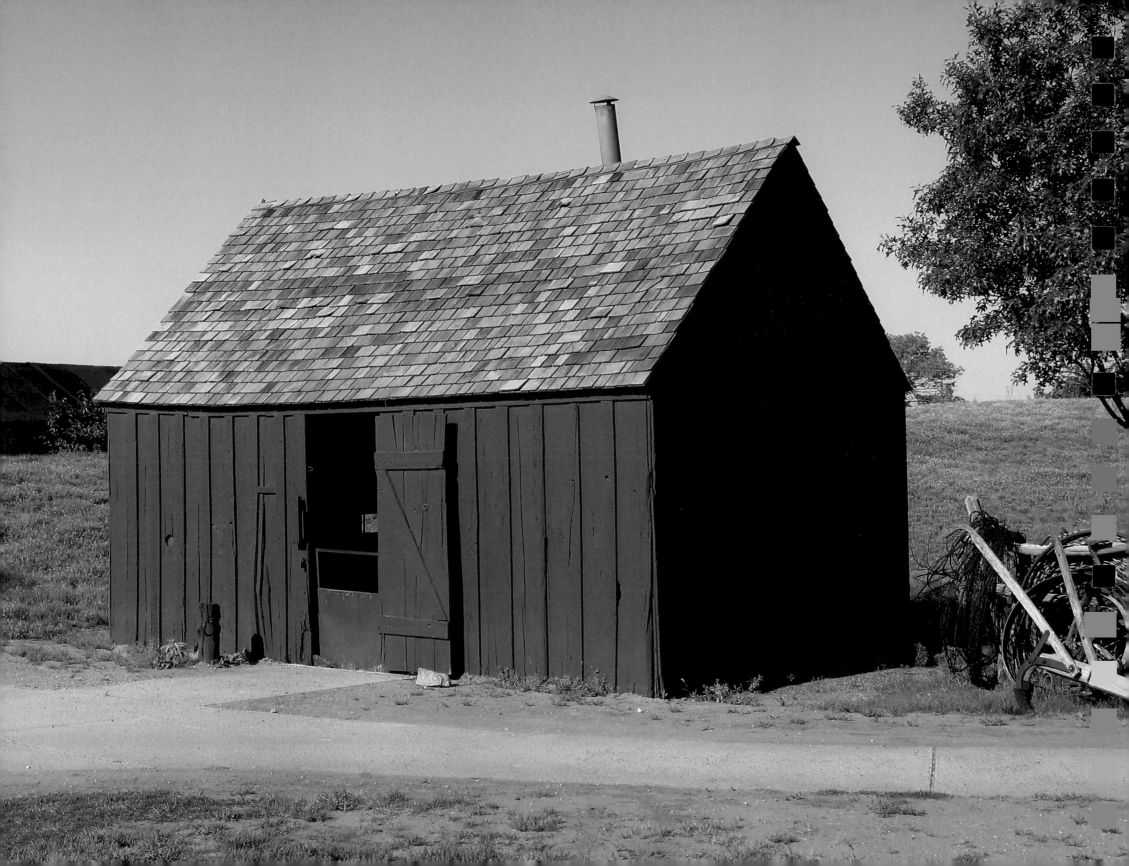

CHAPTER NINTEEN
RENDERBROOK-SPADE BLACKSMITH SHOP
1917

The most distinct sound on a ranch was the ring of a blacksmith's hammer hitting iron. The smell of coal or burning mesquite wood filled the air as bar iron glowed red in the hot fire. In short order, the skilled blacksmith repaired the ranch windmill and created a new rim for a wagon wheel, a pair of shoes for the mule team, and a branding iron for the ranch hands. On a large spread, among the first structures built was the blacksmith's shop. And one of the most valuable ranch hands was the smith.

The blacksmith shop was necessary in towns and on large ranches when barbed wire and windmills hastened the settling of the frontier. The smith could repair or fashion from iron almost anything the ranch needed. Those who were artistic also created spurs. A good smith could count on years of job security, whether as an employee of a large ranch or as a town blacksmith.

As with any profession, blacksmithing had right and wrong ways of doing the job. For example, before a cowboy used a new iron, he heated it in the blacksmith's fire then burned the brand into the wall to test it. The best brands were large enough to be seen easily from a distance, but not so large that they covered much of the cow's valuable hide.

It is appropriate that a blacksmith's shop was the first structure erected in the National Ranching Heritage Center's historical park. It is significant, too, that the Renderbrook-Spade Blacksmith Shop came from the ranch once owned by a manufacturer of barbed wire.

The Renderbrook-Spade Blacksmith Shop came from the ranch once owned by a manufacturer of barbed wire.

Isaac L. Ellwood was one of the first successful developers of barbed wire. In 1889, he and his son, W.L., came to Texas on a visit. Near Colorado City, they saw the 130,000-acre Renderbrook Ranch, named for the cavalry captain who had been killed at the site of a spring once frequented by buffalo hunters and Indian fighters. The Ellwoods bought the property.

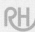

ORIGINAL OWNER
I.L. Ellwood

LOCATION
Near Colorado City, Texas, and Renderbrook Spring in southern Mitchell County on the Renderbrook-Spade Ranch

SIGNIFICANCE
Representative of blacksmith shops built on large ranches

DONORS
Mr. and Mrs. Frank H. Chappell and Mr. and Mrs. B.D. Bassham

DEDICATED
Feb. 22, 1972

Forge Hammer

Most of the Spade blacksmith's tools were included with the structure when it was given to the NRHC for preservation.

Anvil

RENDERBROOK-SPADE BLACKSMITH SHOP
up close

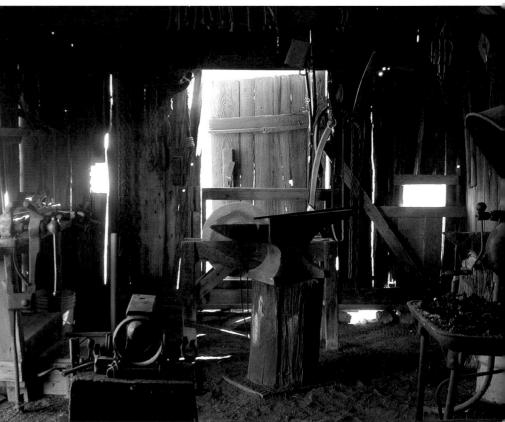

Inside the blacksmith's shop

Isaac returned to his barbed wire business, but W.L. stayed in Texas, where the ranch provided him with a place to keep and admire his horses—Percherons, Clydesdales and the Texas cowponies he came to love. Former Texas Ranger D.N. "Uncle Dick" Arnett was hired to manage the Renderbrook in 1891 when the Ellwoods purchased 128,000 acres in Hale, Hockley and Lamb counties. W.L. bought a small herd of cattle carrying a spade-shaped brand, recognizing their owner, J.F. "Spade" Evans. The brand was purchased with the cattle and registered by the Ellwoods.

Within a few years, the Spade Ranch was broken into farms, which was Isaac Ellwood's plan from the beginning. His company loaned money to the farmers to make improvements, erect windmills and help them through the rough years of depression and drought.

On Jan. 24, 1970, NRHC Director Jerry Rogers assessed the shop and wrote in his fieldnotes: "The building is in good condition and will be easily moved. It is on a fieldstone foundation, and there appears to be little or no rotting around the bottom. It contains a forge, anvil, hammer, drill press, large grindstone, small grindstone, tongs and possibly other equipment that would be usable. There is little evidence of architectural change. Shorty Northcutt, manager of the ranch, said it was spray-painted about two or three years ago, and at that time it looked like it had never been painted before. Electricity has been added, and several small holes have been sawed in the walls."

When brought to the NRHC, the simple board and batten structure with a pitched roof was placed on the same bed of stones it had sat on when originally built. With the structure's donation came the Spade's anvil, forge and other blacksmith equipment.

The Renderbrook-Spade Blacksmith Shop is representative of late 19th-century facilities where a man worked as a farrier, a mechanic, a repairman and an artist, creating iron implements needed to survive on a large, remote ranch anywhere in the West.

The best brands were large enough to be seen easily from a distance, but not so large that they covered much of the cow's valuable hide.

Otto Jones (left), longtime manager of the Renderbrook-Spade Ranch in Mitchell County, and Charles G. Scruggs, editor of *Progressive Farmer* and member of Texas Tech University's Board of Regents, visit at the Renderbrook-Spade Blacksmith Shop during its 1972 dedication at the NRHC.

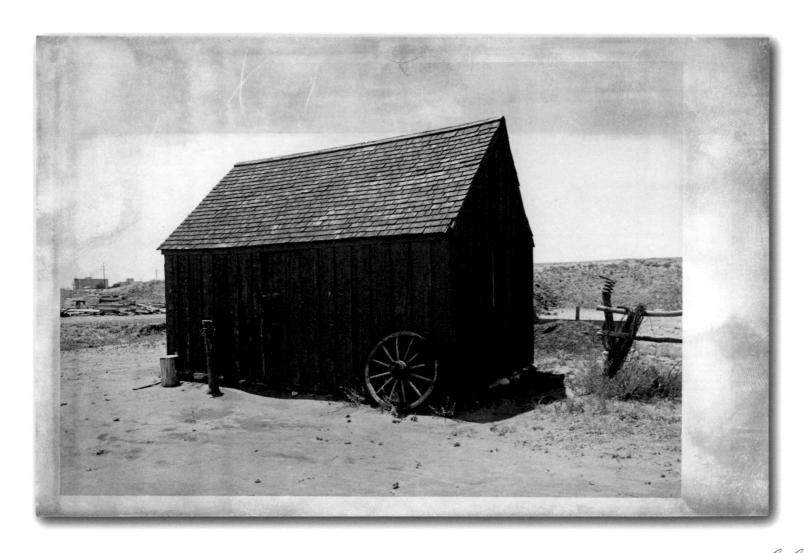

FOR THE RECORD

The milk and meat house from the JA Ranch, made famous by pioneer cattleman and trailblazer Charles Goodnight, arrived at the National Ranching Heritage Center before any other structure. But, since it required disassembly to be moved from its location in Clarendon, Texas, the building was a pile of logs, stones and materials, while the Renderbrook-Spade Blacksmith Shop came to the historical park intact. The shop was quickly restored, gaining it the inaccurate distinction of being the first structure moved to the historical park. More accurately, it was the first one completely restored in the historical park.

original location

RENDERBROOK-SPADE BLACKSMITH SHOP

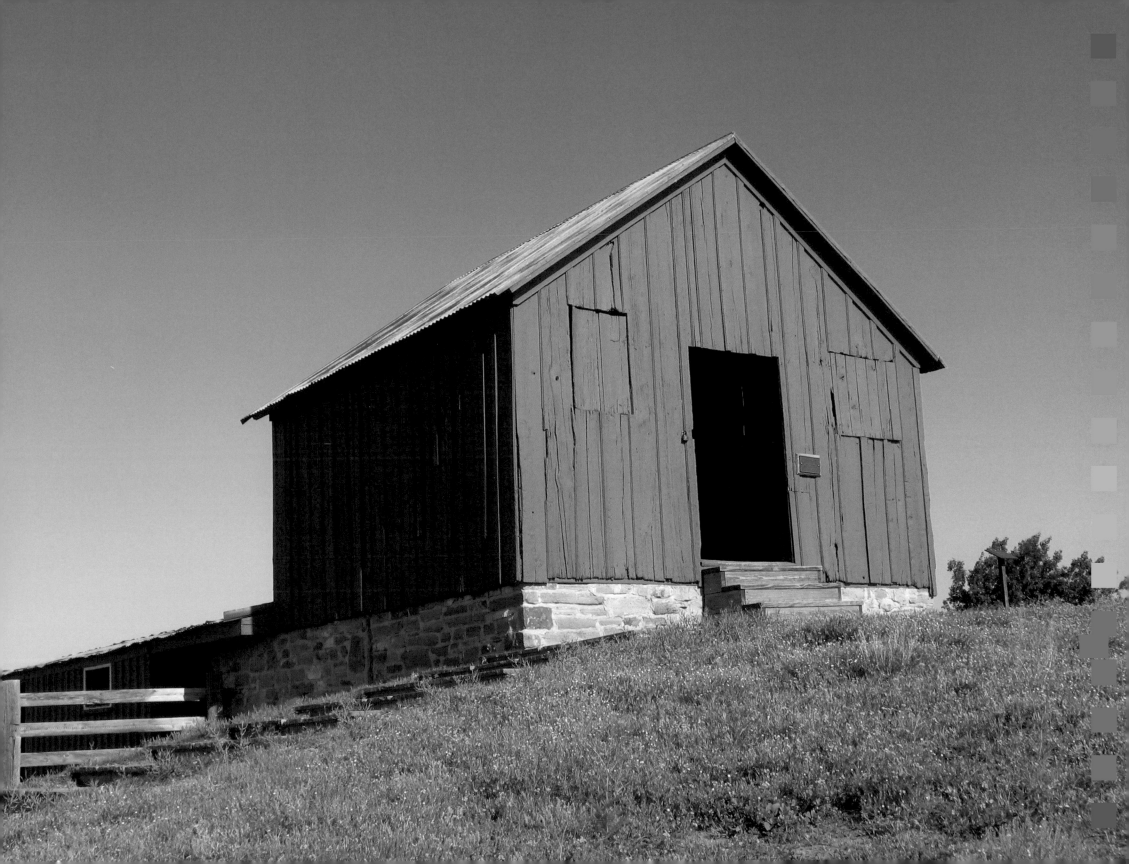

CHAPTER TWENTY

SPUR GRANARY AND STABLE

c. 1900

The Spur Granary was designed to make an easier job each day of feeding the ranch's horses. At the time of its donation to the National Ranching Heritage Center in 1969, the structure was still operative, but it was presented for preservation and interpretation because of its historical value. The granary represents human ingenuity and innovation, byproducts of this well-known ranch.

The Spur started as a road brand used on J.M. Hall's herd in 1879, moving out of the Dry Cimarron in New Mexico to the head of the Middle Pease River in Texas. One of Hall's hands, J.R. Beasley, had previously established for him there what neither realized at the time would be the first headquarters of the Spur Ranch. In 1882, Hall sold all of his cattle and the brand to the Stephens and Harris outfit. Less than a year later, the two sold their entire holdings to the Espuela Cattle Co. (*espuela* is Spanish for spur.) The corporation's president was A.M. Britton of Denver, Colo., and the secretary was S.W. Lomax of Missouri.

While Lomax stayed in Texas with the ranch, Britton traveled to England in search of a buyer for the Spur. He found several men interested in the Texas property. The Englishmen organized the Espuela Land and Cattle Co., Ltd, of London and purchased the Spur Ranch from Britton, Lomax and their partners on April 9, 1885.

In 1886, the Spur kept 800 horses for its ranch work. That number decreased as fences reduced pasture sizes and railroads shortened the distance cattle were driven to market. By 1898, the ranch's work required only 300 horses. The Spur purchased all of its horses from outfits in Texas and Wyoming.

> In 1886, the Spur kept 800 horses for its ranch work. That number decreased as fences reduced pasture sizes.

The English owners brought in an experienced Michigan farmer to start an experimental farming project. The initial tract was 30 acres, probably the first farm in that part of Texas, according to historian William Curry Holden. By 1888, fields were planted in Johnson grass, milo, maize and grain sorghum. The excellent crops led the way for agricultural development of the land. In 1890, manager of the Espuela, Fred Horsbrugh, bought a cotton gin and a French Burr grist mill in

ORIGINAL OWNER
Spur Ranch

LOCATION
Spur Ranch,
Dickens County, Texas

SIGNIFICANCE
Demonstrates the ingenuity of a rancher in capitalizing on the terrain

DONORS
Mr. and Mrs. O.J. Barron Jr. and Mr. A.C. Swenson

DEDICATED
April 10, 1976

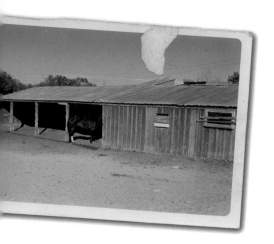

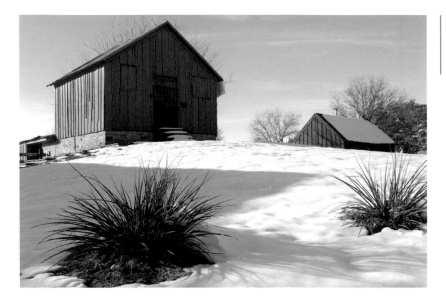

The granary's location on a rise utilized gravity to make daily feeding of the horses easier.

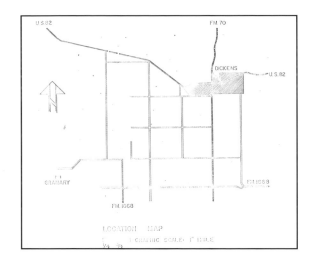

Stables were made slightly smaller in the restoration process.

UPPER LEVEL

GROUND LEVEL

CRAWL SPACE

SPUR GRANARY AND STABLE

up close

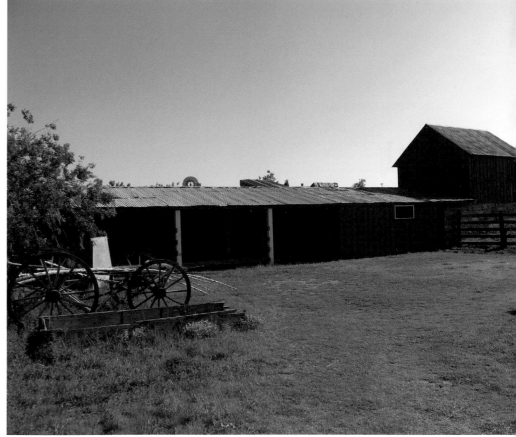

Fort Worth and brought these first pieces of farm machinery into West Texas.

By 1907, the English company sold the Espuela Land and Cattle Co. to E.P. Swenson and his associates. As large ranch owners, the Swensons purchased the land for development. The cattle were sold and the land leased for two years. The owners founded Spur and Jayton and began attracting people to the new West Texas towns.

In 1913, Clifford B. Jones became the Spur's manager, leading ranch operations for 20 years. He was chosen to be the second president of Texas Tech University in 1938, making Jones the last manager of the Spur Ranch. In 1941 the Swenson associates divided their remaining holdings. The daughter of A.C. Swenson and her husband, O.J. Barron, later donated to the National Ranching Heritage Center the granary and funds for stables to be reconstructed.

The unique structure was restored as it had been built—on a hill several feet above its stalls and corrals. The grinding room was on the top level so grain could be poured through holes in the floor into storage bins below or into wooden chutes that led from the floor of the granary to a grain box at the level of the stalls. Trap doors in the roof allowed hay to be dropped into the mangers. With this arrangement, the person responsible for feeding the horses had grain or cracked corn or hay delivered to him by gravity force. The granary and feed box are original; stables are a replication, somewhat reduced in size.

The hill on the granary's north side protected the stables and their horses from cold winter winds. Workmen at the NRHC duplicated the rise by constructing a retaining wall of concrete and lining it with stone brought from a quarry near the Spur Ranch. Earth was packed against the wall until the slope was correct.

Mrs. Coy Dopson, daughter of W.A. Johnson, said her father built the granary in 1895. Another source sites the granary's installation in 1900. Records also show that Henry Johnstone, a manager of the Spur Ranch, oversaw the granary's construction in late 1905. The only record of the granary appears in the Spur's general ledger under "Improvements." Apparently, the "grain house and stables," as they were called, were built in stages, making it difficult to pinpoint an actual date of construction.

In 1913, Clifford B. Jones became the Spur's manager, leading ranch operations for 20 years. He was chosen to be the second president of Texas Tech University in 1938.

Corn sheller

FOR THE RECORD

The Spur's name was given to a prehistoric reptile, and the ranch was the setting for a novel, perhaps an unlikely combination for bragging rights. The reptile was Desmatosuchus Spurensis, its fossilized remains found in 1920 on Spur land by a University of Michigan paleontologist. Bones of prehistoric elephants also were found. The novel was Zane Grey's story of the extermination of the buffalo, *The Thundering Herd*.

original location

SPUR GRANARY AND STABLE

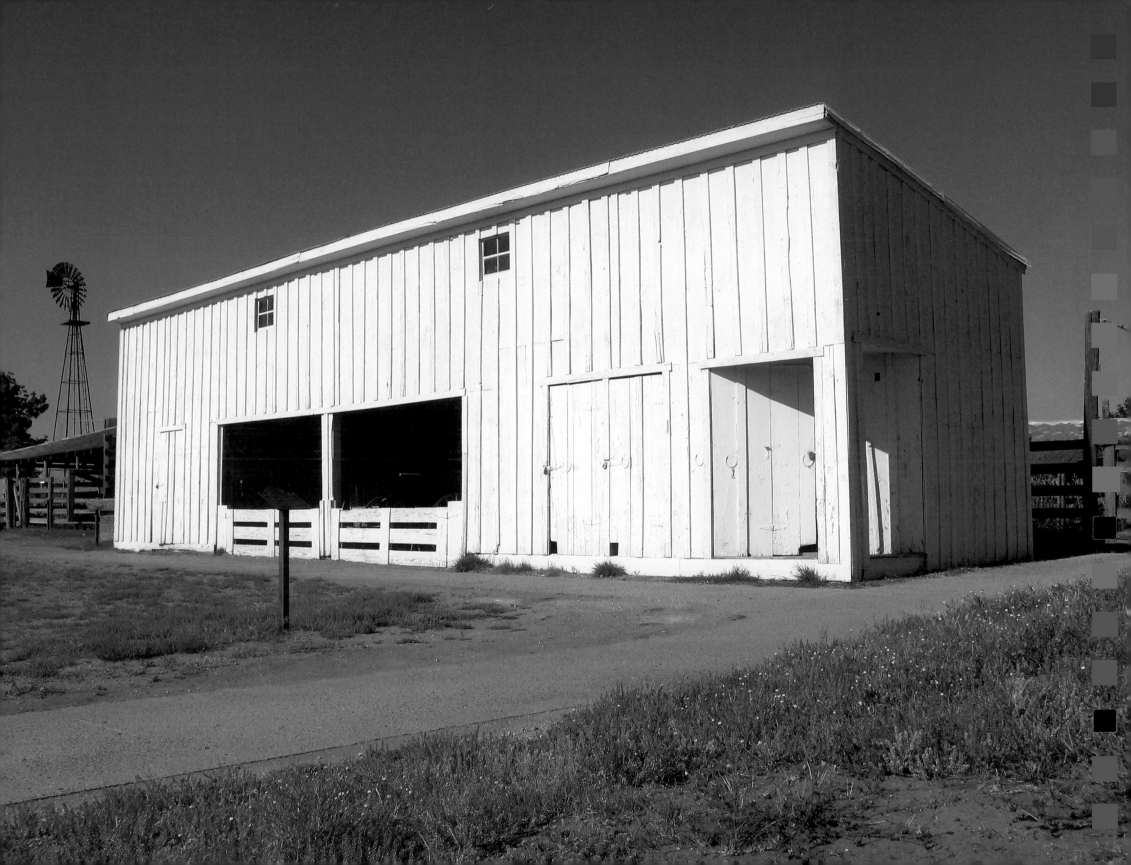

CHAPTER TWENTY-ONE

U LAZY S CARRIAGE HOUSE
1906

Not every rancher had a carriage house, and certainly not those just starting out. The building housed fine buggies and surreys pulled by excellent horses. The carriage house was a possession aspired to by many young men. It came with prosperity and usually a wife and children, as most dignified ladies did not ride long distances horseback. The carriage house was an accouterment of John B. Slaughter's fine ranch headquarters in Post, Texas, made possible from years of hard work and smart business transactions.

John B. was born in 1848, the fourth of six sons of George Webb and Sarah Mason Slaughter. He was likely named for John Bunyan, author of *Pilgrim's Progress*. John B. Slaughter and his brothers were cowboys and drovers. Eventually two of the boys— John B. and C.C.—became Texas cattle barons.

John made his first cattle drive at age 17, earning $15 a month. Many other cattle drives followed as he learned to deal with electrical storms, stampedes, loss of entire horse herds to Indians, and the deaths of cowhands, friends and family, including his first wife, May Burris. John remarried in 1880 to Isabella (Belle) Masten May of Dallas, a former Palo Pinto County school teacher.

Slaughter's business acumen eventually resulted in a bank presidency position and success as a large landowner. In 1898, he built a beautiful, four-story home for his family in Fort Worth, where they entered into the city's societal activities.

> In 1898, he built a beautiful, four-story home for his family in Fort Worth, where they entered into the city's societal activities.

In 1901, Slaughter purchased the Square and Compass Ranch from the Nave-McCord Cattle Co. in Garza and Lynn counties. He returned so often to West Texas, where he had established his U Lazy S operations, that Belle sold the Fort Worth home and moved to the ranch. Slaughter named the outfit for the brand he used on cattle given to him during the Civil War by his father. John B. weathered numerous adversities, including prolonged droughts and severe blizzards that killed thousands of his cattle.

ORIGINAL OWNER
John Bunyan Slaughter

LOCATION
11 miles south of Post, Texas, in Garza County

SIGNIFICANCE
Represents a rancher's prosperity and elegance in frontier society

DONORS
John F. and Ryla Lott and Mary Belle Lott Macy

DEDICATED
Oct. 9, 1971

Block and tackle

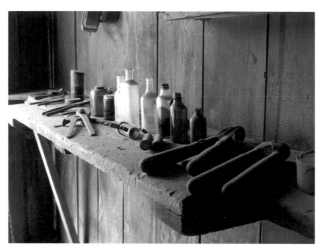

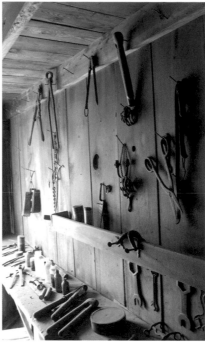

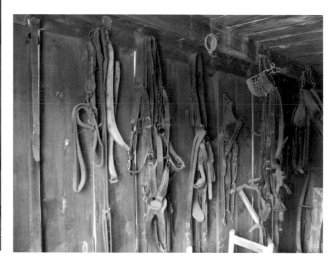

Tack room with tools

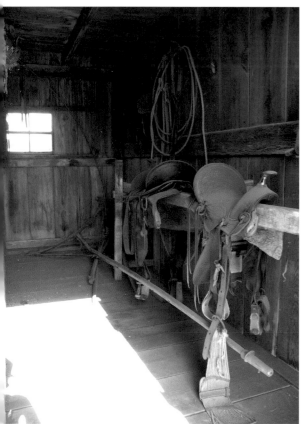

Hay hook

The second floor, or loft, was used for storage. Inscriptions still visible on the walls tell of life on the ranch—
"Boy was it wet in February 1938."

U LAZY S CARRIAGE HOUSE

up close

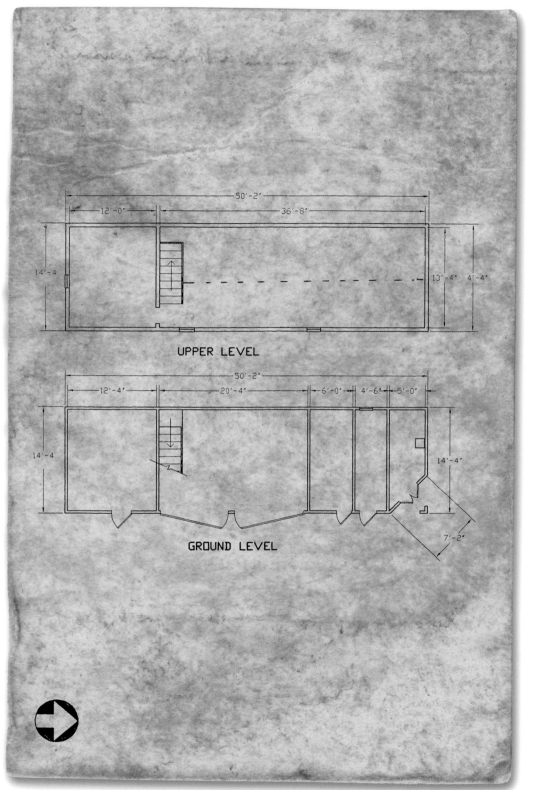

UPPER LEVEL

GROUND LEVEL

Rectangular holes cut at intervals in the base of the building provided entry and exit for ranch cats kept around for rodent patrol.

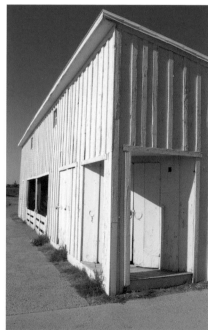

The door to the corner room opened to John B. Slaughter's private saddle room, where, it was learned many years later, more than saddles were stored.

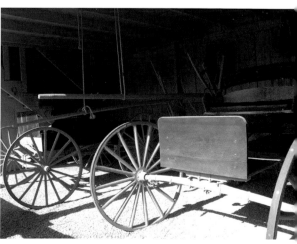

The U Lazy S Ranch included a large home, a carriage and harness/saddle house, fences, corrals, water storage tanks, drilling wells, barn, dipping vats and windmills. The headquarters was south of what is now Post, Texas, in the breaks below the Caprock. In 1906, Slaughter sold some 48,000 acres of his property to C.W. Post, cereal magnate and town developer. When Post came to visit Slaughter and proposed the land deal, he watched a horseman in the distance. He asked Mrs. Slaughter the name of the "little Mexican working those cattle," calling him "the best cowboy I ever saw." She answered, "That is Mr. Slaughter."

After years in the sun, the small-statured John B. was burned brown, and when away from home for long periods, his black hair grew to his shoulders. He was an expert horseman and a successful cattle breeder (even crossing a Brahman heifer with a buffalo bull). Moreso, he was well liked and a modest man, unaffected by the immense wealth he had accumulated.

The well-known rancher died on Nov. 11, 1928, after spending the entire day riding in a roundup. That night he talked of having what he thought was indigestion and died the following morning of heart failure. The funeral was held in the big ranch home. The service was described as overflowing to the yard with people who came to pay their respects. That evening, it was said the long procession of cars with lights burning wound their way single-file across the breaks and up onto the Caprock, "wending their way behind a man who was on his last ride over his beloved ranch."

The house was destroyed by fire in 1937, but the U Lazy S Ranch passed to heirs, who continue its operation. The two-story carriage house was donated in Slaughter's memory by his grandchildren, John F. Lott Sr. (and his wife) and Mary Belle Lott Macy. The building was moved in one piece with very little repair work needed. The board and batten structure featured a shed roof over a loft with an open center portion where buggies and surreys were kept. Storage space was provided for livestock feed and tack, and the building held the private saddle room of John B. Slaughter.

A story is told of a foul smell one always noted when entering Slaughter's saddle room. It emanated from a "dope kit," in which he kept a mixture of pine tar and bone oil for treating open sores on animals to keep them from attracting screwworms, which often caused the animal's death.

The second floor, or loft, was used for storage. Inscriptions still visible on the walls tell of life on the ranch, such as: "Boy was it wet in February 1938," "92 head of saddle horses," the number of cedar posts on hand, and a formula for whitewash. Feed attracted mice and rats, so rectangular cuts were made in the base of the carriage house to allow entry and exit for ranch cats on rodent patrol.

That evening, it was said the long procession of cars with lights burning wound their way single-file across the breaks and up onto the Caprock, "wending their way behind a man who was on his last ride over his beloved ranch."

Horse bit

FOR THE RECORD

When the U Lazy S Carriage House was moved to the National Ranching Heritage Center, the lock on the private saddle room of John B. Slaughter had to be broken off. When the NRHC worker entered, he tripped on a loose floorboard. Lifting it, he found three very old and empty whiskey bottles. Mrs. Slaughter was likely a prohibitionist, and, according to descendants, the old rancher probably just wanted a nip once in a while after a day's work.

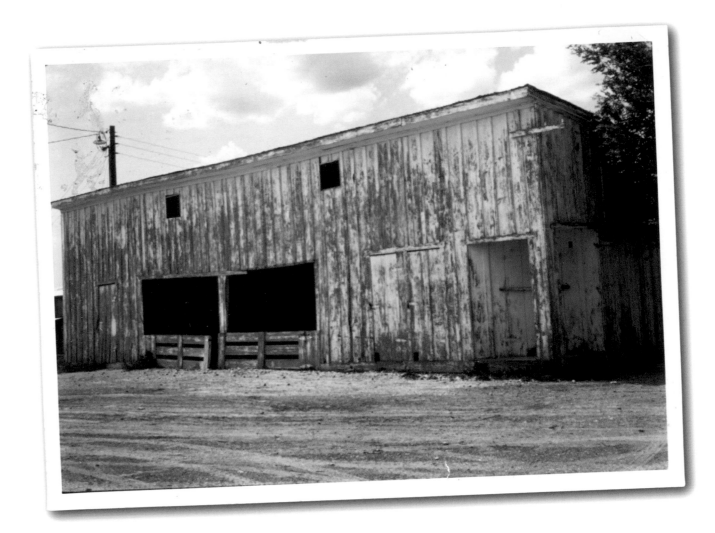

original location

U LAZY S CARRIAGE HOUSE

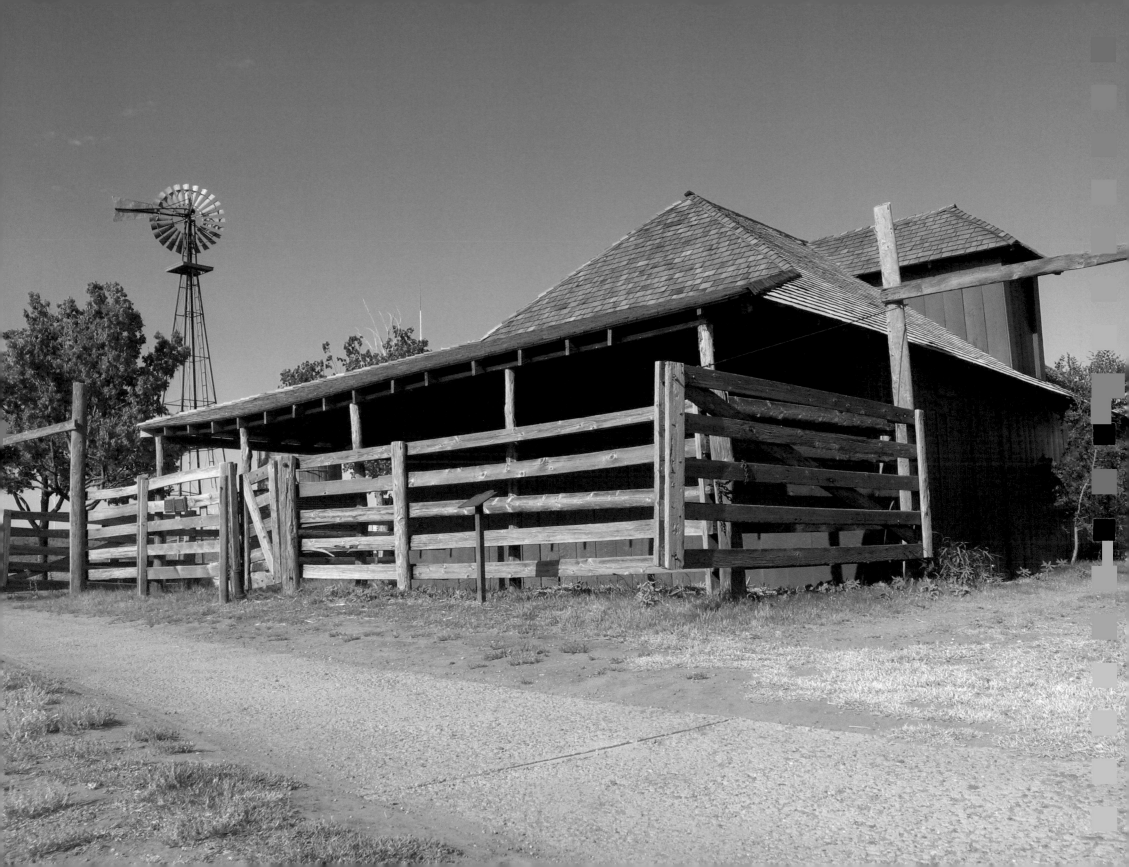

CHAPTER TWENTY-TWO

REYNOLDS-GENTRY BARN

1877

The cattle business could be a good life for those who worked hard and were lucky. Money made from cattle drives often built homes and barns on ranches throughout the West. One such sizeable structure became the stable for Thoroughbred race horses and game cocks, not the kind of livestock found on a typical ranch.

After the Civil War, like many men trying to make a living in the West, George T. Reynolds trailed his herds to northern and western markets. It was on a drive to California in 1868 that he met Mart B. Gentry in Salt Lake City. Gentry was driving racehorses to Texas. The two men hit it off, and Reynolds hired Gentry to work on his ranch. In just a few years, Gentry became foreman of the Reynolds Cattle Co., a vast empire of several ranches. The meeting marked the beginning of a Reynolds, Matthews, Gentry relationship linked for generations in both business and friendship.

In 1877, Reynolds and his wife, Bettie Matthews, built a two-story stone house and barn of long-leaf Texas pine on their Throckmorton County ranch. The lumber was hauled by wagon from the Texas and Pacific Railroad line at Eagle Ford, west of Dallas.

Gentry, wanting his own herd and ranch, in 1884 purchased the Reynolds' beautiful stone house and pine barn. He converted the 35-by-50-foot barn and 12-foot L-shaped shed into a stable for Thoroughbred racehorses he kept for show and breeding purposes.

The barn had six stalls with a window in each one. Entrance into the barn was through the tack room. On the walls were large knobs from which saddles hung by ropes. Bridles and lariats were kept overhead. A stairway connected the tack room to the hayloft. Gentry kept a box of "doctoring medicine" under the stairs and a horse saddled in case of emergency.

In the loft, prairie hay was stored and tossed from the north window to feed horses in the nearby pasture. Under the loft was a carriage room for a Spaulding hack and a buggy, accessed through double Dutch doors. The hack was used as a funeral hearse when needed.

> A stairway connected the tack room to the hayloft. Gentry kept a box of "doctoring medicine" under the stairs and a horse saddled in case of emergency.

ORIGINAL OWNER
George T. and
Bettie Matthews Reynolds

LOCATION
Near the great bend of the Clear Fork of the Brazos River, a few miles northwest of old Camp Cooper in Throckmorton County, Texas

SIGNIFICANCE
Example of a barn used to shelter Thoroughbred horses, not the usual livestock barn

DONOR
Mart B. Gentry Estate

DEDICATED
Oct. 2, 1976

Narrow stairway leads
to the hay loft.

Curry Comb

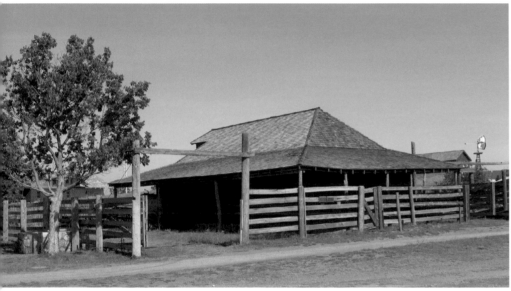

The late Watt Matthews, a nephew of the original
owners, furnished ranch hands and trucks from the
Lambshead Ranch to help disassemble then move the
barn to the NRHC. The Reynolds-Gentry Barn was
delivered on Feb. 13, 1976.

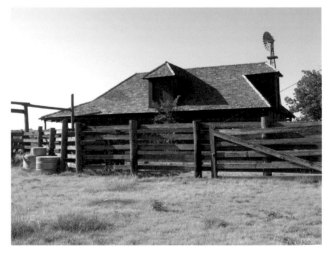

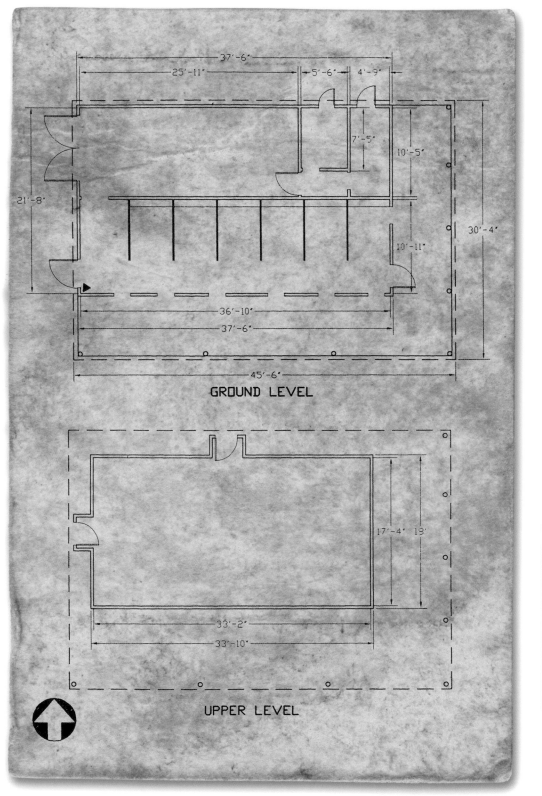

37'-6"

25'-11" 5'-6" 4'-9"

7'-5"

10'-5"

21'-8"

30'-4"

10'-11"

36'-10"

37'-6"

45'-6"

GROUND LEVEL

17'-4" 13'

33'-2"

33'-10"

UPPER LEVEL

REYNOLDS-GENTRY BARN

up close

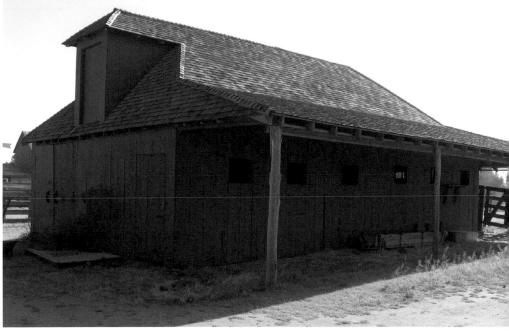

Next to the carriage room were two granaries divided by a partition. Each room had a trap door and a chute to dispense corn and feed to the stall. In nearby sheds, Gentry kept sheep, hogs, milk cows and game cocks. A roost in a corner protected Gentry's exotic birds, which were not fought. Like the race horses, they were kept and admired.

When the roof had to be replaced in 1910, the intricate hipped dormer windows were replaced with a plain A-frame roof. It sagged and fell apart, so when the barn was moved to the National Ranching Heritage Center, the old roof line was returned.

The original color of the barn was confirmed as dark red from paint remaining on some of the timbers. A few pecan posts had deteriorated, so Watt Matthews, a nephew of the original owners, authorized the moving crew to cut and trim pecan logs as authentic replacements from the barn's origins along the Brazos in what was called locally "Reynolds Bend."

Ethel Matthews Casey provided her recollections in 1976 during the barn's dedication. She described Mart Gentry as "loved by every cowboy, cook and helper; boss of all he surveyed." Of the barn, she recalled that it had sheltered Longhorn cattle and Spanish ponies and later Thoroughbred horses and game chickens. "This old barn rang with the laughter of children playing hide and seek and other games."

J.A. Matthews and the Reynolds brothers, W.D. and George T., operated ranching interests near Albany for five years before separating to form two cattle companies. The Reynolds Cattle Co. eventually had most of its holdings in the Big Bend country of Texas. Matthews established what is now the Lambshead Ranch near Albany. Mart B. Gentry, who established his own Gentry Ranch, was associated for 54 years with the Reynolds Cattle Co. He was described by Sallie Reynolds Matthews as "one of nature's noblemen."

A few pecan posts had deteriorated, so Watt Matthews, a nephew of the original owners, authorized the moving crew to cut and trim pecan logs as authentic replacements from the barn's origins along the Brazos in what was called locally "Reynolds Bend."

Joe B. Matthews, a native of Albany, Texas, was memorialized by his wife with a rock-wrapped water tank from which animals on a ranch would drink. It was placed south of the Reynolds-Gentry Barn. The tank was constructed and hackberry trees were planted nearby in Matthews' name. The water tank was dedicated on Aug. 4, 1979.

Beside the Reynolds-Gentry Barn is a salt trough from Hank Smith's Cross B Ranch in Blanco Canyon on the Mackenzie Trail. His was the first ranch on the South Plains of Texas. In 1877-78, Smith built a stone house on the ranch, which was 10 miles north of the present town of Crosbyton. The salt trough originally came from Fort Griffin, Texas, where Smith and his wife, Elizabeth, had previously resided. The trough could have held feed in addition to being a salt or mineral block trough for livestock. The artifact was donated to the NRHC by Smith's granddaughter, Georgia Mae Smith Ericson.

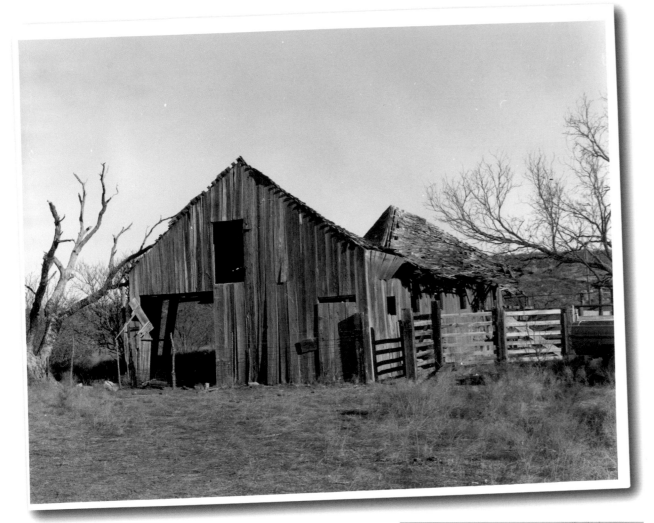

FOR THE RECORD

In 1867, George T. Reynolds was in a group of men pursuing a band of Indians. In the process, he was wounded above the navel by an Indian's arrow. When the shaft was pulled out, the arrowhead remained. On July 15, 1867, after only a few months of convalescing from the wound, Reynolds married his sweetheart, Bettie Matthews. Through the years, the Matthews and the Reynolds families had been good friends, but the marriage of George and Bettie and subsequent marriages of family members made the bonds between the two families even closer. Fifteen years later, the two-inch arrowhead was removed from Reynolds in an operation performed by Kansas City doctors.

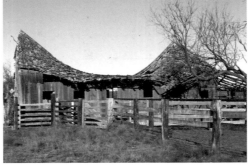

original location

REYNOLDS-GENTRY BARN

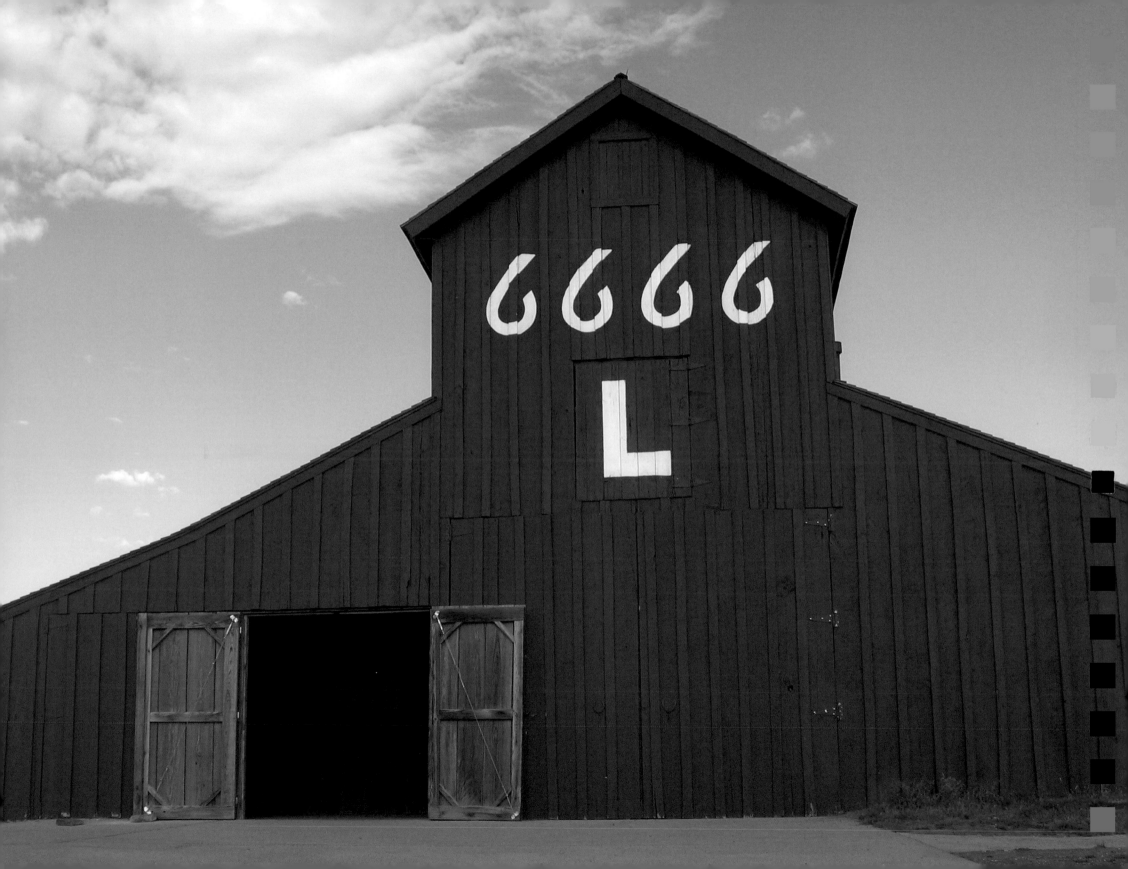

CHAPTER TWENTY-THREE
6666 BARN
1908

If walls could speak, what might this old barn tell? It was built by one of the most influential and prosperous ranchers in Texas and eventually housed expensive horses with fine bloodlines, animals admired by some of the wealthiest men and women in the West. A landmark in Guthrie, Texas, the 6666 (pronounced "Four Sixes") Barn stood for many years near the imposing home Samuel Burk Burnett built in 1917 to be "the finest ranch house in West Texas" and the headquarters of his ranching empire.

The Four Sixes Ranch continues as a forerunner in the cattle industry, and the quality of its American Quarter Horses is known far and wide. Burnett properties include the Four Sixes Ranch in Montana and two ranches in Texas: Dixon Creek and the Four Sixes in Guthrie.

The history of the Four Sixes began with Burnett, who before the age of 20 purchased a herd of cattle wearing the 6666 brand. Burnett recorded the brand in 1875 in Wichita County, Texas, on the Kiowa-Comanche Reservation in 1881 and later in other counties.

The origin of the 6666 brand is unknown, as is the reason it was used by Frank Crowley, from whom Burnett bought the brand and the herd wearing it in Denton County, Texas. But it had nothing to do with a card game and a winning hand of sixes, as legend suggests.

ORIGINAL OWNER
Samuel Burk Burnett

LOCATION
Near Highway 82 in Guthrie, Texas, on the Four Sixes Ranch in King County

SIGNIFICANCE
Represents a historic ranch structure, but modified for modern-day use

DONOR
Anne W. Marion

RESTORED
1981

A single L appears on the east gable of the barn. The L was used by Burk Burnett's father-in-law, M.B. Loyd, a prominent Fort Worth banker, as his horse brand. Burnett acquired it from Loyd to mark the famous Burnett Quarter Horses, which once were stabled in the red barn.

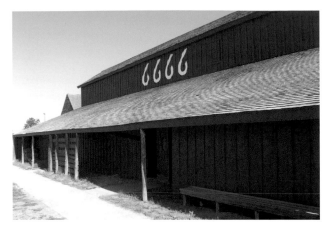

Although much of the barn was restored with new materials, some sections still reflect original elements of the old barn, including the east façade and the southeast fence area.

M. B. Loyd

Burk Burnett

Original wood shows "cribbing" by the 6666 horses.

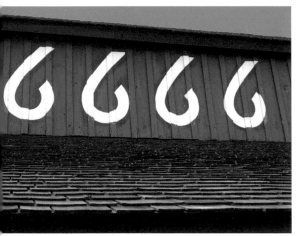

Tom Burnett

Anne Tandy

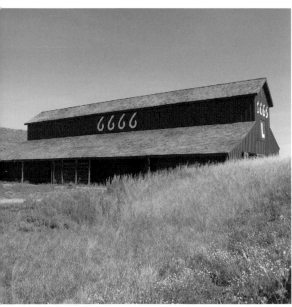

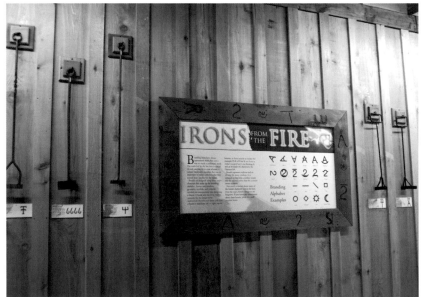

Anne W. Marion

With the cedar wall planks, space was created for the NRHC's "Irons From the Fire" collection of branding irons and their stories.

6 6 6 6
BARN
up close

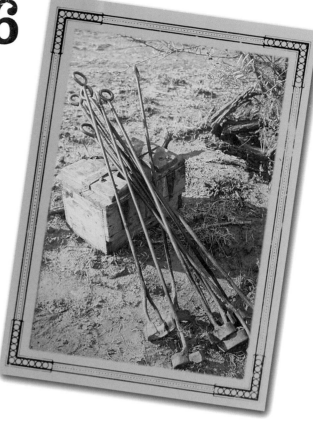

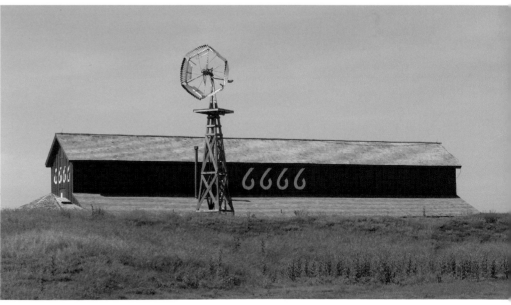

The 6666 is prominently displayed on the 3,512-square foot barn, now a focal point at the National Ranching Heritage Center. A single L appears on the east gable of the barn. The L was used as a horse brand by Burk Burnett's father-in-law, M.B. Loyd, a prominent Fort Worth banker. Burnett acquired it from Loyd to mark the famous Burnett Quarter Horses, which once were stabled in the red barn.

(From left) Andy Wilkinson and Andy Hedges, Red Steagall and Tommy Allsup entertain on the Four Sixes Barn stage.

Brought to the NRHC for reconstruction in 1981, the barn appears much as it did when in use at the Four Sixes headquarters. The interior was changed extensively, however, at the request of Anne W. Marion, who gave the barn as a memorial to her great-grandfather, Burk Burnett; her grandfather, Tom Burnett; and her mother, Anne Burnett Tandy. She accompanied the gift with funds to restore the barn for use during special events and education programs.

Additional improvements to the barn were made possible in 2010 through the support of Mrs. Marion. They include adding insulation throughout the barn and loft, covering the walls with cedar planking, installing large barn lights along with track lighting in the main room and stage area, plus fans and heating units. A pass-through or serving window was cut in a kitchen wall for the convenience of volunteers and caterers. The kitchen was painted and fixtures were replaced. Restrooms were made ADA-compliant.

In the stage area, a sound system was installed and a podium provided. Padded chairs and tables were purchased for use in the main room for banquets and programs. The loft is now insulated, and it is a clean, organized storage space. A former tack room downstairs was fitted with shelving for special event materials. Rollers were attached to the barn doors so

The interior of the barn was to facilitate special events and programs, so a stage area was built in the 120-seat capacity facility.

they would swing open more smoothly, and weather stripping was added to help eliminate the dust blowing under the doors. Concrete sidewalks and ramps were then constructed at each door.

More than a century ago, Burnett began to assemble a ranching empire. As with most significant undertakings, challenges had to be met, problems solved and prices paid. Many factors contributed to the Four Sixes' success story, but perhaps the one element that the ranch has been most dependent on is the Burnett family characteristic of determination.

The Four Sixes Ranch represents both the present and the past, largely due to the foresight of Burk Burnett and the management and support of his descendants, who value their heritage and the prominent ranch's place in the history of Texas and the American West.

FOR THE RECORD

One of Burk Burnett's close friends was Comanche Chief Quanah Parker, son of the white captive woman Cynthia Ann Parker and her war chief husband, Peta Nocona. When severe droughts withered grazing lands in Texas, Quanah allowed Burnett and other ranchers to lease Indian lands in Oklahoma. Burnett included Quanah in the famous wolf hunt with his friends, among them President Theodore Roosevelt. The rancher learned Comanche ways and passed a love of the land and his friendship with the Indians to his own family. Of Quanah's white acquaintances, he counted Burnett as his favorite. He is quoted as having said: "I got one good friend, Burk Burnett, he big-hearted, rich cowman. Help my people good deal. You see big man hold tight to money, afraid to die. Burnett helped anybody." The historically important Burk Burnett Collection of Quanah Parker items, given to the rancher by Quanah and members of his family, was donated to the NRHC by Burnett's granddaughter and great-granddaughter.

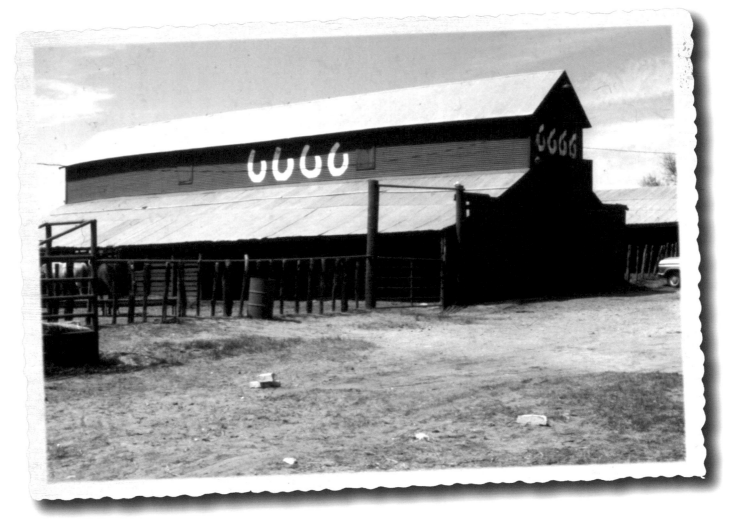

original location

6 6 6 6 BARN

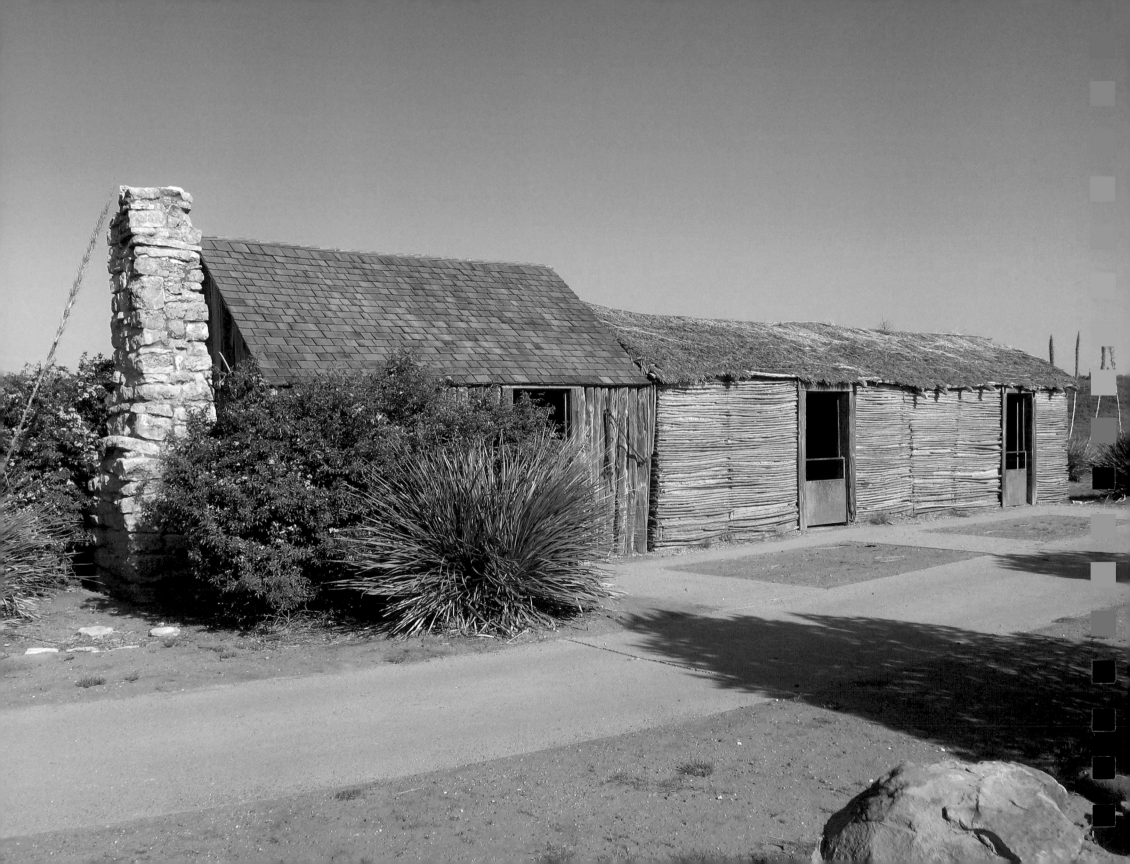

CHAPTER TWENTY-FOUR

PICKET AND SOTOL HOUSE

1904, 1905

A rancher built for the long run, but the pioneer "made do." The settler heading for a new life in the West used materials at hand to construct a shelter for himself and his family. Where he could find trees, he built a log cabin. In hill country, he used river rock and stones. On the plains, he shoveled a hole in the ground for a dugout.

Far West Texas was a country between trees and hills and plains, with no rocks or trees and the soil was sandy. Here were crumbly caliche, small brush and desert plants. But the land was available to homesteaders if they could handle the life it required of them.

Crockett County was named for frontiersman Davy Crockett. It was an area where Uncle Sam experimented with the Camel Corps for desert military transportation. Soldiers at Fort Lancaster fought Indians, and people who passed through the unfenced country included immigrants, gold seekers and cattle drivers, all heading to California for the prosperity it promised.

In 1904, D.B. Kilpatrick and his wife, Truda, moved from Del Rio, Texas, to this stark area, 35 miles southwest of Ozona, to homestead land. After living on the property for three years and making certain improvements, the land would be theirs. The five sections the Kilpatricks settled on were crossed by the Fort Lancaster-Del Rio road, which connected the old San Antonio-El Paso road at Fort Lancaster.

For a shelter, the Kilpatricks looked at what was available to them and adopted the hut-like construction formerly used by Indian sheep and goat raisers along the Texas-Mexico border: the yucca-like sotol plant.

ORIGINAL OWNERS
D.B. and Truda Kilpatrick and Arthur W. Mills

LOCATION
Howard's Draw, 35 miles southwest of Ozona, Texas, in Crockett County, five miles from the Pecos River

SIGNIFICANCE
Demonstrates the ability of ranchers to adapt to their environment

DONORS
L. Bascomb Cox Jr. and Louise Bailey Cox

DEDICATED
April 27, 1974

> People who passed through the unfenced country included immigrants, gold seekers and cattle drivers, all heading to California for the prosperity it promised.

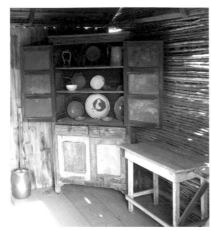

ears

The exterior of the house had a small shelf near the door to add a wash basin and a water bucket with dipper.

Bedroom (right) and Kitchen (bottom)

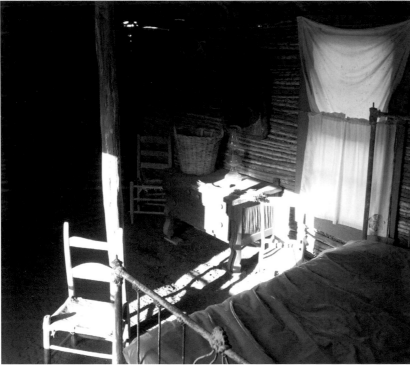

North sotol room was used for storage.

A horseshoe near the door wished its owners good luck.

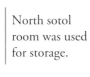

49'-2"

10'-5"

12'-1"

15'-10" 15'-10" 13'-11"

➡

PICKET
AND
SOTOL
HOUSE
up close

The tall stalks grew from the center of sharp-leafed desert plants and died each year becoming wooden-like. They were easily pulled loose for use as "logs."

The couple constructed the two sotol rooms with a rough framework of vertically set cedar posts, about four feet apart. Sotol was nailed horizontally to the cedar posts. More stalks were nailed to the opposite side of the posts, forming a double wall. Soil and small rocks were poured between the walls as filler and insulation. Cedar pieces, material scraps and tin can lids covered the cracks. The couple added a roof thatched with bundles of a lily variety called sacahuiste. The house was drafty with gaps allowing rodents and desert animals to enter in search of food. Perhaps due to the difficulty of living in such a structure, and with the knowledge that living there would need to be for several years, the Kilpatricks didn't last the required time to receive their land grant.

Arthur Mills moved into the sotol house, added a third room, and used upright cedar posts nailed together and set into a trench. He stacked fieldstone to create a fireplace for cooking and heat. He also hauled lumber from Del Rio to cover the floor in the cedar post room, and he shingled the roof. Existence in this home was still stark. The dirt-floored north sotol room was used for storage and a work area. The south sotol, also a dirt-floored room, was a combination kitchen/bedroom until Mills added the wooden-floored picket room, which he built to be the kitchen.

Furnishings included an iron bed, wardrobe and pie safe that were brought in a covered wagon. The walls were too fragile for cabinets, so a crate was nailed up to hold light items. The chuckbox was taken off the wagon and used as a kitchen cabinet and table top. Two large bins stored flour and sugar. Saddles were hung by ropes from the rafters, a common practice to help prevent pest damage. A horse-drawn sled was used to bring water to the house from a well 200 yards away. The well and a windmill were already on the property, left by a large-scale rancher who had constructed them hoping to get his cattle to graze farther away from the Pecos River.

The exterior of the house had a small shelf near the door to hold a wash basin and a water bucket with dipper. Because of the danger of rodents and other animals getting into food supplies, no bulk flour, sugar or vegetables were stored in the north sotol room. Since predators were a problem to ranchers and settlers, traps were often set. A horseshoe near the door wished its owners good luck.

Such buildings as the Picket and Sotol House were built for temporary use, not made to withstand the severe West Texas weather. Because the material was more fragile than logs, lumber or stone, few survived. Jerry Rogers, then director of the National Ranching Heritage Center, termed the structure "a rare and exciting find because it is probably one of the very last of its kind still in good enough condition and near enough to its original state to allow historically accurate restoration."

The house is a tribute to the ingenuity of early settlers who used whatever was available to them when building a home from the sometimes harsh land.

A horse-drawn sled was used to bring water to the house from a well 200 yards away. The well and a windmill were already on the property, left by a large-scale rancher who had constructed them hoping to get his cattle to graze farther away from the Pecos River.

Gourd water dipper

FOR THE RECORD

Restoration of the Picket and Sotol House was slowed by the lack of experience anyone had at working with the desert materials. José María Martínez of San Antonio and Juan Enríque Martínez and Félix Vela of Laredo, Texas, donated their labor to make the thatched roof for the simple hut, or *jacal*, using knowledge of a technique handed down through generations of their families.

original location

PICKET AND SOTOL HOUSE

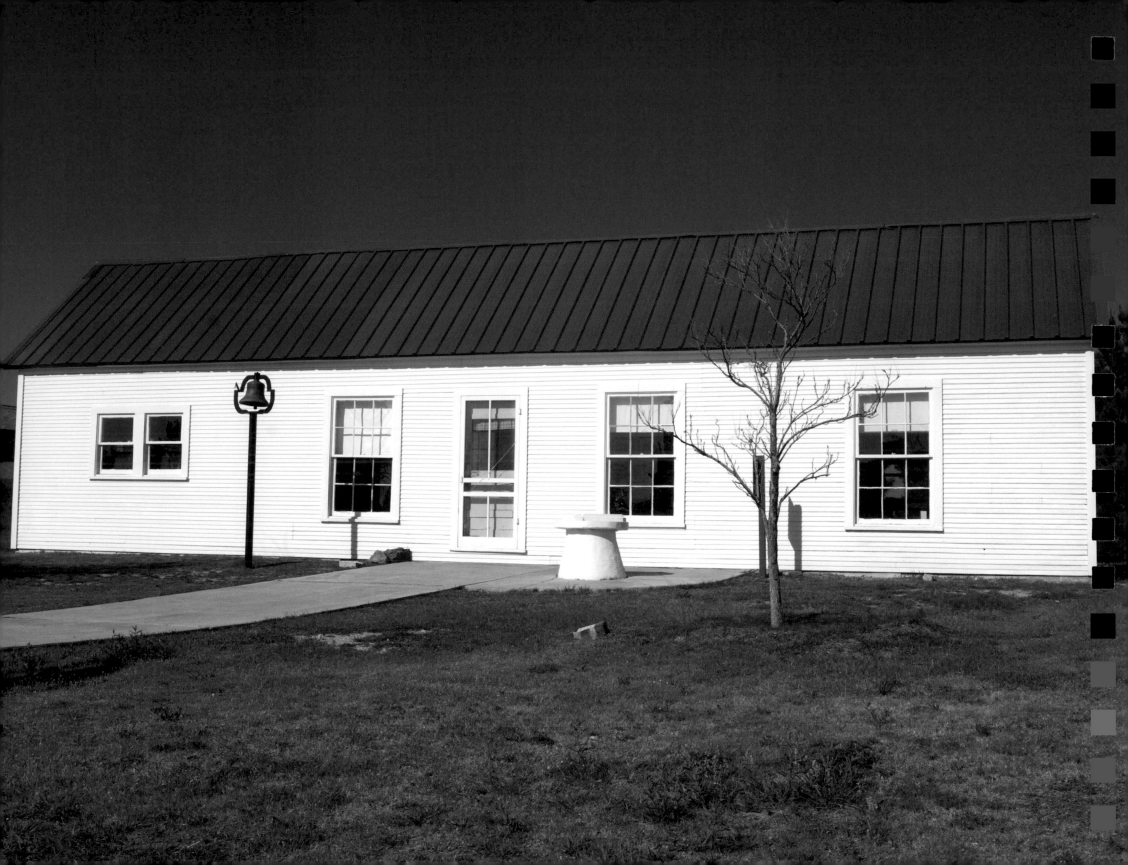

CHAPTER TWENTY-FIVE

PITCHFORK RANCH COOKHOUSE

AROUND 1900

Out the back door of the Pitchfork Ranch Cookhouse, the land dropped off to the north bank of the South Wichita River and horses grazed quietly in nearby pastures. Tame wild turkeys milled around nearby eating corn chips thrown out for them by the cook. In all, it was an idyllic picture, reflective of both today and times gone by.

The Pitchfork Land & Cattle Co. officially began in 1883, but its history goes back even earlier when Eugene F. Williams and Dan Gardner, friends since their boyhood days in Mississippi, formed a partnership in December 1881.

The current boundaries of the Pitchfork Ranch encompass a cowboy's dream of excellent grass and abundant streams, easy valleys to cross yet many breaks for protection from the rare "northers." Those conditions are what brought cattlemen to Pitchfork Country after the military campaigns ended the threat of Indian raids.

Located in the Rolling Plains 80 miles east of Lubbock, the Pitchfork is a mix of flat, open terrain on the northeast side and the rougher Croton Breaks to the west and south. The South Wichita River runs 10 miles through the ranch, and the headquarters sits near the north bank.

The Pitchfork Ranch is defined by its geography. The Big Croton and the Little Croton run together to form Croton Creek and create the Croton Breaks. Such names as West Croton, Dripping Springs and River and Shinnery pastures indicate the influence of the terrain. The breaks provide a challenge for horse and rider. Other areas of the ranch could have been named by a Hollywood scriptwriter—Brushy Pasture, Dark Canyon and West Long Canyon.

In so large an area, the one place where everyone could come together on the vast ranch was the cookhouse. The simple wood-frame structure was a sanctuary for family reunions, birthday parties and, of course, daily meals for the ranch hands and cowboys

Ranch owners donated the building and its furnishings to the NRHC when they decided to replace the old cookhouse with a new dining facility in the same location.

ORIGINAL OWNERS
Pitchfork Land & Cattle Co.

LOCATION
From the Pitchfork Ranch on the Rolling Plains, 80 miles east of Lubbock in Guthrie, Texas

SIGNIFICANCE
Representative of where cowboys ate and shared quiet time with others on the big ranch outfits

DONORS
Pitchfork Land & Cattle Co. board members

DEDICATED
April 26, 2008

Plates were only ~~ned up when it ~~was time to eat.

The cook-house was brought on the back of a truck to the NRHC from its home on the Pitchfork Ranch.

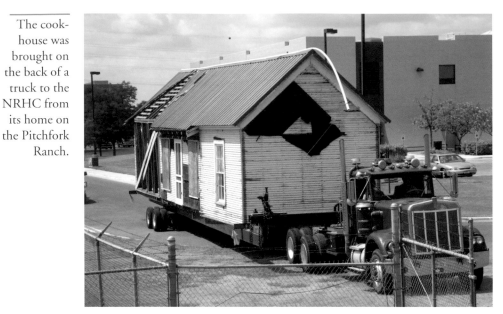

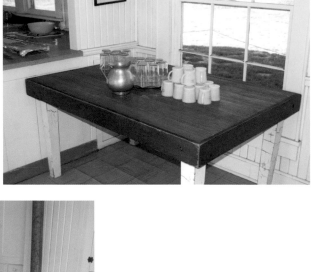

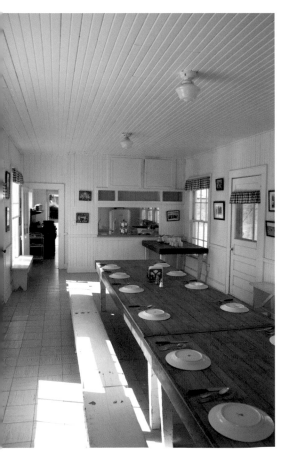

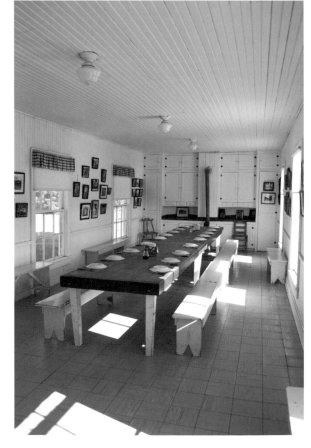

The cookhouse table could always hold a few more people who showed up without notice.

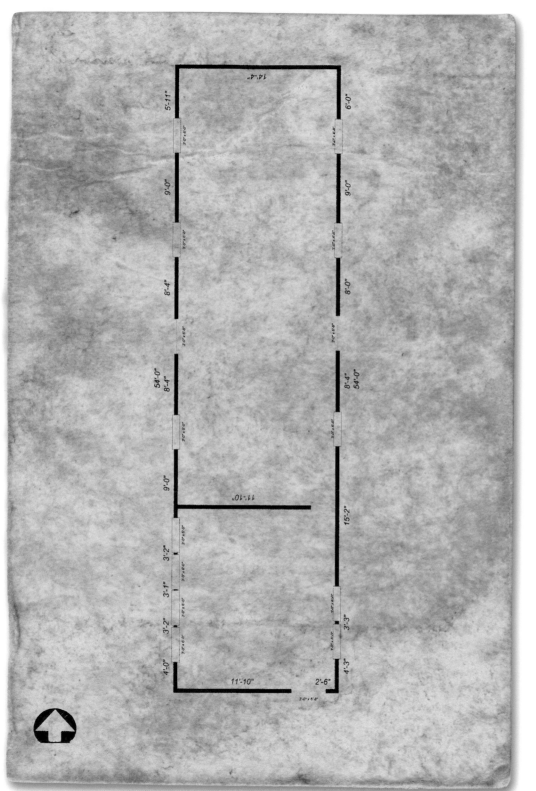

Berneice and Jim Humphreys (left) ha[ve?] a chuckwagon meal under the fly with [] and Mamie Burns. Both men were lo[ng-]time Pitchfork manage[r.]

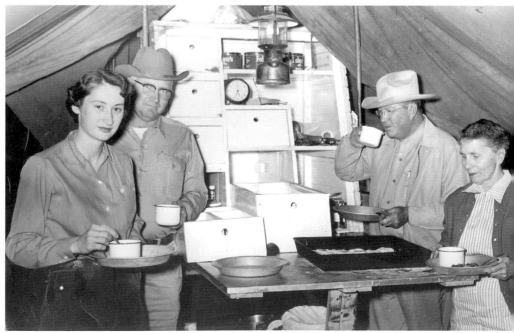

since its construction around 1900. It began as a one-room structure and was expanded over the years. It consists of a kitchen and dining area and was in continuous use by Pitchfork Ranch cowboys for two meals a day until its move to the National Ranching Heritage Center in September 2007. At mealtime, the cowboys waited outside on benches or under a tree until the cook rang the dinner bell.

Though the exterior walls were covered in modern shingles, the original wood clapboard siding is still intact underneath. The interior walls and ceilings are clad with narrow 1-inch by 2-inch beveled plank paneling. The dining hall is a long spare space furnished with well-used wood tables and handmade wood benches.

Over the years, a number of modifications and additions were made to the building. During the moving process, as the cookhouse sat raised about five feet above the ground, it was easy to determine a better construction history of the ranch building. By studying the floorboards and framing differences, the additions to the building were clearly defined, so much so that some of the initial description of the cookhouse had to change.

When the kitchen was built around 1900, a 14-foot by 16-foot structure stood alone as the ranch cookhouse and not, as previously thought, a two-room building. Later a porch was added to the north side. Then a 21-foot long addition was added, again on the north side. Up to this point, the building rested on a dry-stack rock foundation. Then, in the 1920s, one more 17-foot addition was made to the north end with a concrete beam foundation. The original siding was rough wood planking, at one time trimmed out as a board and batten finish. The clapboard siding was likely added during the final addition.

The kitchen is focused around a central work counter with the large gas stove on the east side and the sink and clean-up area on the west. There were no frills—this was a working ranch kitchen. The Pitchfork Ranch Cookhouse provides NRHC visitors with a unique opportunity to experience and understand an aspect of ranch life rarely seen by outsiders.

FOR THE RECORD

In its older days, same as now, the old cook-house was set for a meal with the plates turned-down and an array of condiments and peppers provided. Food was set out from the kitchen and cowboys and guests alike lined up with plate in hand to get their share.

original location

PITCHFORK RANCH COOKHOUSE

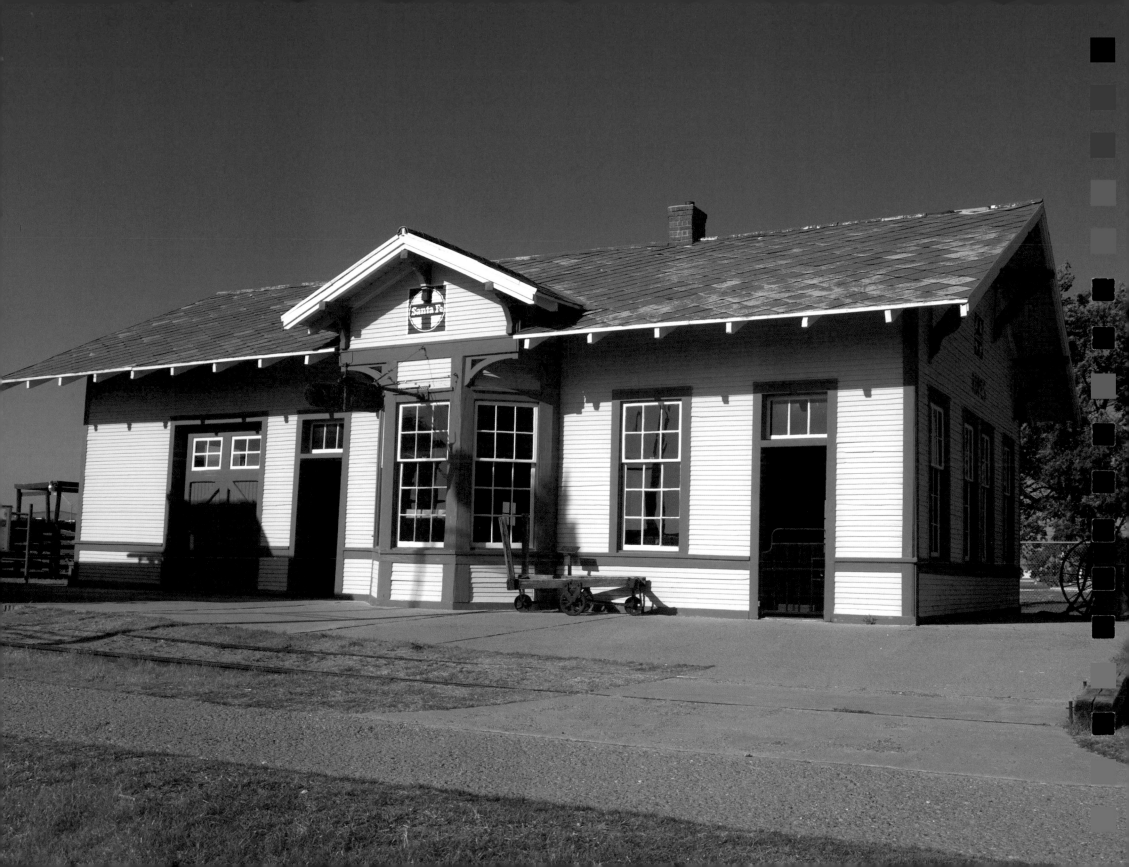

CHAPTER TWENTY-SIX

ROPES DEPOT 1918 AND RAIL CAR HOUSE 1917

"The world had now found us. We watched the lazy prairie take on new life."

The railroad depot was an exciting place. With people coming and going and cowhands returning from cattle markets, all sorts of news was brought from other towns to the far-flung settlements in the West. In the depot, all the arrangements were made for cattle movement, package and freight shipment and passenger travel. Most depots looked similar—even the paint colors were standardized by the railroad company that built them. In some towns, the depot was just one of several buildings comprising a railhead.

The railroad was essential to the growth of ranching, transporting cattle, settlers (some establishing businesses in the towns), manufactured goods, supplies and lumber to the plains. The Spade Ranch near present-day Ropesville, seeing the need for rail service to the area, deeded 85 acres to the railway on the condition that a depot, agent's house and stock pens would be built. Over the years, the depot serviced ranchers from across the South Plains and as far away as New Mexico. In the end, it stood witness to the decline of ranching on the South Plains and the beginning of a farming lifestyle.

The wood-frame Ropes Depot, built on land once owned by Isaac L. Ellwood, a manufacturer of barbed wire, opened on July 1, 1918. Historian Sally Abbe said, "Traditionally, railroads had connected previously settled points. But in the West, railroads were often the forerunners and spurs to civilization. Such was the case with Ropes. The depot was the first business establishment in the town. As more and more farmers and small stockmen moved into the area, the Santa Fe realized the potential economic value of a townsite at the railroad."

Work on the line began on Jan. 1, 1917, but was slowed by the needs of World War I. Mary A. Blankenship, an early settler, described the change. "The world had now found us. We watched the lazy prairie take on new life as swarms of men and teams with handscrapers dumped our soil into a railroad dump, followed by the rail-laying crews and the work trains. We experienced a new prosperity right at home as we sold the myriads

ROPES DEPOT
ORIGINAL OWNER
Santa Fe Railway

LOCATION
Ropesville, Texas, in Hockley County on land donated by the Spade Ranch to the Santa Fe Railway

SIGNIFICANCE
Represents the importance of the railroad in the growth of the ranching industry

DONOR
Adele T. McGinty

DEDICATED
Sept. 18, 1982

RAIL CAR HOUSE
ORIGINAL OWNER
Santa Fe Railway

LOCATION
Levelland, Texas, in Hockley County

SIGNIFICANCE
The handcar was used on line repairs and was a fixture of every depot.

DONOR
Alton Brazell

DEDICATED
1985

Ticket window

Passenger
waiting area

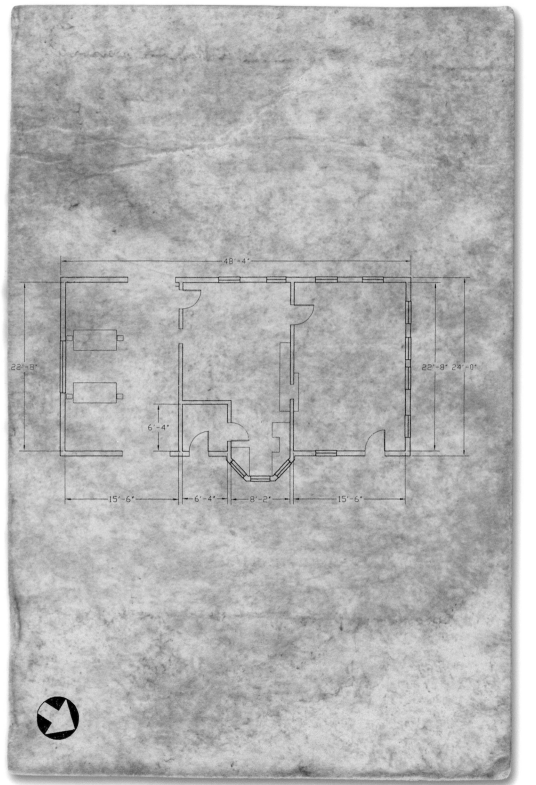

ROPES DEPOT
up close

Safe |

Business office

"Did you
weigh your-
self today?"

of workers our vegetables, eggs, home-canned food, milk, butter, meat, and leased to them our teams and our hands."

"Time took on importance," Blankenship added. "We could set our clock by the noonday train as it stopped to water up at the railroad's giant overhead tank by its own windmill."

Abbe wrote that the Ropes Depot lost some of its business after 1924 when the Santa Fe built another depot and railroad line at Anton, Texas, which was also on Spade Ranch land. In the 1930s and '40s, the depot revived to serve the West Texas farming community. But after World War II, the Santa Fe was forced by escalating costs and declining revenues to limit service. Abbe said the last Santa Fe passenger train ran on May 1, 1971, and all passenger and dining cars were sold to Amtrak. The depot closed on Oct. 15, 1974, and the Santa Fe offered it for sale. It was purchased by William J. McGinty and eventually donated to the National Ranching Heritage Center by his widow.

Santa Fe officials provided the 1910 blueprints of the Ropes Depot to the NRHC to help with its reconstruction. A long porch that had been added to the structure while it was in Ropesville was replaced by the original station platform. The railroad also donated yellow paint for the depot and red paint for the caboose, waiting room benches and other authentic period furnishings. The Spade Ranch provided funds for moving the depot to the NRHC.

The Ropes Depot held an office, receiving area, desk, chairs, ticket window, scale for weighing packages, wood-burning stove, benches and a safe. During a renovation in early 2004, National Ranching Heritage Center historical maintenance staff found an area where a wall had been moved to enclose a small ticket booth. Consulting old records, they were able to remove it and return the depot to its original three large rooms, repaint using authentic colors, repair the stove and refurnish the office and freight area.

Ropes is the only depot in Texas that doesn't bear its town name. The depot preceded the town. Cowboys wanted to call the new rail point "Ropes" for the rope corrals they made to hold livestock before shipping pens were built. It is more likely the depot was named for Horace Ropes, a Santa Fe division engineer who surveyed part of the Panhandle of Texas and Eastern New Mexico in 1888. Ropes residents changed the town name to Ropesville in 1920.

Railroad at Levelland, Texas, and moved it to the NRHC, where it was restored. In 1984, Brazell donated railroad ties, crossing signs, crossing timbers, derail sign, structure sign and a switch control from the removal of the Whiteface to Bledsoe section of the Santa Fe. Railroad employees told Brazell this tool house was identical to those constructed on the Lubbock to Seagraves branch of the Santa Fe Railroad in 1917.

RAIL CAR HOUSE

The Rail Car House was built by the Santa Fe Railway to store track tools, supplies and a handcar. It was a home base for a section gang. Tools were loaded on the handcar and taken up or down the track to make necessary repairs. Every depot had a rail car house.

If railroaders didn't call the structure a rail car house, they referred to it as a tool or work house. It was built as a box and strip structure with pine walls and (originally) a slate roof. A sliding door allowed entry to the handcar. Supply bins and a wall desk were built in one end of the building, and a sliding wooden window provided ventilation.

The 12-by-14-foot Rail Car House was a gift from Lubbock County Commissioner Alton Brazell, who purchased it from the Santa Fe

It was built as a box and strip structure with pine walls and (originally) a slate roof. A sliding door allowed entry to the handcar. Supply bins and a wall desk were built in one end of the building, and a sliding wooden window provided ventilation.

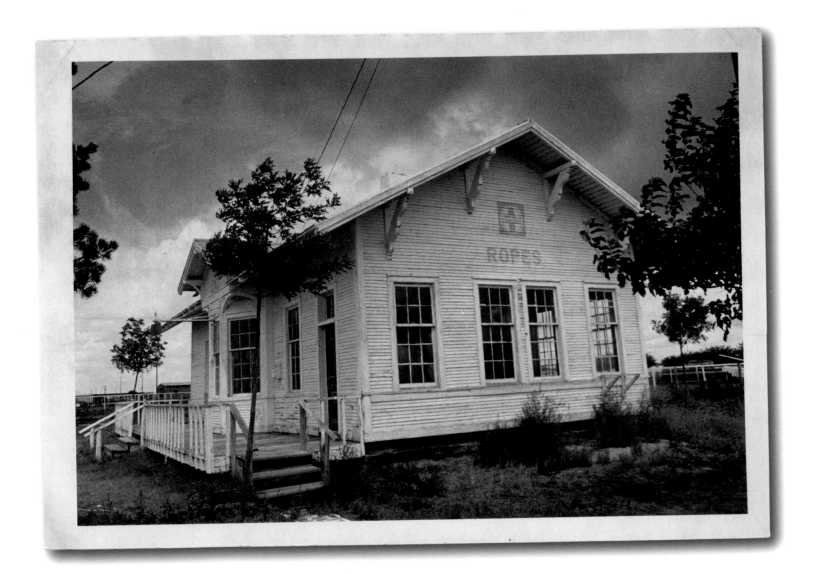

FOR THE RECORD

As a young man, well-known author Max Evans of Albuquerque, N.M., enjoyed listening to the tall tales of old men who gathered in the Ropes Depot. Evans sat with them for hours as they whittled and spat and recalled cowboy escapades in early-day Ropesville. The stories they told the eager young listener inspired Evans in later years when he wrote *Hi Lo Country, The Rounders, Bluefeather Fellini* and about 50 other books. On May 8, 1999, he traveled to the National Ranching Heritage Center and relived some of his own history as he autographed books inside the restored Ropes Depot and told stories of the Old West.

original location
ROPES DEPOT

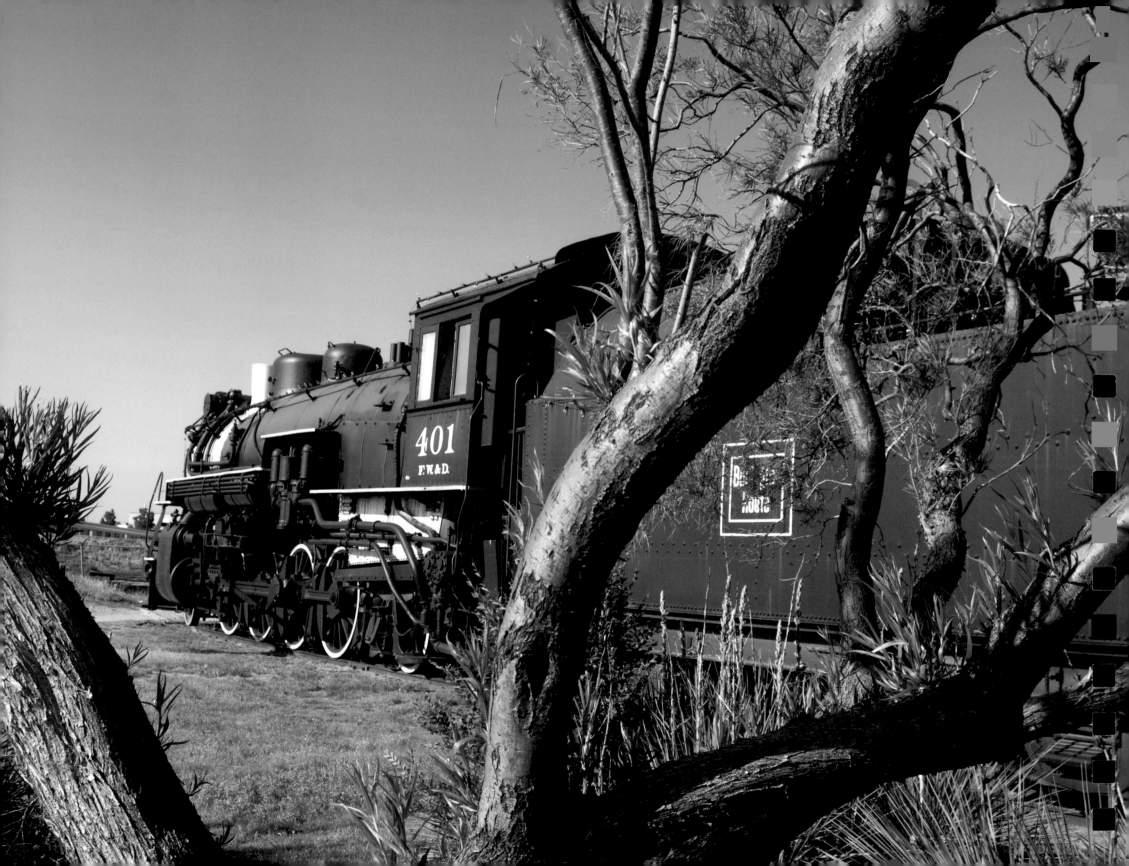

27

CHAPTER TWENTY-SEVEN

LOCOMOTIVE 1923 AND KING RANCH SHIPPING PENS c. 1910, 1934

A steam locomotive originally given to Texas Tech University in the 1960s was moved to the National Ranching Heritage Center where specially laid tracks allowed it to stand next to the restored Ropes railroad station. Together with cattle cars, caboose and shipping pens, they help to tell the story of the railroad's influence on the cattle industry in Texas.

When former vice president of the Fort Worth and Denver railroad line and Texas Tech Regent Wright Armstrong made an effort to acquire a locomotive for the university, he learned that engines had been sold for scrap in 1955. With none available in Texas, the Burlington Railroad Lines, which owned the Fort Worth and Denver, provided an engine from another of its subsidiaries, the Colorado and Southern line out of Denver. Number 4994 was brought out of storage. It was restored and its markings changed to represent the locomotive as one used in West Texas—the Fort Worth and Denver 401. The 4994 is similar in style to the 401, which had been originally built in 1915. Both started in service as coal burners and were later converted to oil.

Built in 1923 by the Baldwin Locomotive Works of Philadelphia, Pa., for freight service on the Burlington Northern's main line, the locomotive was donated to Texas Tech in 1964 and occupied a space near the Coliseum on the Texas Tech campus. In 1983, arrangements were made for it to be part of the historical park at the National Ranching Heritage Center.

Santa Fe Railroad personnel used a switch engine to pull the Texas Tech engine across the highway and onto a temporary spur to the track near the NRHC Ropes Depot. Also acquired for the locomotive were wooden Santa Fe cattle cars, including a rare double-deck car that hauled sheep and small livestock, and the single-deck stock car, which carried cattle and horses. Cowhands escorting their herds often rode in the wooden caboose. The train is typical of those used for shipping livestock in the 1920s and '30s, and the NRHC owns two of only six stock cars that have been preserved from the original Santa Fe fleet of 9,000 cars.

The Cattle Shipping Complex was dedicated Sept. 17, 1983, and included cattle shipping pens from the King Ranch near Kingsville,

Hammer used to drive railroad spikes

LOCOMOTIVE
ORIGINAL OWNER
Chicago, Burlington and Quincy Railroad Co.

LOCATION
Denver, Colorado

SIGNIFICANCE
Representative of freight trains used in early West Texas settlement

MOVED TO THE NRHC
July 26, 1983

DEDICATED
Sept. 17, 1983

SHIPPING PENS
ORIGINAL OWNER
King Ranch

LOCATION
Kingsville, Texas, in Kleberg County

SIGNIFICANCE
Represents pens erected beside railroads in the era following the open range and trail drives

DONATED BY
Tio Kleberg and Leonard Stiles

DEDICATED
Sept. 17, 1983

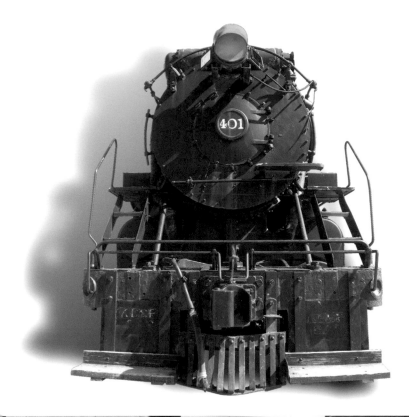

KING RANCH SHIPPING PENS

Texas. The train and shipping pens help tie together the histories of the nation's railroad and ranching industries.

A portion of the Caesar's Pens from the King Ranch, once the largest cattle shipping enclosures in the world, was given to the NRHC to be a part of the railroad complex. A historical marker was placed at the original spot of the Caesar's Pens near Kingsville in South Texas, dating them to the early 1900s and reflecting the name of Caesar Kleberg, rancher and wildlife promoter, born on Sept. 20, 1873, at Cuero, Texas. He moved to the King Ranch in 1900 to begin work as chief assistant to his uncle, Robert J. Kleberg. Caesar made his mark during his 30-year career as foreman of Norias, 40 miles south of Kingsville.

A King Ranch four-man crew brought two trucks carrying gates, posts and steps from the famous pens, which were taken down when the ranch's cattle were no longer shipped long distances. Building plans were obtained from the Santa Fe Railroad for the smallest set of pens,

and these were donated to the NRHC.

The most active period for the pens was the 1920s through the 1970s. Dr. Lauro F. Cavazos, former president of Texas Tech University who grew up on the King Ranch, said he recalled the image of his father, foreman of the Santa Gertrudis Division, perched on the fence of the Caesar's Pens counting cattle. "People worked hard. There was tremendous loyalty, understanding, patriotism— values somehow distorted in today's world."

He said the people who grew up on the King Ranch were taught responsibility and truthfulness by their parents and all the ranch family. "I don't know how or why I was so lucky to have been born at that time, under those circumstances and to that set of parents," Cavazos said. "But life on the King Ranch gives a perfect example of the impact of environment on people and how they comport themselves later in life."

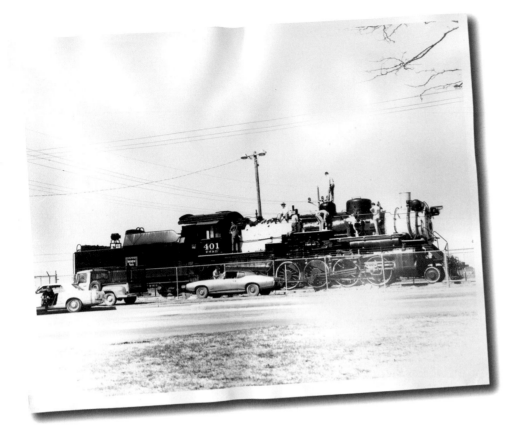

When railroads began shipping cattle, ranchers quickly realized livestock could get jostled by the train's occasional lunges. If one fell, other animals could trample and kill the downed cow. So, it became a regular practice for cattle to be packed tight to prevent falls, and a cowboy accompanied the herd to keep check on them. He traveled in the caboose.

FOR THE RECORD

The term *Kineños* dates to the days of Richard King and the founding of the King Ranch. King needed workers and found them in old Mexico, when he happened upon a drought-stricken village. He invited the villagers to come work for him. Captain King's vaqueros became known as *Los Kineños*, King's Men. Today, numerous fourth-, fifth- and sixth-generation Kineños continue to work in various divisions throughout the King Ranch.

original location

KING RANCH SHIPPING PENS

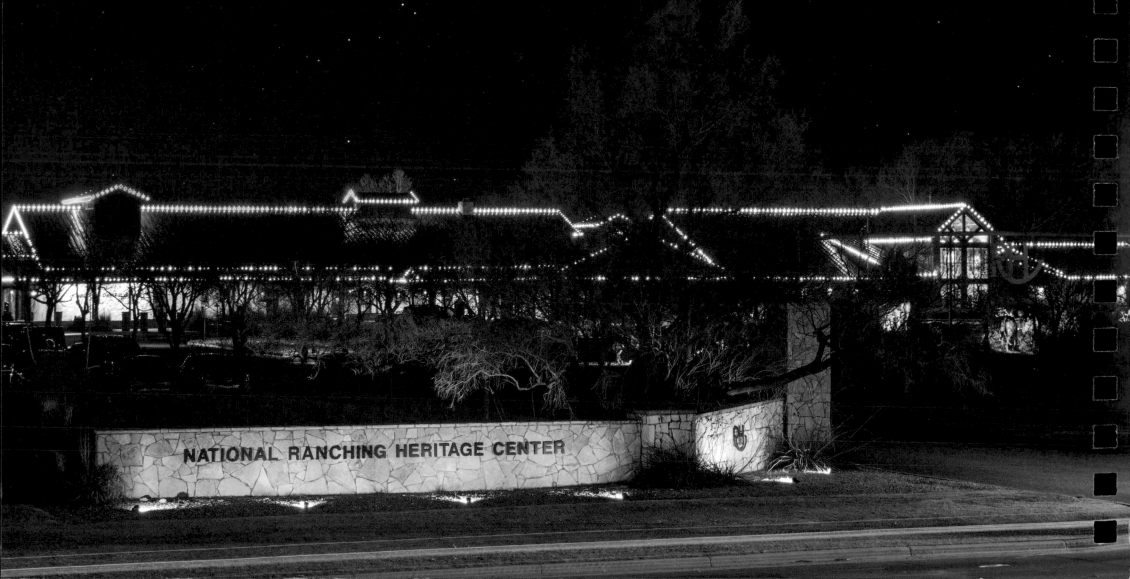

28

CHAPTER TWENTY-EIGHT

ADDITIONAL STRUCTURES

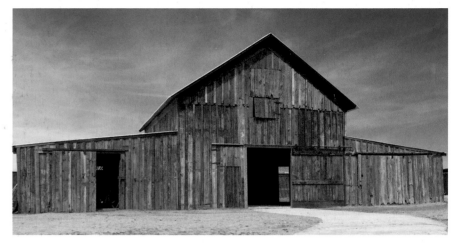

HOFFMAN BARN

Hoffman Barn was built in 1906 at the end of the cattle drive years, disassembled 112 years later and reassembled at the NRHC to become the 50th structure in the historic park. The barn houses a transportation exhibit featuring some of the center's rolling stock—wagons, buggies, 1923 Model T car and 1923 Model TT one-ton truck. Lawrence H. Jones drove cattle from ranch land in Scurry County, Texas, to the Texas and Pacific railhead at Colorado City. He came with his family to early Scurry County as homesteaders and built the barn to have a place to rest and feed cattle. The barn, roof and walls were painted red numerous times and withstood the West Texas weather for more than a century. One of the Jones daughters married a Hoffman, and the land where the barn was built has stayed in the Johnny Hoffman family since that time. The barn was dedicated Sept. 20, 2018.

PITCHFORK RANCH PAVILION

Named for the historic Pitchfork Land and Cattle Co. in Guthrie, Texas, the pavilion is an all-weather structure. It was renovated in 2004, adding increased dimensions, new hard-surface flooring, and attractive lighting and ceiling fans. Large doors were added on three sides so the facility can be enclosed or opened for year-round use. A large stone fireplace dominates the east wall. Originally dedicated as the D Burns Memorial Barbecue Pavilion in 1981, the new structure was renamed by the Pitchfork Ranch board to recognize and honor all of the ranch's managers since it was organized in 1883.

SLAUGHTER MEMORIAL ARBOR

The wisteria-enhanced George Webb Slaughter Memorial Arbor was built as a shady respite for visitors to the NRHC. In the early history of the West, the brush arbor was an important part of a settlement. Before a town had funds for a church, a brush arbor was usually constructed to be the temporary site of services, Sunday picnics after circuit-rider preachings, dances on holidays and ranchers' meetings. It was a shady area built among trees and near a stream or river, when possible. The facility was given by Slaughter family members in memory of the Rev. George W. Slaughter, a famous Palo Pinto County pioneer preacher and rancher.

C.T. AND CLAIRE McLAUGHLIN ARBOR

Originally a brush arbor, the attractive McLaughlin Arbor and Memorial Grove features concrete flooring, lantern-like light fixtures and picnic tables in an open-air setting. The arbor is located at a bend in the sidewalk in the most traveled part of Proctor Park. It is one of the NRHC's non-historical structures meant for use by the public as a rest area. Adjacent to the arbor on the east is the Pioneer Memorial Grove, which is comprised of tall shade trees and comfortable benches. The arbor honors the memory of prominent Texas oilman C.T. McLaughlin and his wife, Claire, who owned the Diamond M Ranch in Snyder.

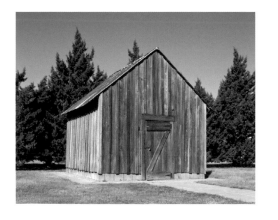

HILL SMOKEHOUSE

Relocated from Frank B. Hill's farm/ranch in Palo Pinto County, Texas, the smokehouse represents an important element in pioneer life. In this structure, meat was subjected to slow wood-smoke cooking, during which it permeated the meat, preserving it and enhancing its taste. The smokehouse was built by Frank B. Hill in 1913, replacing a deteriorating log smokehouse. The new board and batten structure had a roof of galvanized press-form sheet metal. Hill obtained materials from an old store in Whitt, Texas. Eventually, the smokehouse was used to store sorghum and other items. When given to the NRHC by the Hill family, the smokehouse showed evidence of a fire with charring and a burn hole on the south side.

THE BLANKENSHIP COWCHIP HOUSE

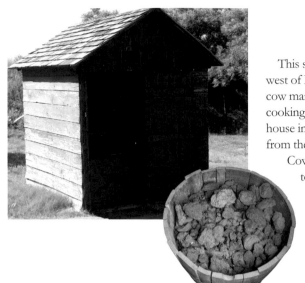

This structure was built in 1907 on the Blankenship Ranch west of Ropesville in Hockley County, Texas. It stored dried cow manure called cowchips, which were burned for heat and cooking when wood was not available. The Blankenships built a house in Lubbock, and in 1919 the cowchip house was moved from the ranch to Lubbock to be used for the same purpose. Cowchips were hauled by wagon from the ranch to Lubbock to keep the building filled. Family members said the cowchip house was forgotten over the years until the residence was torn down in 1983. Doyle Blankenship Thornhill rescued the cowchip house and offered it to the National Ranching Heritage Center. It recognizes a necessity of life on the treeless West Texas prairies.

WILD COW CORRAL AND GATE

The wild cow corral with its trap gate came from the Block Ranch in Capitan, N.M. The old corral demonstrates how cattle were gathered in the high country, unlike the way cowboys performed the task on flat land. In the mountains, ranch hands devised a way to catch the cattle by building wooden corrals among the trees and putting feed inside the gates. Wild cattle nudged the gates to get in to the feed. When the gate closed, the animals could not push it open from within. Cowboys, or "brush poppers," gathered the cattle and used burros and horses to lead the cows down the mountain into the ranch's pens for branding. It was donated to the NRHC by Hap Canning, owner of the Block Ranch, and dedicated Oct. 29, 2004.

CORRALS VARIED IN DIAMETER

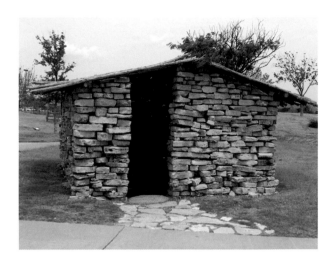

MAIL CAMP

The mail camp was located on the Mare Pasture of the Lowrance Ranch about 25 miles northeast of Guthrie in Knox County, Texas. The single-door, stacked rock structure with a pole and brush roof dates from the late 1870s. It was located north of an old military/stageline road and may have served as a rest stop or way station for the early military couriers. Later, it was used by postal contractors as they handled mail for early ranch settlers. The mail camp helped establish settlement of the frontier for ranch use. The structure was donated by Ruth Lowrance in memory of her late husband, Ed, and dedicated April 23, 2005.

115

PITCHFORK
LOADING CHUTE
AND
CORRAL

Corral facilities became part of ranching after the trail drive era ended and cattle were shipped by train to meat-packing centers. The corrals and loading chute located in the vicinity of the Spur Granary and the Reynolds-Gentry Barn are original. They were provided to the NRHC by the Pitchfork Land and Cattle Co. in honor of D Burns, long-time manager of the ranch in Dickens and King counties. Burns supervised construction of the corrals to ensure its authenticity. At its dedication, he said that he hoped the Pitchfork Loading Chute and Corral would serve long and usefully. "They are not pretty, but hell for stout," Burns said, "and are a useful tool in handling livestock."

OLD BLOCK
(RANCH)
DRIFT FENCE

The historic Block Drift Fence was built c.1885 by El Capitan Land and Cattle Co. (Block Ranch). It stretched from the west end of the Capitan Mountains to Vaughn, N.M., forming the ranch's western boundary for its cattle. The only part remaining of the 80-mile long fence at the time of its donation to the NRHC was in the Haspris Canyon pasture on the Wilson Ranch headquartered near Ancho, N.M. The fence was intended to keep livestock from drifting north off the Block Ranch rangelands. The fence was donated by Rex and Carol Wilson and dedicated Oct. 29, 2004.

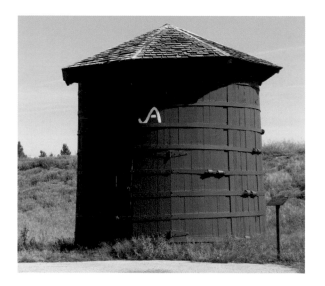

JA OAT BIN

This wooden water tank was first used about 1890 in the Griffin pasture on the JA Ranch in Palo Duro Canyon, Texas. It held a reserve water supply for 3,000 cows. Moved to the ranch headquarters in the 1920s, it was used as the oat bin to feed the horse herd. The bin was given to the NRHC by M.H.W. Ritchie and his daughter, Cornelia. It was dedicated May 21, 1988.

SLAUGHTER ROUND PEN

AND NANCE SNUBBING POST

Where cowboys broke and trained their own horses, the round or breaking pen was an important feature. After roping an "unbroke" horse in the corral, a cowboy wrapped the loose end of his rope several times around the snubbing post in the center of the corral to gain control over the animal. Once tied down, it was easier for a cowboy to saddle the horse and start the gentling process. Circular corrals, without sharp corners, protected both the cowboy and the horse. Mr. and Mrs. Don W. Slaughter provided funds for the erection of this corral. The snubbing post was donated by Mrs. Elton Nance and her son, L.E. "Sonny" Nance, in memory of his father.

SLAUGHTER TOWER AND TANK

This windmill tower and water tank is used with the Improved Clipper Windmill. They were given in memory of pioneer cattleman and rancher George M. Slaughter by George M. Slaughter Jr. and his sons, George III, Don W., and Tom V. George Morgan Slaughter (1862-1915) was the first son of Christopher Columbus Slaughter (1837-1919) and Cynthia Ann Jowell (1844-1876). George Morgan learned the cattle business from his father and managed the Lazy S and Running Water Ranches. The Slaughter round pen, windmill tower and tank were dedicated on Oct. 2, 1976.

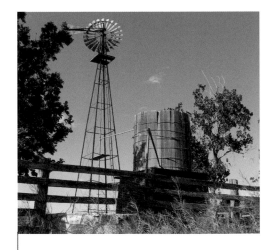

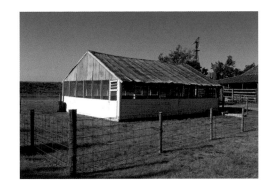

CANON RANCH SHEEP HOSPITAL SHED

Built in 1928-29, the sheep hospital was in use until 1955 for treatment of sheep and goats for screwworm. The hospital also treated infections that resulted from branding and other medical problems. The facility isolated the infected animals, making it easier to provide care. The treated animals were released into a separate pen to the west of the building. The sheep hospital serves to educate people about the sheep industry as part of the ranching trade and the story of the screwworm and its eradication. The structure was donated by George Canon from his Canon Ranch between Ozona and Fort Stockton in Pecos County, Texas.

SUPER J CABLE TOOL SPUDDER

To drill for oil, a rig called a Spudder was enlisted. A large, cumbersome mass of cables and bits, the rig was invaluable to the drilling operation. Donated to the National Ranching Heritage Center to help tell the story of how oil turned many ordinary men into brilliant ranchers, this Fort Worth Super J was made in 1935. It could drill to depths of 5,000 feet. These portable cable-tool drilling rigs replaced the older standard-fixed rigs. The steel masts on this spudder were cut down from their original 70-foot height to the 35-foot height displayed at the NRHC. A precisely engineered machine, modern versions of this rig are still being used in Third World countries today. The rig was donated by Kimble Guthrie of Big Spring, Texas, and dedicated on May 20, 2006.

29 CHAPTER TWENTY-NINE WINDMILLS

PIPE RAYMOND VANELESS WINDMILL c. 1918

The introduction of windmills into arid country allowed settlement to occur and ranching and agriculture to prosper. Windmills pumped deep water to provide water for livestock, crops and people. They also became landmarks and symbols of life for travelers. Althouse Wheeler Co., beginning in 1912, produced the Pipe Raymond Vaneless windmill. The blades face away from the wind and fold back as wind speed increases, enabling the mill to turn at a constant rate. The mill had red cypress blades dipped in white paint and trimmed in red. It was the most frequently seen vaneless mill on the Great Plains. Also called a Walpole, or Waupon, the windmill was relocated from near Ulysses, Kansas, in Grant County.

ECLIPSE WINDMILL 1898

To the settler or roving cowboy, a windmill's creak and groan were a life sign. It signified water. On the Texas South Plains, the wood-wheeled Eclipse, patented in 1867, was the windmill of choice. More than 300 furnished water for cattle and cowboys on the huge XIT Ranch. Oldtimers say the big 14-foot wheel was "the only one that could get deep water." This Eclipse was located in Sherman County, Texas, and restored for the NRHC. The wooden wheel, sails, tail and fan were recreated according to specifications in an old catalog. It was moved to the site in 1970 to top a well on a berm and supply water to the nearby JA Milk and Meat House. The Eclipse was used by the railroads as they built west across the Great Plains after the Civil War. The railroads needed water for the steam-powered engines. The exposed parts made it necessary for someone to climb the tall tower and grease the parts as often as once a week.

MONITOR SOLID WHEEL WINDMILL c. 1905

Windmills opened the range for large-scale ranching enterprises. Where no surface water was available, the windmill pumped water from far below the ground into tanks for cattle, horses and the humans who tended them. Produced commercially from 1898 through the 1930s, the Monitor Solid Wheel windmill was manufactured by the Baker Co. of Evansville, Wisc. It had a reputation for durability, even when neglected. As windmills provided water, mesquite roots provided fuel. On the plains, mesquite grew wild. One cowboy said, "In this country, we climb for water and dig for wood."

STAR MODEL 15 WINDMILL c. 1915

On the Plains, the Star was the second most popular windmill behind the Eclipse. This one was made by Flint and Walling Manufacturing Co. in Kendallville, Ind. It is 48.6 feet tall, has a millwheel 14 feet in diameter and an alemite grease fitting, probably installed in the 1920s or 1930s. The Star was restored at the NRHC with its original red, white and blue paint covering cypress and white oak.

IMPROVED CLIPPER WINDMILL
c. 1910

To keep windmills turning and pumping on large ranches, a windmiller was employed like a modern-day mechanic to keep the parts in working order. For smaller ranches, a town blacksmith provided the service. Montgomery Ward Co. distributed this turn-of-the-century windmill variety. The galvanized steel wheel measures 6 feet in diameter and rises 30 feet above ground. The cypress water tank and tower were used on George Slaughter's ranch west of Lubbock. Author/journalist Charles Kuralt wrote that around Lubbock and in other flat, dry parts of the country, windmills were "the great *vertical* sight to see. To passers-through, the windmills of the West were beautiful symbols."

AERMOTOR WINDMILL
AFTER 1933

An Aermotor 702 windmill from the Snyder Ranch near Baird, Texas, and a 27-foot tower were given to the NRHC by Jim and Byron Snyder. This particular windmill came from the Callahan County Poor Farm, which was on land purchased by James and Marguerite Snyder, Jim and Byron's parents. The Snyder Ranch has been family-owned and in continual use since 1893. The first Aermotor windmills became available in 1888. In 1933, the Aermotor 702 was introduced, featuring replaceable bearings and screw-type wheel arms. The windmill was set in place in Proctor Park near the King Ranch Shipping Pens.

MONITOR VANELESS
L MODEL WINDMILL
c. 1918

A Monitor Vaneless L was installed in Proctor Park on Oct. 23, 1999, just north of the Four Sixes Barn. The 10-foot windmill uses a spring governor. The six sections of blades were made of wood and dipped twice in white paint then decorated with red tips. A discus-shaped balance weight, in 1918, was phased out in favor of a football-shaped counterweight that was made from reinforced concrete and steel. This model was manufactured in 1912. It was given to the NRHC by well-known windmill collector Billie Wolfe.

FOR THE RECORD

Between 1941 and 1946, Aermotor, long known as a manufacturer of windmills, became a subcontractor for Bell and Howell and built precision lens mounts for the highly secret Norden Bombsight.

BIBLIOGRAPHY AND RELATED READINGS

Prepared by Jim Pfluger

Abbe, Sally Still. "South Plains and Santa Fe Railway Depot, Ropes, Texas." July 27, 1981. Research files, National Ranching Heritage Center, Lubbock, Texas.

Adair, Cornelia. *My Diary, August 30th to November 5th, 1874.* Austin: University of Texas Press, 1965.

Adams, Ramon F. *Western Words: A Dictionary of the American West.* Norman: University of Oklahoma Press, 1968; new ed., 1981.

Aermotor Windmill History (2002-2004) [online]. Retrieved May 11, 2004 from http://www.aermotor windmill.com/Company/History.asp.

Ainsworth, Troy M. "El Capote Cabin and Texas Folk Architecture." August 21, 2001. Research files, National Ranching Heritage Center, Lubbock, Texas.

Ainsworth, Troy M. "Las Escarbadas, the XIT Ranch, and Indigenous Architecture." September 2001. Research files, National Ranching Heritage Center, Lubbock, Texas.

Ainsworth, Troy M. "Louis Martin, the Adelsverein, and German-Texan Folk Architecture." November 2001. Research files, National Ranching Heritage Center, Lubbock, Texas.

Ainsworth, Troy M. "National Architecture and the Box and Strip House." August 2001. Research files, National Ranching Heritage Center, Lubbock, Texas.

Ainsworth, Troy M. "Renderbrook-Spade Blacksmith Shop." n.d. Research files, National Ranching Heritage Center, Lubbock, Texas.

Ainsworth, Troy M. "The Barton House." July 31, 2001. Research files, National Ranching Heritage Center, Lubbock, Texas.

Ainsworth, Troy M. "Victorian Architecture and the Barton House." July 31, 2001. Research files, National Ranching Heritage Center, Lubbock, Texas.

Anderson, H. Allen. "Waggoner Ranch." *The Handbook of Texas Online* (2002) [online]. Retrieved May 6, 2004 from http://www.tsha.utexas.edu/handbook/online/articles/view/WW/apw1.html.

Blankenship, Maxine. "The Cow Chip Age." Spring 1986. Research files, National Ranching Heritage Center, Lubbock, Texas.

Blankenship, Mary A. "The West Is For Us." n.d. Research files, National Ranching Heritage Center, Lubbock, Texas.

Boyce, Rodger. News Release. February 22, 1972. Research files, National Ranching Heritage Center, Lubbock, Texas.

Brown, Bill and Keith Hardison. Interview with Delbert Gilbert. Oct. 17, 1981. Research files, National Ranching Heritage Center, Lubbock, Texas.

Burton, Gerry. "The First Ranch Structure at Museum." *Lubbock Avalanche-Journal.* (August 18, 1970).

Burton, Harley True. *A History of the JA Ranch* (thesis, June 1927), Ann Arbor, Michigan: University Microfilms Inc., 1966.

Christian, Worth. "Old 401." n.d. Research files, National Ranching Heritage Center, Lubbock, Texas.

Cisneros, José. *Borderlands.* Edinburg, Texas: Hidalgo County Historical Museum, 1998.

Clarke, Mary Whatley. *The Slaughter Ranches & Their Makers.* Austin: Jenkins Publishing Co., 1979.

Clayton, Lawrence and J.U. Salvant. *Historic Ranches of Texas.* Austin: University of Texas Press, 1993.

Crawford, Henry B. "The El Capote Cabin: Research Methodology for a History and Furnishing Plan." Proceedings of the 1996 Conference and Annual Meeting of the Association for Living Historical Farms and Agricultural Museums. Volume XIX, 1997.

Crawford, Henry B. "Hedwig's Hill: A German Texas Log House." September 7, 1996. Presentation to German-Texan Heritage Society. Lubbock, Texas.

Dale, Edward Everett. *The Range Cattle Industry, Ranching on the Great Plains from 1865 to 1925.* Norman: University of Oklahoma Press, 1930; new ed., 1960.

Denham, Claude S. "The Origin of the Picket and Sotol House: Remarks on the occasion of the dedication of Picket and Sotol House." April 27, 1974. Research files, National Ranching Heritage Center, Lubbock, Texas.

Denman, Gilbert M. Jr. "Remarks on the occasion of the dedication of El Capote Cabin at the National Ranching Heritage Center." October 26, 1975. Research files, National Ranching Heritage Center, Lubbock, Texas.

Eaton, Tommy, Georgellen Burnett and Sandy Staebell. "Educational Interpretation of the Waggoner Commissary." n.d. Research files, National Ranching Heritage Center, Lubbock, Texas.

England, B. Jane. "Daniel Waggoner." *The Handbook of Texas Online.* (2002) [online]. Retrieved May 6, 2004 from http://www.tsha.utexas.edu/handbook/online/articles/view/WW/fwa8.html.

Evans, Derro. "Ranching in Retrospect." *Texas Homes.* (September 1985): pp. 56-57, 60-61.

Ewing Halsell Foundation Biennial Report, July 1, 1979-June 30, 1981. San Antonio, Texas. 1981.

Fleming, Sharon E. *Building La Frontera.* M.A. Thesis, Texas Tech University, 1998.

"The Four Sixes." (Exhibit gallery guide). Lubbock: National Ranching Heritage Center, 2003.

Frantz, Joe B. "Civilization has moved on and enveloped the XIT: Remarks on the occasion of the dedication of Las Escarbadas at the Ranching Heritage Center." March 27, 1977. Research files, National Ranching Heritage Center, Lubbock, Texas.

Frissell, Toni and Holland McCombs. *The King Ranch 1939-1944.* Fort Worth: Amon G. Carter Museum of Western Art, 1975.

Goldsmith, Charles Adams Jr. Interview. April 26, 1973. Research files, National Ranching Heritage Center, Lubbock, Texas.

Green, Bill. "El Capote Cabin notes." n.d. Research files, National Ranching Heritage Center.

Haley, J. Evetts. *Charles Goodnight, Cowman and Plainsman.* Boston: Houghton Mifflin Co., 1936; reprinted ed., Norman: University of Oklahoma Press, 1949.

Haley, J. Evetts. *The Diary of Michael Erskine.* Midland, Texas: The Nita Stewart Haley Memorial Library, 1979.

Haley, J. Evetts. *The XIT Ranch of Texas and the Early Days of the Llano Estacado.* Chicago: Capitol Reservation Lands, 1929; reprinted ed., Norman: University of Oklahoma Press, 1967.

Holden, William Curry. *A Ranching Saga, The Lives of William Electious Halsell and Ewing Halsell.* San Antonio, Texas: Trinity University Press, 1976.

Holden, William Curry. *The Espuela Land and Cattle Company: A Study of a Foreign-Owned Ranch in Texas.* Austin: Texas State Historical Association, 1970.

Holden, William Curry. "The Role of the Ranch Headquarters Association in Financing the Ranching Heritage Center." 1976. Research files, National Ranching Heritage Center, Lubbock, Texas.

Holman, Andrea Cheryl. "Observations of Historical Construction of the Masterson JY Bunkhouse." June 19, 1974. Research files, National Ranching Heritage Center, Lubbock, Texas.

Jackson, Jack. *Los Mesteños: Spanish Ranching in Texas, 1721-1821.* College Station: Texas A&M University Press, 1986.

Jennings, Diane. "Will Family Rift Doom Ranching Dynasty?" *The Dallas Morning News.* (August 3, 2003) [online]. Retrieved August 11, 2003 from http://www.dallasnews.com/dmn/news/stories/080303dntexranchdeath.42127.html.

Johnson, Byron. "Blacksmithing." n.d. Research files, National Ranching Heritage Center, Lubbock, Texas.

Jordan, Terry. *Texas Log Buildings: A Folk Architecture.* Austin: University of Texas Press, 1978; second printing, 1994.

Kelly, Louise. *Wichita County* [Texas] *Beginnings.* Austin: Eakin Press, 1982.

Kelton, Steve. Rendeerbrook: *A Century Under the Spade Brand.* Fort Worth: Texas Christian University Press, 1989.

"King Ranch Kinenos" (2004) [online]. Retrieved May 4, 2004 from http://www.king-ranch.com/index/kinenos.

Kuralt, Charles. *American Emblems.* New York: Simon and Schuster, 1998.

Levacy, John H. Jr. "Matador Half-Dugout." *Lubbock Magazine.* (March 1998): pp. 24-25.

Lott, John F. Sr. Personal communications with author about history of Hedwig's Hill. February 2004.

Lott, John F. Sr. Personal communications with author about history of the Ranch Headquarters. April 1, 2004.

Lott, Virgil N. and Mercurio Martinez. *Kingdom of Zapata.* San Antonio: The Naylor Co., 1953.

Lundberg, Russell. *My Life on the Matador, A cowboy at the Red Lake Camp from 1937-1941.* Privately printed manuscript from oral history, 1986.

Macy, Robert. Personal communications with author about history of U Lazy S Carriage House. May 2004.

Maddox, Cyndi. "Remembering Life on the Plains." *Southern Living.* (April 1986): pp. 23-24, 26.

Matthews, Sallie Reynolds. *Interwoven: A Pioneer Chronicle.* College Station: Texas A&M University Press, 1982.

McAlester, Virginia and Lee. *A Field Guide to American Houses.* New York: Alfred A. Knopf, 1984.

McCarty, H.A. "History and Operation of the W.T. Waggoner Estate," April 16, 1970. Research files, National Ranching Heritage Center, Lubbock, Texas.

Meador, Douglas. *Trail Dust.* Matador, Texas: Tribune Publishing Co., 1967.

Metcalf, Susan. "Exhibit depicts railroading and ranching." *The Santa Fe Magazine.* (September 1983).

Muckelroy, Duncan. "The History of the Hedwig's Hill Double Log Cabin." n.d. Research files, National Ranching Heritage Center, Lubbock, Texas.

Murrah, David J. *C.C. Slaughter: Rancher, Banker, Baptist.* Austin: University of Texas Press, 1981.

O'Neal, Bill. *Historic Ranches of the Old West.* Austin: Eakin Press, 1997.

Parvin, Bob. "Be It Ever So Humble, There Was No Place Like Home on the Range." [reprint]. *Texas Highways.* (February 1978).

Pearce, W.M. *The Matador Land and Cattle Company.* Norman: University of Oklahoma Press, 1964.

Pfluger, Jim. *Pitchfork Country: The Photography of Bob Moorhouse.* Lubbock: National Ranching Heritage Center, 2000.

Porter, Roze McCoy. *Thistle Hill, The Cattle Baron's Legacy.* Fort Worth: Branch-Smith, Inc., 1980.

Price, B. Byron. "Docent Open House Guidebook." Lubbock: National Ranching Heritage Center, 1976.

Price, B. Byron. "Ranching Heritage Center Guidebook." Lubbock: Ranching Heritage Center, 1977.

Price, B. Byron. "Ranching Heritage Center School Tour Guidebook." Lubbock: Ranching Heritage Center, 1977.

"Ranching Heritage Center Bicentennial Souvenir Program." July 2-4, 1976. Research files, National Ranching Heritage Center, Lubbock, Texas.

Ranch Record. Lubbock: Ranching Heritage Association:
Vol. 1, no. 1 (March 1, 1972)
Vol. 1, no. 2 (June 1, 1972)
Vol. 1, no. 3 (September 1, 1972)
Vol. 1, no. 4 (December 1, 1972)
Vol. 2, no. 1 (March 1, 1973)
Vol. 2, no. 2 (June 1, 1973)
Vol. 2, no. 3 (September 15, 1973)
Vol. 2, no. 4 (December 1, 1973)
Vol. 3, no. 1 (March 1, 1974)
Vol. 3, no. 2 (June 1, 1974)
Vol. 3, no. 3 (September 1, 1974)
Vol. 4, no. 1 (March 1, 1975)
Vol. 4, no. 2 (June 15, 1975)
Vol. 4, no. 3 (September 1, 1975)
Vol. 4, no. 4, (December 1, 1975)
Vol. 5, no. 1 (March 1, 1976)
Vol. 5, no. 2 (June 1, 1976)
Vol. 5, no. 3 (September 1, 1976)
Vol. 5, no. 4 (December 1, 1976)
Vol. 6, no. 1 (March 1, 1977)
Vol. 6, no. 2 (June 1, 1977)
Vol. 6, no. 3 (September 1, 1977)
Vol. 7, no. 2 (September 1978)
Vol. 9, no. 1 (March 1980)
Vol. 9, no. 2 (September 1980)
Vol. 11, no. 1 (January 1981)
Vol. 11, no. 2 (April 1981)
Vol. 11, no. 3 (July 1981)
Vol. 11, no. 4 (December 1981)
Vol. 12, no. 4 (December 1982)
Vol. 12, no. 5 (Spring 1983)
Vol. 12, no. 6 (Fall 1983)
Vol. 12, no. 7 (Winter 1983)
Vol. 13, no. 2a (Summer 1984)
Vol. 13, no. 2b (Winter 1984)
Vol. 13, no. 3 (Spring 1985)
Vol. 13, no. 5 (Spring 1986)
Vol. 27, no. 1 (Spring 1999)
Vol. 27, no. 3 (Fall 1999)
Vol. 28, no. 3 (Summer 2000)
Vol. 29, no. 2 (Spring 2001)
Vol. 30, no. 1 (Winter 2002)
Vol. 31, no. 2 (Summer 2003)
Vol. 34, no. 1 (Spring 2004)

Robinson, Willard B. National Endowment for Humanities Grant Application. March 3, 1975. Research files, National Ranching Heritage Center, Lubbock, Texas.

Robinson, Willard B. "Utility Shaped Ranch Building's Architecture." June 1976. Research files, National Ranching Heritage Center, Lubbock, Texas.

Simon, Ted J. "From Dugout to Victorian Manse, Homes Tell the Rancher's Story." Texas Highways. (October 1985): pp. 36-43.

Slatta, Richard W. *The Cowboy Encyclopedia.* Santa Barbara, California: ABC-CLIO, Inc., 1994.

Suddeth, Andrea. *Scots Dive on the Matador Ranch.* Thesis, Texas Tech University, 1994.

Talbot-Stanaway, Susan, Bettie Mills and Imogene Bowman. "The Ranching Heritage Center: A Self-Guided Tour." Lubbock: The Museum, Texas Tech University, 1983.

Tucker, Bob, Sally Scott and Susanne Cox. "The Waggoner Commissary: Furnishings, Transactions and Stock." n.d. Research files, National Ranching Heritage Center, Lubbock, Texas.

Viola, Herman J. and Carolyn Margolis. *Seeds of Change—500 Years Since Columbus.* Washington, D.C.: Smithsonian Institution, 1991.

"Volunteer Guidebook." Lubbock: Ranching Heritage Center, n.d.

"Waggoner, William Thomas" *The Handbook of Texas Online.* (2002) [online]. Retrieved May 6, 2004 from http://www.tsha.utexas.edu/handbook/online/articles/view/WW/fwa9.html.

"Waggoner Ranch History" (2004) [online]. Retrieved May 4, 2004 from http://www.waggonerranch.com/WaggHist.htm.

Walker, Dale L. The Boys of '98, *Theodore Roosevelt and the Rough Riders.* New York: Tom Doherty Associates Book, 1998.

White, Benton R. *The Forgotten Cattle King.* College Station: Texas A&M Press, 1986.

Woods, Lawrence M. *British Gentlemen in the Wild West: The Era of the Intensely English Cowboy.* New York: The Free Press, 1989.

Woolley, Bryan. *Mythic Texas.* Plano, Texas: Republic of Texas Press, 2000.

ACKNOWLEDGEMENTS

The NRHC is grateful for the untold hours of research, writing and rewriting **Marsha Pfluger** devoted to developing the first edition of this book in 2004 and then updating the second edition in 2010. While others provided assistance, Marsha was always the central figure in decision-making and preparation. Her unique writing style as a storyteller fills every page. She placed each historic structure in the framework of events happening in the life of the owners and the life of a nation. As the NRHC has grown and added new structures, it has become necessary to update Marsha's original work without altering the beauty of her storytelling. Marsha retired from Texas Tech University in 2014 after being NRHC associate director for nearly 14 years.

The NRHC is grateful to the **Helen Jones Foundation** for funding not only this third edition of *A Walk Through the National Ranching Heritage Center,* but also for many years of support in a myriad of efforts to share the ranching story. Helen DeVitt Jones was born into one of the early ranching families of West Texas in 1899. She lived on the family's 52,000-acre Panhandle ranch until time to attend school and eventually graduated summa cum laude from the University of California at Berkeley. Mrs. Jones never forgot her ranching roots and became a patron of the NRHC and other philanthropic causes after forming the Helen Jones Foundation in 1984.

When there is no storyteller, the story is lost in time as if it never happened. The NRHC has helped tell the ranching story to every new generation since the center was dedicated in 1976.